FRIDA KAHLO
AT HOME

FRIDA KAHLO AT HOME

SUZANNE BARBEZAT

FRANCES
LINCOLN

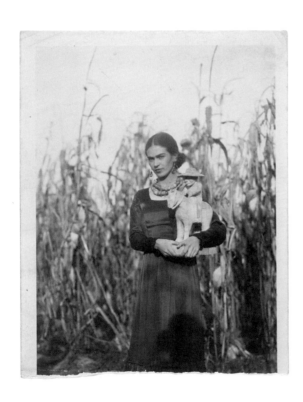

CONTENTS

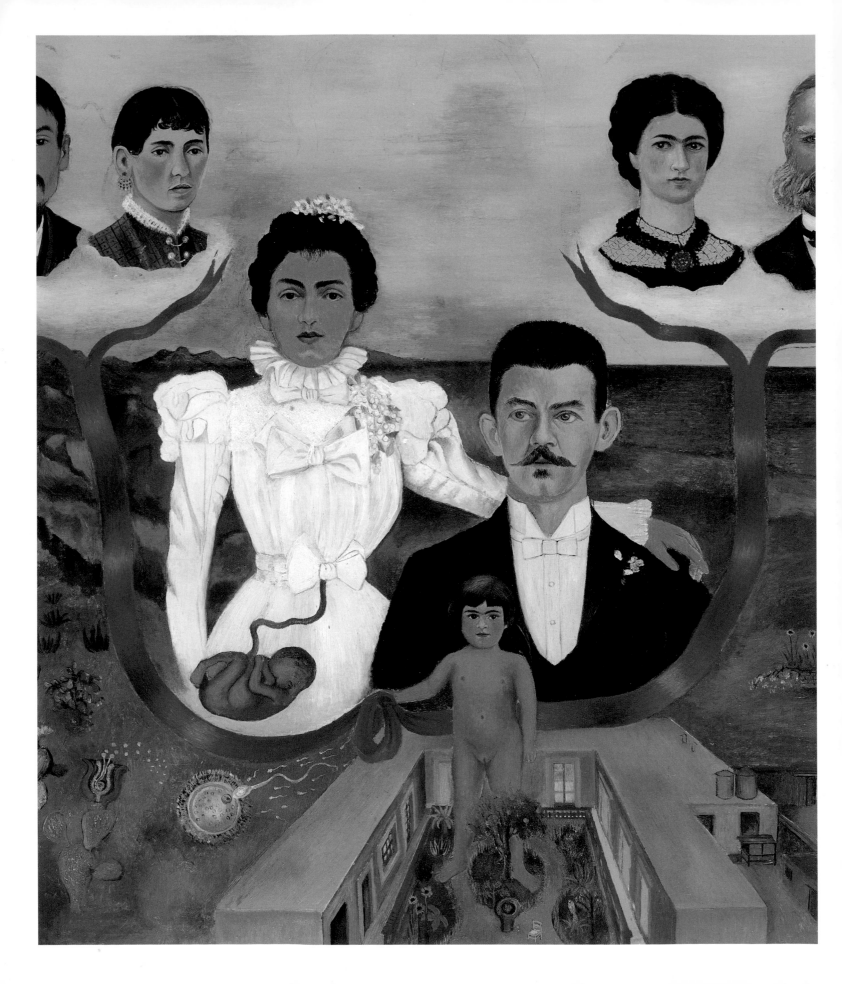

ORIGINS & CHILDHOOD IN COYOACÁN

A cobalt blue house stands on the corner of Allende and Londres streets in a comfortable but unassuming residential area of the Mexico City borough of Coyoacán. Apart from its colour and the sign above the door, there is little on the outside to distinguish it from its neighbours. Yet, on most days of the week, a line of people waiting to get in stretches down the block. Magdalena Carmen Frida Kahlo y Calderón was born here on July 6, 1907. She was the third daughter of Guillermo Kahlo, a German immigrant and prominent photographer of the time, and his second wife, Matilde Calderón, a young woman of Spanish and indigenous Mexican descent. The house was built just three years before Frida's birth, on a plot of land that her parents had purchased in the then burgeoning district.

Frida would claim throughout her life that she was born in 1910, aligning her birth with the outbreak of the Mexican Revolution. This was just one of the ways in which she embroidered the truth of her life to shape the identity she wished to project. In fact, she was born just a few years before the end of the presidency of Porfirio Diaz, a time characterized by political stability, accelerated economic growth and technological progress, but also great social inequality.

Frida's father had arrived in Mexico in 1890. Not yet 20 years old, he was a slim young man with elegant manners. He had thick brown hair, grayish-blue eyes and a penetrating gaze. He was clean-shaven at the time, but would soon grow a dapper moustache that he kept for the rest of his life. He suffered from sporadic epileptic attacks, possibly as a result of an injury sustained in his youth. At the time of his arrival, there was a community of about 500 Germans living in Mexico City. They were, for the most part, prosperous merchants who had little interest in integrating into Mexican society. They were there to take advantage of the economic opportunities in Mexico: the government of Porfirio Diaz encouraged foreign investment by giving tax exemptions and other incentives to foreign businesses.

FAR LEFT Matilde Calderón, Frida's mother

LEFT Guillermo Kahlo, Frida's father

BELOW Frida's parents pictured soon after their marriage in 1898

Diaz had been in power since 1876, ruling authoritatively over the country along with his advisers, a group of men known as '*los Científicos*' (the Scientists), who advocated Positivist principles of order and reason, and the maintenance of a strict social hierarchy. With his desire for social order, Diaz responded swiftly and strongly to disruptions of any kind. During this period, highways, railroads, telegraph lines and oil fields were built and there were significant developments in the mining and textile industries. The upper classes favoured European styles in art, architecture and fashion, and purchased luxury goods imported from Europe. Although President Diaz was of indigenous and European ancestry, he downplayed his indigenous heritage and championed European culture and civilization. Some say he went so far as to powder his face to make himself appear more European.

Unlike the majority of his compatriots, Frida's father had every intention of making Mexico his permanent home. Within a few years of his arrival, he changed his name from Wilhelm to Guillermo, obtained Mexican citizenship, and married a Mexican woman named Maria Cardeña. He worked as a clerk for a few different German-owned businesses, including Casa Boker, a hardware shop, and Joyeria La Perla, a jewellery store. He and Maria had three children. The second died in infancy and Maria died giving birth to the third, leaving Guillermo a widower at 27 with two young daughters in his care.

He promptly proposed to one of his co-workers at La Perla. Matilde Calderón was a petite 21-year-old with delicate features and a dimple in her chin. She was the daughter of Antonio Calderón, a photographer from Morelia, and Isabel Gonzalez from Oaxaca, the convent-educated daughter of a Spanish general. Matilde was the eldest of their twelve children, a devout Catholic, and though she was lacking a formal education, she was bright and good with numbers. She and Guillermo were married in a Catholic ceremony on February 21, 1898. Matilde's mother Isabel attended, but her father had already died.[1]

Guillermo was given his late father-in-law's camera. Although he had not received any formal training in photography, he was a meticulous technician and his work shows a keen eye for composition and perspective. He gave up his job at the jewellery shop and devoted himself to photography full-time. He specialized in photographing architecture, machinery and landscapes. Although he wryly commented that he preferred not to take photos of people because he did not like to make beautiful what God had made ugly,[2] people were often the subject of his photos: he took portraits of clients and his family, as well as self-portraits.

His first important commission was to document the construction of Casa Boker: the German-owned hardware store was building a new headquarters and his previous employers hired Guillermo to document the entire process. The building was a symbol of modernity as it was the first in Mexico that had an American steel frame.[3] The construction took just sixteen months, and Guillermo recorded each step, from the digging of the foundation to the building's extravagant inauguration ceremony. Guillermo's photography offered a striking portrait of the country's architectural wealth and economic progress, just the sort of message the government wished to convey to the world. He captured the modern development of the country on film. His photos of buildings, factories and machinery often appeared in Mexican newspapers and magazines to illustrate the nation's technological and industrial advances.

In 1904, Guillermo received an important government commission to photograph Mexico's architectural heritage for a series of high-quality albums that were to be published on the centenary of Mexican independence. That same year, he received a sum of money from Germany, his inheritance following the death of his father. These circumstances allowed Guillermo and Matilde to purchase a plot of land to build a home for their growing family; along with the daughters from his first marriage, they soon had two more: Matilde, born in 1899, and Adriana, born in 1902.

They looked to settle just outside the city. Coyoacán was a quiet village with a rich history dating back to ancient times, located about eight kilometres south of the centre of Mexico City. Its name means 'Place of the Coyotes' in Nahuatl, the language of the Aztecs. The village square was a popular meeting place, and just off the main square, the San Juan Bautista church dated to the 16th century. The surrounding land was mostly devoted to agriculture, and the area had a distinctly rural feel, with orchards, streams and mountains nearby. When public transportation made the trip to Coyoacán more accessible to Mexico City residents, it came to be seen as a leisure destination. Well-to-do

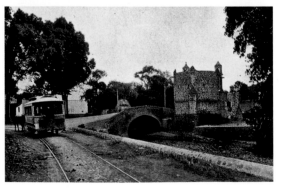

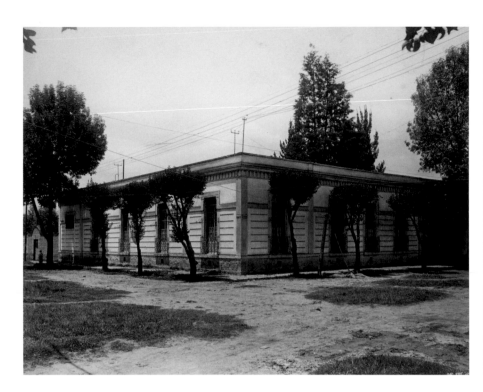

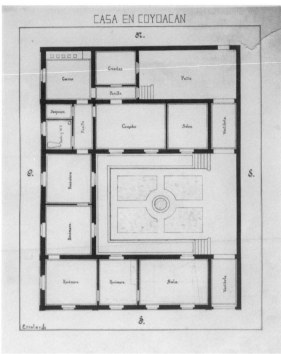

CASA EN COYOACAN

LEFT Jardín Centenario in Coyoacán, photographed by Guillermo Kahlo, and the new tram, linking the village to the centre of Mexico City

ABOVE The Kahlos' new home in Coyoacán

ABOVE RIGHT Floor plan for the single-storey house

OVERLEAF View of the church of San Juan Bautista today, off the main square in Coyoacán

families from the city visited on the weekends, seeking to escape the bustle of the city for more tranquil surroundings. As time went on, some of them purchased homes there, either to use as vacation houses, or to live year-round.[4]

In 1890, the land belonging to the Hacienda San Pedro y San Pablo in Coyoacán was converted into Colonia del Carmen, a new urban development conceived as an upscale residential area. The streets were named after European cities and leaders of Mexico's independence movement. Lots were marked off and numbered, and agencies marketed the plots to wealthy Mexico City residents. President Porfirio Diaz himself inaugurated the neighbourhood, which was named after his wife, Carmen Romero Rubio, and ten years later he would donate a French-built kiosk which would become the most prominent feature of Coyoacán's main square. Electric trolleys were introduced in 1900, cutting the commute to the centre of Mexico City to about an hour. Coyoacán was far enough outside the city to maintain its rural feel, but close enough for people who worked or went to school in the city to travel there and back in a day. Still, the majority of the streets in Colonia del Carmen would not be paved until the 1960s.[5]

Guillermo and Matilde purchased a 1200-square-metre lot in Colonia del Carmen, just a few blocks from the Coyoacán village square. The name of the architect who drew up the plan of the house is not known, but with his interest in architecture, Guillermo certainly would have had a say in its design. The house had a traditional Mexican floor plan with adjoining rooms surrounding a central patio in a horseshoe shape. A high wall separated the property from its neighbour to the east. It was a single-storey home, but its tall windows

and the row of privets growing along the outside of the house gave it a stately look. A base of volcanic rock elevated the four-metre-high walls from street level by an additional half metre. Plasterwork in the walls added the decorative elements of horizontal frets and cornices. The windows had French doors and cast iron balconets, adding to the home's elegance. Initially, the exterior walls were likely either white or a light pastel colour, with the trim in a darker tone. The home would not acquire its characteristic dark blue colour until later.[6]

The main entrance on Londres street led to a large vestibule, which opened on to the central patio. The house had four bedrooms, a living room, dining room and kitchen, as well as a small service patio and servants' quarters at the rear of the house, next to the kitchen. An orange tree growing in a round raised bed had pride of place in the central patio. A narrow corridor around the perimeter of the patio was surrounded by a low brick latticework wall. The patio had many plants, but in these early years they were small and did not give much shade. Birdcages hung from the walls, and the family had a number of pet dogs. The patio would frequently be the site for gatherings of family and friends, which Guillermo often captured with his camera. Inside, the family home was furnished with French-style furniture in the fashion of the time, and Guillermo had a German piano,

LEFT The central patio of the house in Coyoacán, site of frequent gatherings of family and friends

BELOW Guillermo with his library of books

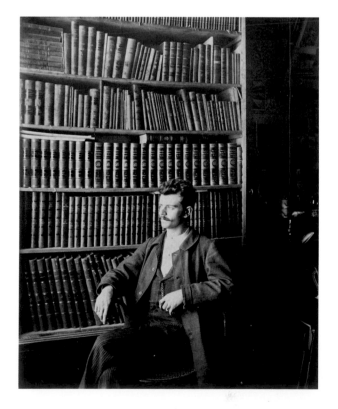

which he played well, and a large collection of books (he was particularly fond of reading the German philosopher Schopenhauer).

Guillermo and Matilde's first years together were happy and comfortable. A photo of the couple, taken early in their marriage, shows them smiling, looking carefree and affectionate. Several photos of Matilde reveal her in candid moments with their children. But in 1905, shortly after moving to their new home in Coyoacán, Matilde gave birth to a son who only lived a few months. Two years later, Frida was born. Matilde became pregnant again shortly after having Frida, so she did not breastfeed her. They hired an indigenous woman as a wet nurse. When her parents discovered that the woman had been drinking, they dismissed her and hired another woman named Hilaria to replace her. Hilaria and her son Chucho, Frida's 'milk brother', would remain in the household for many years.[7] The youngest Kahlo, Cristina, was born just eleven months after Frida. Guillermo's oldest daughters Maria Luisa and Margarita were sent to be educated in a convent, but they visited the family on holidays and maintained close ties with their half-sisters.

In September 1910, Mexico celebrated its 100th anniversary of independence from Spain. The same month marked the 80th birthday of President Diaz, who had been in power for over thirty years. He had a raft of official events planned: shows, parades and inaugurations of new monuments, including the Angel of Independence, a golden statue of a Winged Victory on a 40-metre-high column, a triumphant symbol of the city. Many foreign dignitaries attended the celebrations, affording them the chance to see and appreciate that Mexico was a modern, progressive country and its capital was on a par with European cities.

While the president's attention was on the centenary festivities, there were rumblings in the country. Labour and land struggles had been building for some time. In 1906, a large group of miners in Cananea, Sonora had gone on strike; their main point of contention was the disparity of pay for Mexican versus foreign workers. A few months later, textile workers in Puebla and Veracruz also went on strike in protest of

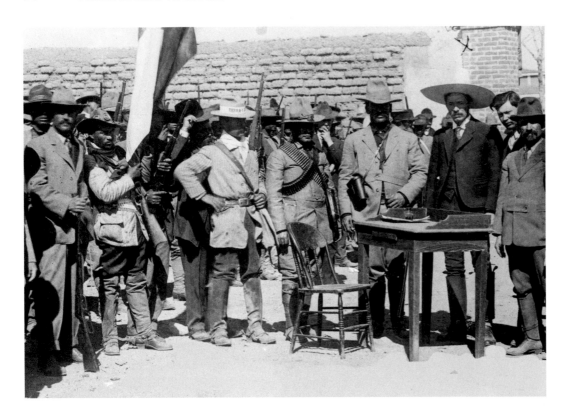

their poor working conditions. Both movements were vigorously quashed by authorities and many workers were killed in both incidents. In rural areas, the indigenous people had been run off their land and forced to work for large plantations. Receiving little pay, they had no option but to receive goods for credit at the company store, becoming indebted and further impoverished.

Francisco Ignacio Madero came from a wealthy family in northern Mexico, but he had idealistic hopes of reforming the country through democratic means. He tried running against Diaz in the elections earlier in 1910, but Diaz had Madero jailed and declared himself the winner. When Madero was released, he published a plan which called for an uprising against the government. The revolt was scheduled for November 20, 1910, and would mark the beginning of the Mexican Revolution. Pancho Villa and Pascual Orozco in the north, and Emiliano Zapata in the south, led militias in support of Madero. In May 1911, Porfirio Diaz resigned from office and fled to France, where he remained in exile until his death. Madero became president. He was hated by the wealthy, who had done well under Diaz, and did not institute changes swiftly enough to appease those who had fought for him and were anxious for social reform and land redistribution, so the violence continued.

With the onset of the revolution, Guillermo's government commissions ceased, and as it progressed, other sources of income dried up. The Kahlo family's economic situation became more difficult as time went on. Eventually they were forced to mortgage the house,

LEFT Leaders of the Mexican Revolution, 1910, including Francisco Ignacio Madero, Rodolfo Fierro, General Pascual Orozco and Abraham Gonzalez

BELOW Revolutionary leader Emiliano Zapata, illustrated by José Guadalupe Posada

sell off their elegant furniture and china, and take in boarders. They kept the piano, which served as a reminder of easier times.

Some of Frida's earliest memories were of the revolution. She remembered the *Decena Trágica* (the Ten Tragic Days), a particularly bloody period that took place in February 1913, and led to the assassination of Francisco Madero. Coyoacán was the scene of conflicts between Zapatistas and Carrancistas, supporters of revolutionary leaders Emiliano Zapata and Venustiano Carranza. She recalled in her diary: 'My mother opened the balconies on Allende Street for the Zapatistas, so the hungry and the wounded could jump over the balcony into our drawing room. She tended to their wounds and fed them corn *gorditas* which was the only food we could get in Coyoacán at the time.'[8] In the Coyoacán Friday market they sold printings of revolutionary songs illustrated by José Guadalupe Posada for one centavo. She remembered hiding in a wardrobe that smelled of walnut wood with her sister Cristina and singing them while her parents kept watch.[9]

Cristina was Frida's closest companion, and the most conventionally pretty of the Kahlo sisters; in contrast, Frida had a striking and unusual beauty that drew the eye, with heavy eyebrows that met in the centre of her forehead and a self-possessed gaze that is apparent even in her father's earliest photographs of her. Frida was fiery and capricious, a natural leader, and her more docile and less clever sister easily fell into the role of follower, though Frida later said that she had been envious of Cristina: 'I was very ugly and I had an admiration complex for Cristi.'[10] They attended the local school, and had many friends among the neighbourhood children. Frida was playful and mischievous, but also had an introspective side.

At the age of six, Frida was struck with polio. It began as a sharp pain in her leg. Her parents soaked her leg in walnut water and applied hot cloths to it. She was bedridden for several months. During that time, she became more introverted and invented an imaginary playmate. In her mind, she travelled to her friend's world and shared all her troubles

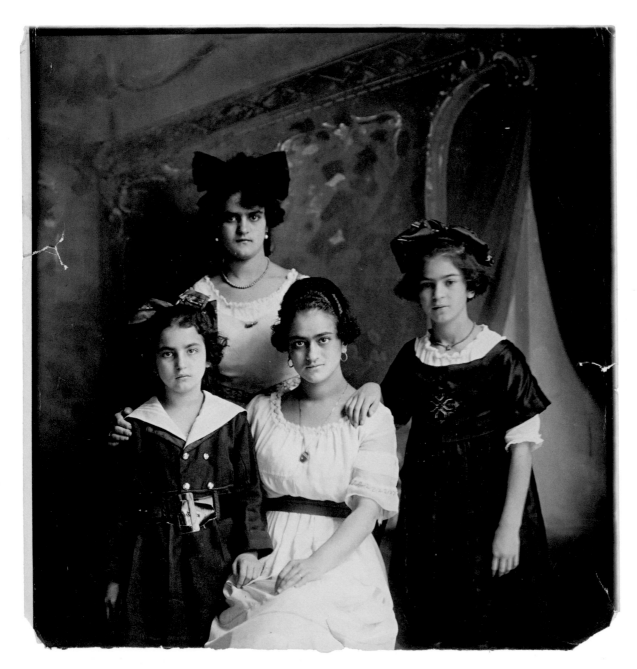

LEFT The Kahlo-Calderón sisters: Cristina, Adriana, Matilde and Frida aged ten

RIGHT Frida aged five

BELOW RIGHT Frida dressed for her first communion

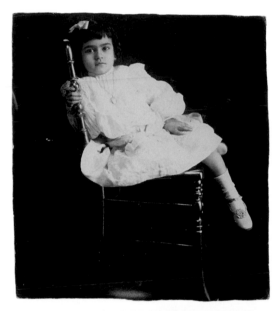

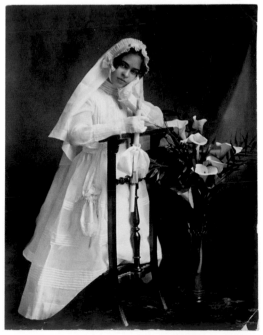

while her imaginary friend danced and laughed; afterwards Frida would feel relieved, like a weight was lifted from her. She recovered, but her right leg would remain shorter and thinner than the left for the rest of her life.[11] As a child she wore several layers of socks to hide the deformity.

The doctor recommended that Frida undertake a programme of physical activity in order to gain her strength back following her illness. Her father encouraged her to play sports, even some in which girls generally did not participate. The neighbourhood children teased her and called her 'Peg Leg Frida'. Although the words hurt, she refused to let it show and became even more daring and adventurous, proving that even with her physical limitation she could perform great feats, such as climbing trees and fences, or doing acrobatic stunts on a bicycle or skates. She was slender, nimble and fearless. She would later take the nickname that children had used to tease her, signing messages to her friends: Peg Leg Frida of Coyoacán of the Coyotes.[12]

When she was seven, Frida helped her older sister Matilde, then 15, to run away with her boyfriend, closing the window behind her when she left. Matilde was missing for four years, to their parents' dismay. Although her mother and father normally did not speak of her sister's absence, one day as they were riding the trolley together, Guillermo exclaimed to Frida, heartbroken: 'We'll never find her!' They did find her a few years later, living in a nearby neighbourhood with the same boyfriend, whom she later married. Their mother was slow to forgive her namesake and would not speak with her or allow her into the house for several years.

Frida's mother insisted her daughters attend church with her. Frida was close to her mother, but found her religious zeal excessive. 'My mother was a great friend to me, but the religious thing never brought us close to each other; she would reach the point of hysteria for her religion.'[13] When the family said grace before meals, Frida and Cristina made faces at one another, trying not to laugh while everyone else kept their heads piously

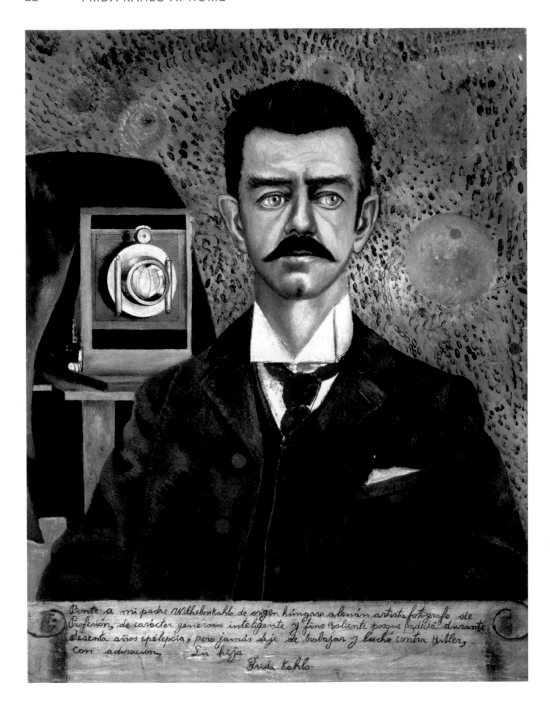

bowed. The two sisters attended catechism classes in preparation for their First Communion, but whenever possible, they escaped to a nearby orchard to climb trees and eat fruit until the class let out and they could safely go home, their subterfuge undetected.

Frida had an easier relationship with her father. Guillermo saw much of himself in her. Although he could be severe, he had a wry sense of humour and was a tender father, particularly with Frida, whom he favoured. Frida accompanied him on photography

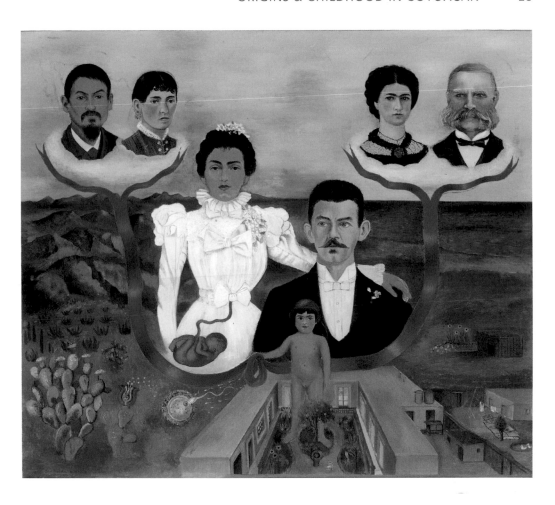

LEFT Frida Kahlo, *Portrait of My Father*, 1951, oil on board, 60.5 x 46.5 cm, Museo Frida Kahlo, Mexico City

ABOVE Frida Kahlo, *My Grandparents, My Parents and I (Family Tree)*, 1936, oil and tempera on metal, 30.7 x 34.5 cm, Museum of Modern Art (MoMA), New York

assignments and assisted him in his studio and in the darkroom. He schooled her in photography and showed her how to retouch photos using tiny paintbrushes. She was always at the ready to come to his aid if he suffered an epileptic seizure. She would spring into action, making sure he was all right while guarding his equipment to prevent its theft.

Frida made a portrait of her father in 1951, ten years after his death. He appears seated next to his camera, looking to one side. The painting is a compilation of two photographs he took of himself. The wall behind him has circular shapes that appear to be a view of cells and sperm through a microscope, perhaps a nod to his role in her creation, or hinting at her father's artistic fecundity. Along the bottom of the canvas, she painted a scroll on which she wrote a dedication: 'I painted my father Wilhelm Kahlo, of Hungarian-German origin, professional artist-photographer, whose nature was generous, intelligent and polite. He was courageous, having suffered from epilepsy for sixty years, but he never stopped working and he fought against Hitler. Adoringly, his daughter Frida.'

The dedication is not entirely factual: Frida perpetuated several myths about her father. His family did not have ties to Hungary, but had lived in the area around Baden-Baden and Pforzheim (now Württemberg-Baden state) for generations. She affirmed that he was Jewish,

but he was baptized as an infant in the Lutheran church in Pforzheim.[14] There is also no evidence to suggest that he was involved in politics or any efforts to fight against Hitler.[15] She most likely misrepresented his origins as a way of dissociating her family from Germany's Nazi regime. Another myth about Guillermo is that he was an atheist. Although he was significantly less religious than his wife, in a letter to Frida he admonishes her: 'Respect God above all, because he reigns over everything (even when many say otherwise). . .'[16]

Guillermo's example and instruction in art had an important role in shaping Frida's artistic sensibilities. Aside from the professional photographs he took, he enjoyed experimenting with the camera and taking self-portraits, a great many of which show him looking directly at the camera with the same unflinching gaze his daughter would adopt in her numerous paintings of herself. Guillermo was also an amateur painter: he did watercolours of landscapes, and most certainly painted the backdrops in his photography studio.[17] She often posed for him, and from an early age learned how to present herself to the camera. He stimulated her intellectual curiosity and encouraged her artistic endeavours.

Frida depicted her home and origins in the 1936 painting *My Grandparents, My Parents and I*. In the painting, she depicts herself as a child of three or four years of age in the courtyard of a miniature version of her family home, with her parents and grandparents floating above her. The small-scale house is true to life, with light blue walls and an orange tree in the centre of the courtyard. Frida is naked, and her bare feet are planted among the greenery in the house's central patio. Instead of depicting the village where she grew up, Frida placed the house in a sparse but distinctly Mexican landscape, with a few native plants: a flowering nopal cactus and some agave in the distance. To one side of the house, Frida painted an ovum with a crowd of sperm rushing toward it; the largest one is about to make contact.

Her parents are the largest figures in the painting. They appear in the centre of the composition as they looked in their wedding portrait, but on her mother's pristine wedding gown, there is a fetus with an umbilical cord that leads to a bow at Matilde's waist. Her grandparents float above their offspring, surrounded by clouds; Guillermo's parents above him, floating over the ocean that appears in the top right corner of the canvas, and Matilde's parents are above her, over a mountainous landscape. In this painting, Frida included three important moments in her creation and development: the moment of her conception, as a fetus in her mother's womb, and as a small child. Significantly, she depicts her conception

Arcos de Coyoacán, photographed by Guillermo Kahlo in the 1930s

as taking place on Mexican soil. She is surrounded by the people who contributed to her gene pool, and they are all linked by a ribbon representing her bloodline, which the child Frida holds in her right hand.

Although we can read this and many of her works as purely autobiographical, Frida was knowledgeable about art history, moved in sophisticated circles of artists and intellectuals, and was keenly aware of what her contemporaries were producing. While her work uses her personal story as subject matter, through it, she explores broad themes of gender, fertility, hybridity, the life cycle and nationalism. At a time when the Nazis were using genealogical charts for eugenics, Frida depicted her family tree celebrating her mixed ancestry and challenging negative images of hybridity, while at the same time defining herself as essentially Mexican. She firmly situates herself, as though rooted, within the house where she was born, which formed a vital part of her identity. Although she would live in other places, the house in Coyoacán would always be her home.

SCHOOL DAYS IN MEXICO CITY

Frida Kahlo, detail from *Self-Portrait in a Red Velvet Dress*, 1926

Frida became a student at the National Preparatory School at the age of 15. With this step, a new world opened up to her. She began a course of studies that would lead to medical school after five years. Although her connection to home and family would always be strong, attending the school led her away from the paths her sisters took. She would no longer be confined to quiet Coyoacán. Like her father, she would ride the trolley every weekday morning past the farmers' fields and into the big city.

The school was housed in a Baroque 18th-century building in the heart of Mexico City, just two blocks from the Zócalo, the city's extensive main square. The solid construction of thick walls and spacious courtyards had originally served as a Jesuit boarding school. The building's striking facade is covered in porous red volcanic rock and decorated with ornate portals, pilasters and lintels in contrasting grey quarry stone. Inside, three levels of arched walkways surround courtyards of various sizes. Frida and her classmates attended student assemblies in a meeting room filled with sumptuously carved 17th-century mahogany and cedar choir pews that had been salvaged from the convent of Saint Augustine. The room also had numerous oil paintings adorning the walls: portraits of men who had played important roles in the school's history. In the early 20th century, an extension of two small courtyards and a theatre were added on the south side of the building. The new southern facade mimicked that of the original north-facing one.

The prestigious preparatory school was founded in 1867 to offer a high-quality secular education at the upper secondary level. Mexico's great thinkers and leaders were among its distinguished alumni. The school's original curriculum was based on the Positivist philosophy of Auguste Comte and taught that all knowledge comes from observed phenomena. This marked a profound shift from the earlier educational model rooted in religion. By the time Frida entered the school, there were new streams of thought, with many people rejecting

the Positivist point of view and arguing for a humanistic approach. These ideas provoked heated debate while Frida was a student.

The school admitted its first female student in 1882. However, at the time of Frida's enrolment 40 years later, there were still only thirty-five girls in a student body of 2,000. Frida arrived with her dark hair cut in a short bob with unruly curls. Although the students did not wear uniforms, she wore a traditional schoolgirl's outfit: a white blouse and navy blue pleated skirt, and a straw hat with bows. Despite her demure attire, Frida was not one to follow the rules. Girls were expected to be on the upper floor when they were not in class. Frida had other ideas, to the frustration of the girls' prefect, who sent a note to Frida's parents to notify them of her behaviour. The prefect had many complaints: Frida was frequently far from the girls' department, loitered on nearby street corners, and was often seen in the company of students whose conduct was unsatisfactory. She noted that Frida always responded agreeably when corrected, but did not change her conduct.[1]

Frida traded her straw hat for a knit cap when she joined a group of students who were known as '*Los Cachuchas*' (The Caps) due to their headwear. At a time when everyone wore hats, wearing a cap instead symbolized their refusal to adhere to social norms. They were well-read and politically aware teens with a strong rebellious streak; they enjoyed playing pranks on teachers and other authority figures. There were seven boys and two girls in the group. Frida styled herself Cachucha #9. One of the group's preferred meeting places was the nearby Ibero-American library, where they read and discussed literature as well as politics and ideas.

Frida became romantically involved with fellow Cachucha Alejandro Gomez Arias, the group's leader. He was a well-spoken, charismatic and attractive young man. When they were apart, they wrote to one another. Many of their missives were short notes to arrange meeting times and places. When they were apart for longer periods, their letters reflected their desire to be together and their intense mutual longing. Her correspondence with Alejandro marked the beginning of a prolific letter-writing habit that Frida would maintain throughout her life.

It was an exciting period of renewal in the country. The revolution had caused great destruction and loss of life, but by its end, Mexico had gained a new constitution incorporating many revolutionary ideals: it prohibited re-election of high-level public officials, established rights for workers, made natural resources national property, limited

RIGHT Alejandro Gomez Arias

FAR RIGHT At the age of 15, Frida became a student at the National Preparatory School in Mexico City

BELOW The cathedral and National Palace in Mexico City, 1926

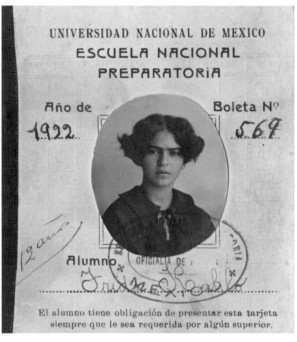

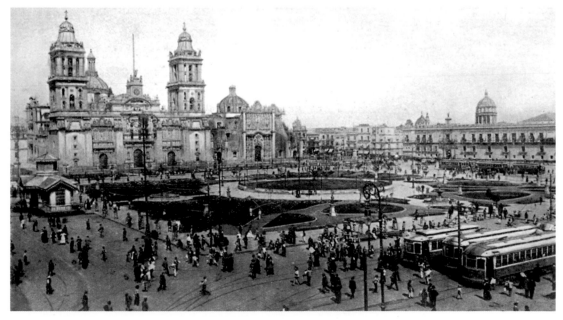

the power of the Catholic Church, and laid the foundation for land reform. Álvaro Obregón became president in 1920, and Mexico finally experienced a period of relative peace and stability since the revolution's outbreak a decade earlier. Obregón worked to maintain order and create economic stimulus. He began the redistribution of land to peasants and restructured the country's economic system. He supported labour and forming workers' organizations.

Rebuilding and fostering a new sense of identity and national pride was a huge task. President Obregón enlisted the help of a great thinker, José Vasconcelos, to lead the efforts as Minister of the newly created Secretary of Education. Vasconcelos had a plan to teach

San Ildefonso College, which served as the National Preparatory School from 1867 to 1978

all Mexicans to read, make art and culture widely available and instil a sense of national pride that valued both the indigenous heritage and European influences that make up Mexican identity, as well as the country's modern accomplishments. Vasconcelos believed that Mexico's redemption would come through the arts. He had classic works of literature printed and distributed. He encouraged popular artistic expression, hiring muralists to paint public buildings with a message of national pride. Their work would promote a revitalized national identity that re-envisioned Mexico's history.

The National Preparatory School was the testing ground for the muralism project. The same year that Frida entered the school, several painters began decorating the building's interior walls. The students had strong political views and their reactions were mixed. Many did not agree with Vasconcelos' plan to educate the masses and were affronted that their school housed the inception of this campaign. The painters were targets for pranks, their murals were defaced, and at times the artists feared for their personal safety. Some of the muralists took to carrying pistols to ward off troublesome students.

Vasconcelos assigned artist Diego Rivera to paint a mural in the school's theatre, part of the building's new annex. Rivera had just returned to Mexico after having spent most of the preceding 14 years living in Europe. He had returned home for a brief visit in 1910 and witnessed the outbreak of the revolution, but he departed again for Europe, where he remained until 1921. The 36-year-old painter was a large man with dark wavy hair, a pot belly and protruding eyes. He was genial and a great storyteller, spinning tall tales that captivated his listeners. Frida was fascinated by him, and she was not the only one. Though far from presenting the conventional profile of a ladies' man, he was very popular with women. Even while married he engaged in numerous dalliances. He had returned from Europe with his political views undefined, but he soon joined the Mexican Communist Party and became one of its most vocal members.

Frida did not express an interest in pursuing a career in the arts during her school days. Her plan was to become a doctor. Yet, her boundless creativity showed itself in a variety of ways. She doodled and made sketches in her school notebooks and decorated her letters to Alejandro and other friends with illustrations. She gifted an aunt with a serving tray on which she had painted a still life of poppies. She wrote poetry, even having one of her poems published in the newspaper *Universal Ilustrado*. And she gravitated toward Diego Rivera.

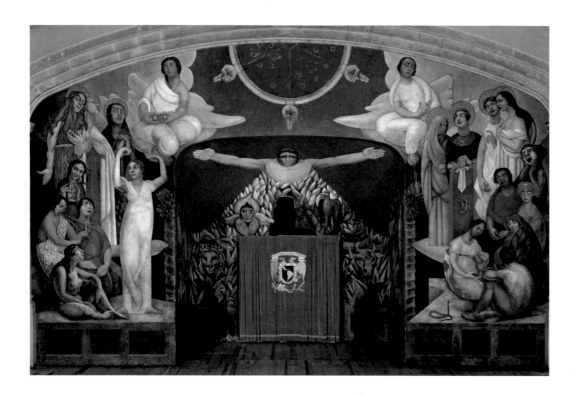

Her fascination with him was no doubt a combination of interest in his art, his politics, and the man himself. She took any opportunity to see him. Two undated handwritten notes from this period demonstrate her interest. In a note to her classmate Adelina Zendejas, Frida wrote that 'the Pot-Bellied Genius' had promised to explain his work and the models he chose for the mural, and she encouraged her friend to come along.[2] On another occasion, she sent a note to her mother saying she was going to stay late at school because Diego Rivera was giving a conference. Amusingly, to explain her interest in the conference, she added about Diego: 'I think he's from Russia and I want to learn about Russia.'[3] Diego had not yet visited Russia (he would go in 1927), but he had been married for ten years to a Russian woman and spoke a bit of the language.[4] With his extravagant manner, he likely perpetuated the idea that he was involved in the Russian Revolution during the years that

LEFT Diego Rivera, *Creation*, 1922–3, fresco in encaustic and gold leaf, 708 x 1219 cm, Anfiteatro Bolivar, Escuela Nacional Preparatoria San Ildefonso, Mexico City

BELOW Diego Rivera, 1929

he had actually spent painting and gallivanting in Europe. Frida later explained: 'There was beginning to be talk about Diego; that he had returned from Russia and was giving talks on Russian theatre and art. I would go to hear him.'[5]

The mural in the preparatory school theatre was Rivera's first, and he entitled it *Creation*. It covered the back wall of the stage, an arched area with a niche containing a monumental organ in the centre. His European influences are evident in the composition and style. The work contains Christian symbolism, along with the message that José Vasconcelos wished to convey: that human nature is improved through culture and the arts. Diego was ultimately unsatisfied with this mural; he had not yet found his distinctively Mexican style.

Unlike the other muralists, Rivera depicted recognizable models in his work. He purposely included models representing people of both European and indigenous descent. His wife, Lupe Marín, posed for three different figures in this mural, including the nude figure of Eve. Tall and strong, with flashing green eyes and a fiery temperament, she represented Rivera's ideal of feminine beauty.[6] They were married in a church ceremony in June 1922, shortly before Rivera began work on the mural, and they had two daughters together. This was Diego's second long-term union. While he lived in Europe, the Russian artist Angelina Beloff had been his common-law wife for ten years.

Frida and her friends played pranks on the artists. Rivera presented a particularly appealing target with his great girth, stuck up on the scaffold. They soaped the steps, thinking to trip up the fat man, but he had a slow, ambling gait and never fell. He was rumoured to be having an affair with one of his models, the artist Nahui Ollin who was known as a proponent of free love.[7] Frida hid in a dark corner and, when the painter was with Nahui, called out: 'Lupe is coming!' to rattle him. But one day when discussing their aspirations for the future, Frida commented to her classmates that she planned to have a child with the artist. Her friends laughed at her ludicrous statement.

Diego remembered that Frida came to watch him at work. In his autobiography, he recounts that he was in the theatre with Lupe when Frida approached to ask if she could watch him paint. 'She had unusual dignity,' he recalled, 'and self-assurance, and there was a strange fire in her eyes. Her beauty was that of a child, yet her breasts were well developed.' He said he didn't mind at all, and she sat watching him intently for several hours, inciting Lupe's ire.[8]

Rivera's mural was inaugurated in March 1923. Shortly thereafter, he joined a group of artists to form the Syndicate of Technical Workers, Painters and Sculptors. David Alfaro Siqueiros, José Clemente Orozco, Xavier Guerrero and Carlos Mérida were also members. Some of the ideals they stood for included drawing artistic inspiration from the indigenous peoples and valuing public monumental art over easel art, which they saw as a bourgeois, individualistic art form. They were in solidarity with labourers and determined that they should receive the same wages as house painters. The Syndicate's manifesto stated: '. . . the art of the Mexican people is the most wholesome spiritual expression in the world, and this tradition is our greatest treasure. [It is] great because it belongs collectively to the people, and this is why our fundamental aesthetic goal must be to socialize artistic production and wipe out bourgeois individualism.'[9]

The Kahlo family's financial situation did not improve with the conclusion of the revolution. Guillermo continued to take photos of buildings and landscapes as well as portraits, but large commissions were not forthcoming. Frida often helped in her father's studio. After school, she would head there to do her homework and assist with a variety of tasks, but it soon became apparent that she needed to find a job to contribute to the family's finances. She looked for work she could do after school and on holidays. Some of the jobs she held included working in a pharmacy and at a lumberyard where she had to count the number of beams produced and record their colour and quality. She also took a course to learn typing and shorthand with the hope of finding a secretarial position. At 17, Frida began to work as an apprentice engraver in the studio of Fernando Fernandez, a friend of her father's. He was impressed by her work and artistic ability. He wrote: 'I put in her hands a book with reproductions of the marvellous work of Anders Zorn and I was truly surprised by the faculties of this marvellous artist. She copied directly by pen by sight without any other indications . . .'[10] This arrangement lasted only a few months before Frida suffered an accident that would alter the course of her life.

After school on September 17, 1925, Frida and Alejandro walked around the centre of Mexico City. It was the day after Mexican Independence Day and there were still stalls set up in the streets selling patriotic paraphernalia. Frida bought a *balero*, a traditional wooden cup-and-ball toy. Later, they boarded a bus for Coyoacán, but Frida realized that she had left her umbrella behind. They got off and went back to look for it. They did not find the umbrella, and they boarded another bus to resume their journey. Buses had only recently been introduced in Mexico City and were seen as a novelty; many people favoured them over trolleys, which had been around since the turn of the century. The buses were brightly painted, but quite flimsy. The inside of the bus had long wooden benches on either side. It was quite crowded, but Frida and Alejandro found a spot to sit together near the back of the bus.

In front of the San Juan market, a trolley car veered off course. The bus passengers saw the trolley coming at them as if in slow motion. The trolley squeezed the bus against the corner of the building. It seemed to stretch and stretch until finally it blew apart in a sudden explosion. In the first moments after the collision, Frida was not aware of the extent of her injuries. Her initial thoughts were of the brightly coloured balero she had been carrying with her, wondering where it was. A metal handrail had impaled Frida through the abdomen. Somehow her clothing had come off in the accident and a packet of gold dust powder another passenger had been carrying had burst open, covering her naked body. With her lithe body sparkling gold, she looked oddly graceful, prompting a passerby to exclaim: '*¡La bailarina!*' A man noticed that she was impaled by the handrail and took action. He grasped the metal pole with two hands and, placing his knee on her chest, he brusquely removed the pole. Frida began to scream horrifically, drowning out the sound of the approaching ambulance sirens.[11]

A few people died at the scene of the collision and many more were badly injured. Because Frida's injuries were severe, the medical personnel first attended to others who had a better chance of surviving. Alejandro, who had sustained only minor injuries in the crash, implored the doctors to examine her. When they did, they found that her injuries were extensive. She had multiple fractures in her spinal column and pelvis. Her collarbone, two ribs and her right leg were broken. Her right foot was crushed and her left shoulder was dislocated. She was taken to the Red Cross Hospital on San Jerónimo Street, just a few blocks from the scene of the accident.

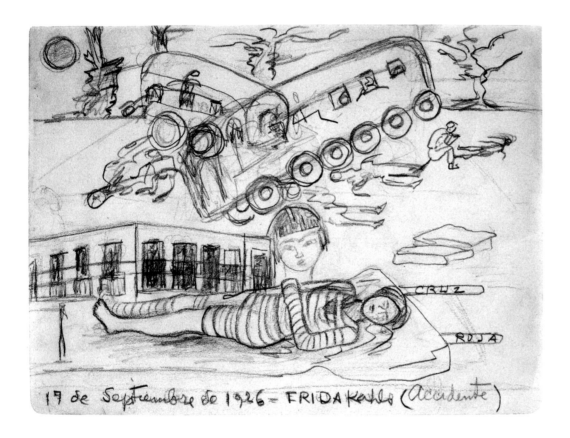

Although Frida's older sister was still not welcome in the family home, Matilde came to see her in the hospital every day. She helped the nurses and kept Frida and the other patients in good spirits by telling stories and jokes. Frida's parents were mostly absent from her bedside because they were suffering from health issues. Her mother had begun to have seizures similar to her father's. Frida said that when her mother heard about her accident, she was speechless for a month because of the impression it made on her. Her sisters feared that seeing Frida in her injured state would further impact on their mother's health. Her mother visited her twice during her hospital stay, and her father only once.[12]

LEFT Frida Kahlo, *The Accident*, 1926, pencil on paper, 20 x 27 cm, Juan Rafael Coronel Rivera, Cuernavaca

BELOW Retablo, c. 1943, oil on metal, 19 x 24 cm, private collection

los Esposos guillermo Kahlo y Matilde c. de Kahlo Dan las gracias
a la Virgen de los Dolores por Haber Salvado
a Su niña Frida del accidente acaecido en 1925
en la Esquina de Cuahutemozin y Calzada de Tlal...

While Frida was recovering, a doctor told her she would never be able to have children because of the damage to her pelvis. Frida imagined that her hospital stay was due to a pregnancy and that she had given birth to a baby boy named Leonardo. She created a fake birth certificate stating that she was the imaginary child's mother, and listed Alejandro Gomez Arias and Isabel Campos (a childhood friend from Coyoacán) as his godparents.[13] This experience would inform Frida's later choices and feelings about having children.

After spending one month in the hospital, Frida returned home to continue her convalescence. Her family could make her more comfortable at home than she had been in the hospital. They moved her bed outside for a few hours each day so she could enjoy the fresh air and sunlight in the house's inner courtyard. Her parents and sisters were solicitous, but she felt that they didn't understand or believe her pain. Her mother was the only one who seemed to care, but the family urged Frida to not confide in her mother because of her health issues. In addition to suffering near-constant pain, Frida felt isolated and bored. Her friends had visited her in the hospital, which wasn't far from school, but it was more difficult for them to come all the way to Coyoacán. To distract herself, she read, studied and wrote letters, mainly to Alejandro, but also to other friends. With her parents' help, she took up painting to pass the time. Her father gave her his paints and her mother ordered a special easel that allowed her to paint lying down. They attached a mirror to her bed's canopy so she could see herself and make self-portraits.

Frida would never paint her accident, but she did make a sketch depicting the collision and herself lying in a cast that nearly covered her entire body. In mid-November, her parents had a mass said for her in Coyoacán's San Juan Bautista church to give thanks for her survival. Frida later found a votive painting depicting a scene that was uncannily similar to her accident. It showed a girl lying on the ground between a trolley and a bus that had collided. Frida altered the image to make it even more fitting to her situation, painting in joined eyebrows on the

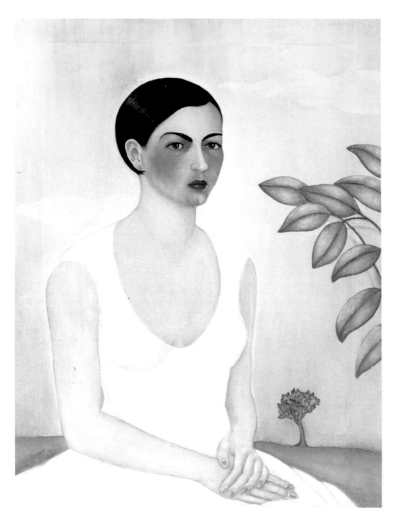

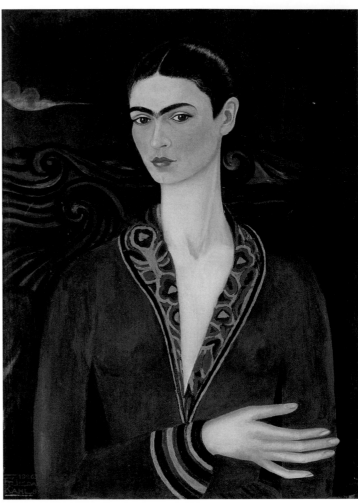

girl's forehead and writing 'Coyoacán' on the side of the bus. She painted over the original inscription and added the following words: 'The couple Guillermo Kahlo and Matilde C. de Kahlo give thanks to the Virgin of Sorrows for having saved their daughter Frida from the accident that happened in 1925 on the corner of Cuahutemozín and Calzada de Tlalpan.' In doing so, she was participating in a long-held tradition. This type of votive painting, called an 'ex-voto' is a form of popular religious art giving thanks to a saint or the Virgin Mary for a blessing or miracle. It can be thought of as a prayer of gratitude and devotion in the form of a painting. The event is depicted in the central plane, the saint who intervened usually appears in the upper section, and there is a written message on the bottom explaining the miracle. Usually painted on small tin sheets, a medium that is both inexpensive and durable, this art form originated in Europe but became very popular in Mexico during the colonial period. Frida would later make extensive use of the conventions of ex-voto painting in her artwork, creating a link between her Mexican identity and her personal experiences.

ABOVE LEFT Frida Kahlo, *Portrait of My Sister, Cristina*, 1928, oil on wood, 99 x 81.5 cm, private collection

ABOVE RIGHT Frida Kahlo, *Self-portrait in a Red Velvet Dress*, 1926, oil on canvas, 80 x 60 cm, private collection

RIGHT Frida Kahlo, *Have Another One*, 1925, watercolour and pencil on paper, 17.5 x 24 cm, Government of the State of Tlaxcala, Instituto Tlaxcalteca de Cultura, Museo de Arte de Tlaxcala

Just three months after the accident, Frida was active again. In December 1925, she wrote to Alejandro that she had gone to his house in Mexico City to look for him, but he was not there.[14] She had missed several months of school and did not return. Her medical costs strained her family's already difficult economic situation. She gave up her dream of becoming a doctor and resumed helping her father in his studio while looking for work to help pay the bills. Frida's return to an active life was too hasty, however. She suffered a significant relapse a few months later and had to return to bed. Possibly the doctors at the Red Cross hospital had neglected to perform x-rays on her spine, or her family had not been able to afford the recommended tests, but three discs in her spine were found to be out of alignment.

She spent most of the ensuing two years enduring treatments, many of them torturous, in an effort to correct her spine. She underwent months of wearing constrictive corsets constructed of plaster, leather or metal. On one occasion, she was suspended from her head for two and a half hours while a plaster corset was applied and then she had to remain on tiptoe for two more hours while it dried. To her frustration, on her return home she found that the plaster was still damp.[15] The doctors warned her that she might still have to undergo surgery if the corsets and other treatments proved ineffective.[16]

Frida continued to write letters and paint. During the summer of 1926, she painted *Self-Portrait in a Red Velvet Dress* as a gift for Alejandro. In her letters to him, she called it 'your Botticelli'. The painting has a decidedly Renaissance influence. Frida depicted herself with elegant features, a long neck and elongated hands. The central figure stands out from the dark background of a stormy sea with rolling waves and deep grey sky. She signed it in September 1926 and wrote in German on the back: '*Heute ist immer noch*', which means 'Today is always'. When giving it to Alejandro, she asked him to hang it somewhere low so that when he looked at it, it would be as if he was looking at her.

In March 1927, Alejandro departed for an extended trip to Europe. Mostly confined to her bed, Frida despaired at the unfairness of her situation. Besides the physical torment, she didn't have any distractions to keep her mind off her multiple sources of stress. She worried about her parents' health: her mother had seven attacks in one month, and her father was also unwell. In addition, their financial situation was getting desperate. Frida felt completely powerless. She could only paint and hope to get better so that she could help her parents instead of being a burden on them.

During these early years, Frida experimented with different styles of painting. She did a few watercolours that mostly portray outdoor scenes in Coyoacán. These are in a quaint style recalling the murals on the walls of pulquerías, neighbourhood taverns selling pulque, a drink made of fermented agave nectar. She did several portraits of family and friends;

BELOW Frida Kahlo, *Portrait of Miguel N. Lira*, 1927, oil on wood, 106 x 74 cm, Government of the State of Tlaxcala, Instituto Tlaxcalteca de Cultura, Museo de Arte de Tlaxcala

RIGHT Frida Kahlo, *Café de los Cachuchas (Pancho Villa and Adelita)*, 1927, oil on canvas, 65 x 45 cm, Government of the State of Tlaxcala, Instituto Tlaxcalteca de Cultura, Museo de Arte de Tlaxcala

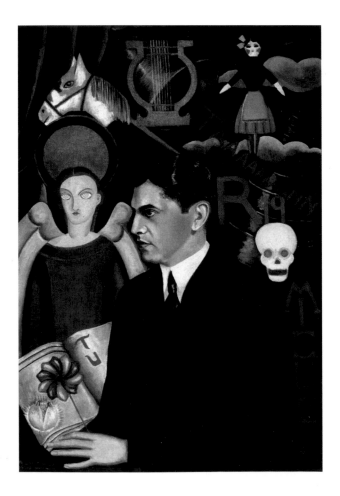

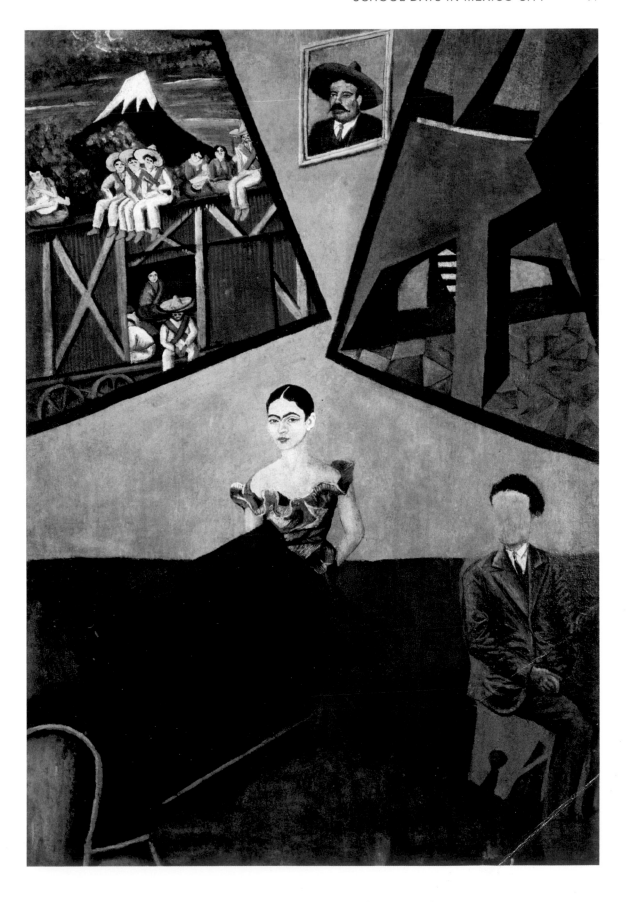

her sisters Adriana and Cristina, and friends Alicia Galant, Ruth Quintanilla, Jesús Ríos and Miguel N. Lira were all portrait subjects. The portrait of Lira stands out as being more experimental in style and composition. Lira, a poet who was a good friend and fellow Cachucha, requested that Frida paint his portrait, and specified that the background be 'in Gomez de la Serna style'.[17] He was referring to a Spanish writer and proponent of the avant garde, or perhaps more specifically to Diego Rivera's 1915 Cubist portrait of the Spaniard that shows him surrounded by objects that evoke his literary oeuvre. Frida painted Lira's portrait and filled the background with a variety of symbols: an angel and a lyre referring to his name, a book in his hands with the word *Tú* written on it (the title of his first book of poetry), as well as other symbols that are more difficult to interpret, but were probably obvious to Frida's group of friends.[18] Frida was not pleased with this painting, saying that the subject looked 'like a cardboard cutout' and that she didn't know how Lira could say that he liked it. The work can be seen as a forerunner to her later portraits and self-portraits in which she incorporates symbols in a subtle way, adeptly blending them with the subject and background in a way that comes across as unintentional.

The painting *Café de los Cachuchas* (also known as *Pancho Villa and Adelita*) is unfinished and undated, but was most likely executed around 1927. Frida appears in the centre, wearing a glamorous off-the-shoulder gown and with her sleek hair parted in the middle. She is sitting at a table, with three pictures hanging above her showing images from the revolution. The scene is rendered in a skewed perspective, with the pictures on either side of her head tilted at odd angles. Directly above her is a framed picture depicting the revolutionary Pancho Villa. Other Cachuchas sit at the table with her. Here Frida painted herself as a young, modern woman who was part of a café culture of artists and intellectuals, a world from which she was separated when she was convalescing, but to which she was anxious to return.[19] The image presents a stark contrast to the way Frida would later depict herself.

When Alejandro returned from Europe, they resumed their courtship. Their romance lasted until early 1928. He fell in love with their mutual friend Esperanza Ordoñez and broke off his romantic relationship with Frida, though they remained friends throughout her life and she would continue to write letters to him recounting important events and sharing her thoughts. He would carefully save all of her letters as well as the self-portrait she gave him. Soon after her breakup with Alejandro, she found another love interest who would occupy her time and affection.

Frida at 18, photographed by her father,
Guillermo, in 1926

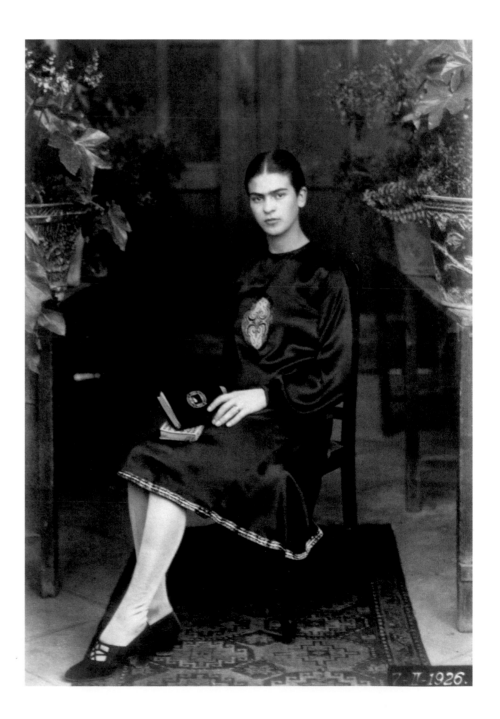

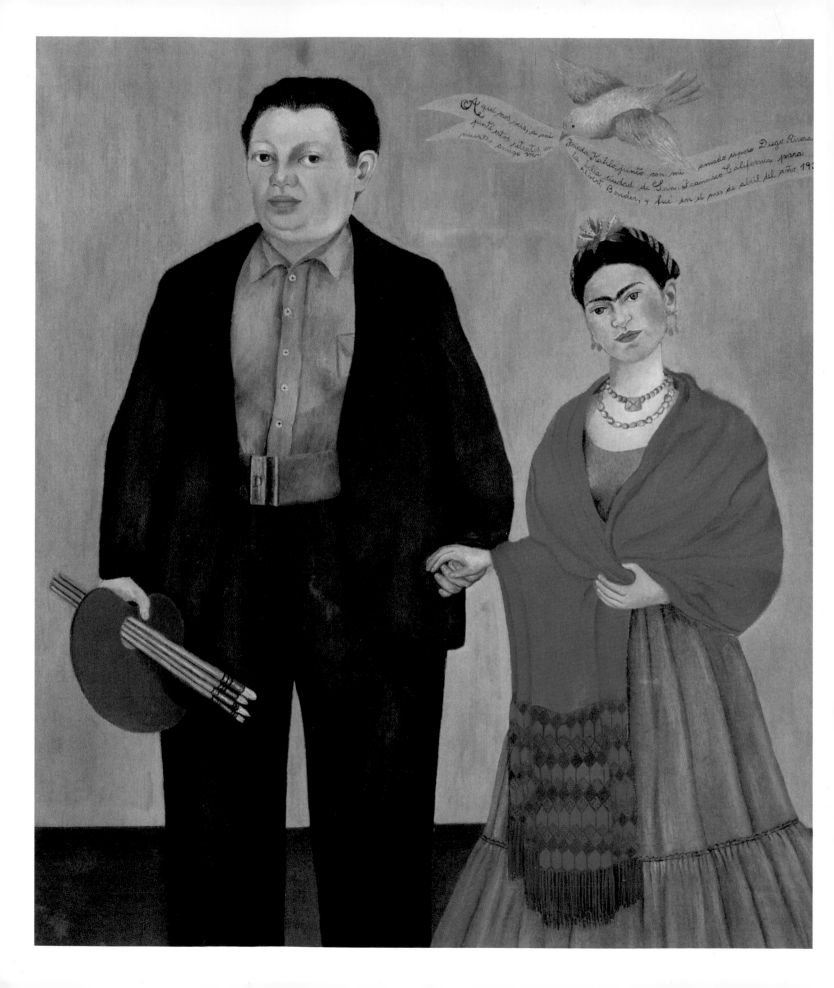

AN UNLIKELY MATCH

Frida never fully recovered from the bus accident. The consequences of her injuries coupled with her prior physical issues would cause recurring health problems.[1] She had pain in her leg and back intermittently, but enjoyed a few years of mobility and relatively good health during which she began to explore more deeply the three interests by which she would define her life: painting, politics and Diego Rivera.

Mexico's political climate changed considerably during Frida's convalescence. When President Obregón's term ended, Plutarco Elias Calles took office. Initially, his policies were very similar to those of his predecessor, but he soon showed increasing intolerance to the church, labour and the left. The constitution contained a few articles with anticlerical measures, but Obregón had not enforced them. Calles did: in 1926, he instituted the 'Calles Law', which forbade public manifestations of Catholicism, required clerics to register with the government, dissolved monastic vows and orders and banned religious schools. In protest, bishops suspended public worship and mandated a boycott against the government. Catholic peasants rose up in arms to the call of '¡*Viva Cristo Rey!*' (Long live Christ the King!). Bloody revolts broke out in the states of Jalisco, Guanajuato, Durango, Michoacán, Zacatecas and Colima. The conflict came to be known as the Cristero War.

There were changes at home too. Frida's younger sister met a handsome *charro*, a Mexican cowboy, at the Coyoacán town fair and married him. Cristina would have two children, a girl, Isolda and a boy, Antonio. Cristina was the only Kahlo sister to have children. Unfortunately, her husband drank excessively and was a womanizer, so she left him, returning with her children to live in her parents' home. Her sisters helped with the children, and Frida grew particularly close to her niece and nephew, doting on them throughout her life.

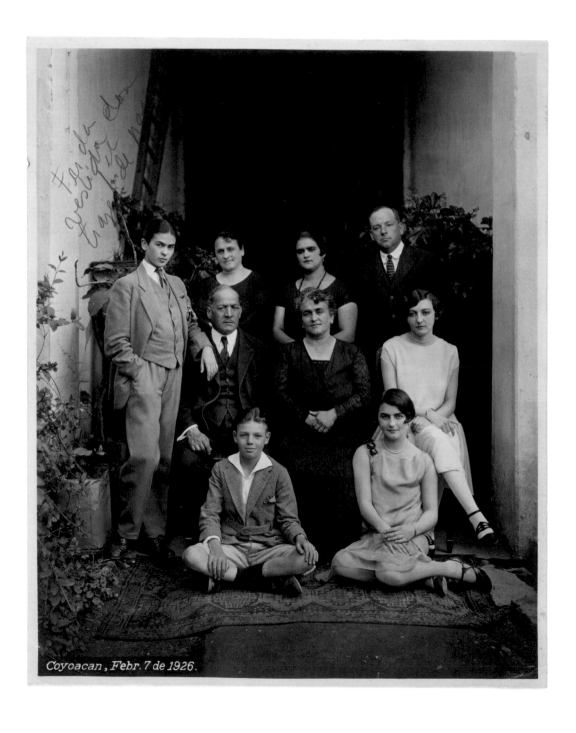

Coyoacan, Febr. 7 de 1926.

LEFT Kahlo family portrait, Coyoacán, photographed by Guillermo Kahlo, 1926

BELOW Frida Kahlo and her friend, the photographer Tina Modotti, 1928

As a teen and young adult, Frida experimented with different styles of dress. She was clearly aware of the power of clothing in crafting her identity, and enjoyed making a statement and even shocking people with her different looks. In some family photos, she appears wearing a sober dark dress and a large crucifix, in others she sports a man's three-piece suit with her hair slicked back and carrying a jaunty walking stick. At times she wore a low-cut dress in flapper style. She soon favoured a different style, though not yet the traditional indigenous clothing that became her signature. She first donned the worker's attire that demonstrated her association with the Communist Party.

Although Frida never resumed her studies, she maintained friendships with several of her school friends. One of her chums, Germán de Campo, was involved in left-wing politics. Through him, Frida met and became friends with photographer Tina Modotti, and soon became re-acquainted with Diego Rivera. About ten years Frida's senior, Modotti was born in Italy, but had immigrated to the United States as a teen. She worked as a model and silent film actress before becoming involved with photographer Edward Weston, who served as her mentor and taught her photography. Weston left his wife and children and he and Modotti moved to Mexico in 1923. They set up a portrait studio in Mexico City and ran in bohemian circles. Author Anita Brenner commissioned them to take photos for her book of Mexican art and history, *Idols Behind Altars*. In 1926, Weston and Modotti embarked on a photography expedition, travelling through the Mexican countryside while the Cristero War was raging. The trip made Modotti aware of the difficult life circumstances of the majority of Mexico's population and she became devoted to depicting their struggles and helping their cause. Weston returned to the United States and his family, but Modotti remained in Mexico and continued to work as a photographer. She joined the Communist Party in 1927 and became its unofficial photographer, capturing party activities as well as murals by Diego Rivera and other important artists.

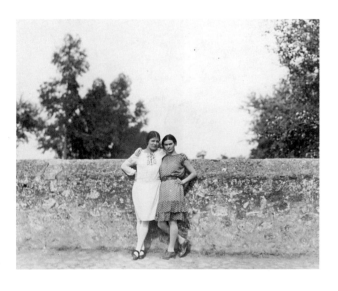

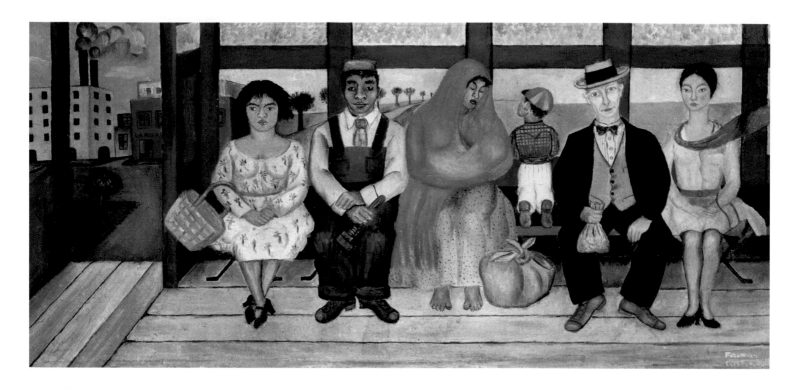

ABOVE Frida Kahlo, *The Bus*, 1929, oil on canvas, 26 x 55.5 cm, Museo Dolores Olmedo Patiño, Mexico City

RIGHT Frida Kahlo, *Portrait of Virginia*, 1929, oil on board, 77 x 60 cm, Museo Dolores Olmedo Patiño, Mexico City

It was an era of radicalism. Frida's friendship with Modotti and her circle exposed her to a bohemian lifestyle devoid of the conservative values she had grown up with. Frida joined the Communist Party in 1928. She said that her experience witnessing the revolution and her disagreements with her mother's Catholicism led her to leftist ideology. Modotti frequently hosted gatherings of artists and intellectuals, and they often became rowdy when discussing their ideas. It was at one of these get-togethers that Frida re-encountered Diego Rivera. When he became annoyed with the choice of music, he pulled out the pistol he carried and shot the phonograph. His brazen action both frightened Frida and aroused her interest, and she decided to seek him out.

Diego had been working steadily since Frida's earlier encounters with him. Upon completing the mural at the preparatory school, he immediately tackled his next assignment, painting the walls of the Ministry of Education building a few blocks away. He covered the corridors and stairwells surrounding two courtyards with themes of labour, agriculture, folk traditions and political reform. When Diego was only halfway through the job, Vasconcelos, who had hired him, resigned from his post as Minister of Education. The new officials wanted to oust Diego, but favourable critiques from abroad made them rethink their stance, and they kept him on.

Though the other muralists did not receive government commissions under the Calles administration, Diego had a steady flow of work. He received another commission to paint murals in the National Agricultural School's new premises in the former hacienda at Chapingo. He divided his time between the education building and the former hacienda,

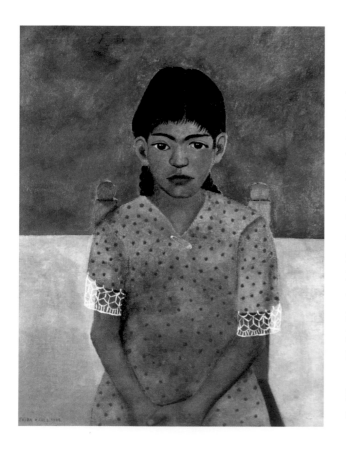

working very long hours. On one occasion after working all night, he fell asleep on the scaffold and tumbled down, fracturing his skull. His wife Lupe thought he was exaggerating the injury, but after hearing the doctor's diagnosis, she tended to him lovingly.

Lupe, pregnant with their second daughter, posed for him for a monumental figure representing the fertile land in the chapel at Chapingo, but Modotti served as his model for several other female figures. The two had a brief affair. This was the final straw for Lupe, and their marriage fell apart soon afterward. In 1927, Diego was invited by the Communist Party to attend the tenth anniversary of the October Revolution in Russia. When he returned, Lupe was involved with Jorge Cuestas, a poet she later married. Diego returned to his work. Though marriage had never inhibited him, he took advantage of being single by having numerous flings.

It was at this time that Frida sought him out. She approached him while he was at work in the Secretary of Education. She boldly called to him to come down from the scaffold and look at a few of the paintings she had brought, and to give her his honest opinion. She asserted that she was not interested in hearing empty compliments; she wanted to know if her work was good enough for her to someday earn a living through her art. Diego was charmed by the girl and impressed with her work. 'The canvasses revealed an unusual energy of expression, precise delineation of character, and true severity. They showed none of the tricks in the name of originality that usually mark the work of ambitious beginners.'[2] He told her she must keep painting. She invited him to visit her at home to see more of her artwork. He called on her in Coyoacán the following Sunday. That was the beginning of their courtship. 'I would go to see him paint in the afternoon, and afterward he would take me home by bus or in a Fordcito – a little Ford that he had – and he would kiss me.'[3]

Frida briefly considered pursuing mural painting, but Diego dissuaded her, advising her to find her own authentic artistic expression. Other than this direction, Diego fully encouraged and supported her art.

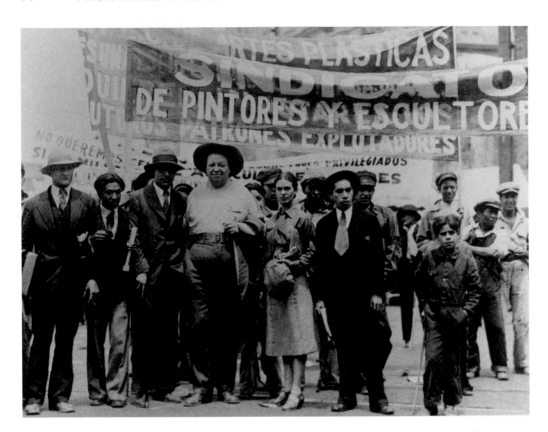

Though he had never asked anyone what they thought of his work before, he asked Frida. He valued her opinion and took her comments to heart. Frida's work changed during this time, moving toward representing more Mexican themes and subject matter. She painted *The Bus*, *Portrait of Virginia* and *Two Women*. Rivera's influence can clearly be seen in these paintings. Her style is reminiscent of Mexican folk art: the colours are brighter and the lines more rounded than in her earlier work.

In *The Bus*, Frida depicted a scene undoubtedly very familiar to her: a row of people sitting on a long bench inside a bus that is passing through a rural scene, approaching an area with factories, smoke billowing out of their chimneys. Like Diego, she includes people of a variety of ethnicities and social classes that make up Mexican society: a middle-class housewife carrying a market basket, a worker wearing denim overalls and holding a wrench, a barefoot peasant woman nursing a baby wrapped in a shawl, a little boy looking out of the window, a businessman holding a bag of money, and a fashionably attired young woman with a scarf around her neck.[4] Frida depicted these representatives of Mexican society sitting together companionably. It is a pleasant scene in which she has captured a moment of everyday life. However, knowing the accident she suffered, it carries the implicit message that such a complacent scene can turn to tragedy in the blink of an eye.

Diego included Frida in a mural on the third floor of the Secretary of Education. In a series entitled *Ballad of the Revolution*, the panel called *Distributing Arms* (also known as *The*

LEFT Diego Rivera and Frida Kahlo at the May Day Parade in Mexico City, 1929, photographed by Tina Modotti

BELOW Diego Rivera, detail from *Distributing Arms (The Arsenal)*, from the Court of Fiestas, 1928, mural, Secretary of Education, Mexico City

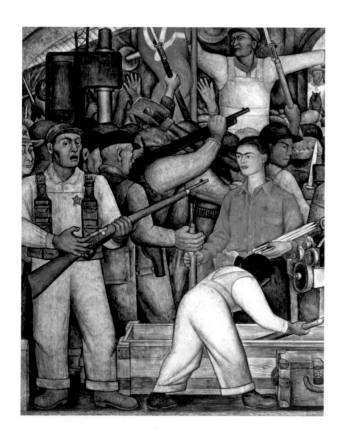

Arsenal) shows her handing out weapons to the people engaged in the revolutionary struggle. She appears in the centre of the panel wearing a red shirt with a star on the breast. Though Diego often showed Lupe as a passive symbol of feminine beauty, he depicted Frida as an active participant in societal change. Diego also included Modotti and her new lover, Cuban exile Julio Antonio Mella in the same mural panel. Mella was a student leader and communist trying to organize the overthrow of the Cuban government of General Gerardo Machado. One evening in early 1929, as he and Modotti were out walking, Mella was shot and killed. The Mexican government accused Modotti of being complicit in his death. Both Diego and Frida wrote letters vouching for her and she was eventually cleared of the crime.

The earliest known photo of Frida and Diego together was taken by Modotti. It shows them in the May Day march in 1929. They were at the front of the delegation for the Syndicate of Technical Workers, Painters and Sculptors. In the photo, Frida is wearing a long-sleeved, collared blouse with a tie and a knee-length A-line skirt, a worker's outfit that showed her Communist Party alliance.

When he had completed his work in the Ministry of Education, Diego was asked to paint a series of murals in the National Palace depicting the entire history of Mexico. Around the same time, he was offered a commission to paint a mural in a meeting room in the Ministry of Health. There he painted six large nudes symbolizing Purity, Strength, Knowledge, Life, Moderation and Health. Diego used three models, representing each of them twice. His models were an indigenous woman from Tehuantepec, an American artist named Ione Robinson, and Frida's sister Cristina. It was Frida's idea for her sister to pose for him, and Diego depicted her as both Strength and Purity. Robinson, also a good friend of Modotti's, acted as one of Diego's assistants while he worked on the National Palace murals, and was rumoured to be having an affair with him.

As Diego painted the history of the country, the presidential elections of 1928 brought about new conflicts. With an eye to resuming the office

following Calles' presidency, Álvaro Obregón had the constitution changed to allow a president to be re-elected for non-consecutive terms. He was elected, but was assassinated just a few days before he would have taken office. Emilio Portes Gil became interim president, but Calles maintained control behind the scenes. Portes Gil served for 14 months while new elections were called. Calles created a political party, the *Partido Nacional Revolucionario* (National Revolutionary Party) and backed Pascual Ortiz Rubio for president. José Vasconcelos, the former Minister of Education, also ran. Many of Frida's former classmates supported Vasconcelos, including her friend Germán de Campo, who was shot and killed while he was giving a speech in support of the former Minister. As a member of the Communist Party, Frida backed a third candidate, Pedro Rodríguez Triana. Ortiz Rubio was declared the winner, though many suspected fraud. Calles remained active behind the scenes, taking on the title '*Jefe Máximo de la Revolución*' (Maximum Chief of the Revolution), and he maintained political control over the country until 1934. This period of Mexican history is referred to as the 'Maximato', since it was the Jefe Máximo who wielded the power.

This time of change impacted Diego's work life as well. In 1929, he was named director of the San Carlos Art Academy, where he had studied before travelling to Europe. He planned extensive modifications to the curriculum, aiming to transform it into a modern experimental school with students training in all disciplines and working long hours on apprenticeships as well as in the classroom. His sweeping reforms were met with general dissent and he was soon forced to resign.

It was during this turbulent period that Frida and Diego were married on August 21, 1929 in a civil ceremony at the Coyoacán town hall. Frida said that she borrowed her outfit, consisting of a long skirt, blouse and *rebozo* (Mexican shawl), from the maid. Her father was her only family member to attend. A photo and a note about the event appeared in the newspaper the following day, emphasizing the simplicity of the wedding: 'The bride dressed . . . in very simple street clothes, and the

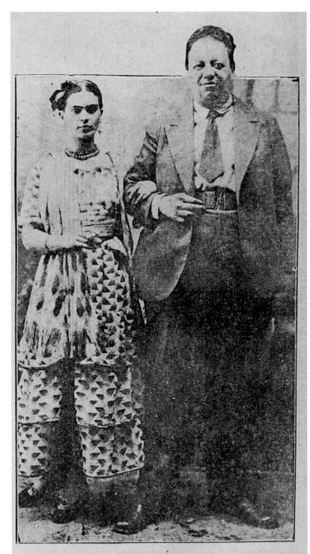

SE CASO DIEGO RIVERA.—El miércoles último, en la vecina población de Coyoacán, contrajo matrimonio el discutido pintor Diego Rivera con la señorita Frieda Kahlo, una de sus discípulas. La novia vistió, como puede verse, sencillísimas ropas de calle, y el pintor Rivera de americana y sin chaleco. El enlace no tuvo pompa alguna; se celebró en un ambiente cordialísimo y con toda modestia, sin ostentaciones y sin aparatosas ceremonias. Los novios fueron muy felicitados, después de su enlace, por algunos íntimos.

painter Rivera dressed "de Americana" and without a vest. The marriage service was unpretentious; it was celebrated in a very cordial atmosphere and with all modesty, without ostentation, and without pompous ceremonies.'[5]

By all outward appearances they made a strange pair. She was 22 years old (and claimed to be only 19), petite and just over five feet tall. He was twice her age, tall and rather fat. He was an atheist and a known womanizer. This was his third marriage. Frida's mother was not happy about the match. She said that the pairing was like the marriage of an elephant and a dove, but her main objection was that in the eyes of the Catholic Church, Diego was still married to Lupe. Frida's father was more accepting. On the practical side, he realized that his daughter's health problems would likely continue throughout her life,

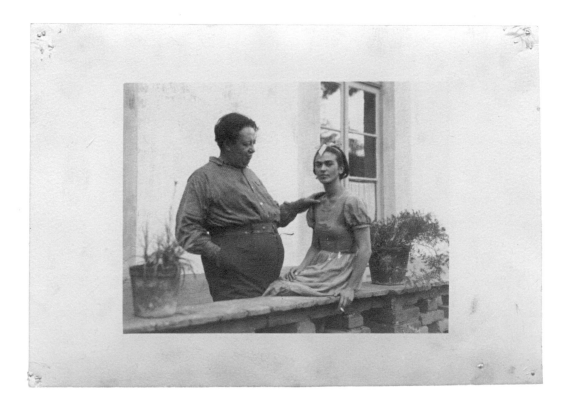

and was undoubtedly relieved that she had found a husband who would provide for her and pay for the medical treatments she would require. Ultimately, Frida's happiness was important to them, and it was obvious she was very much in love with Diego and he clearly also cared very much for her. Before the wedding, Guillermo warned Diego that Frida would always have health troubles, and also that she was a 'concealed devil'.[6] The latter comment probably served to arouse Diego's interest more.

Frida was very different from his previous wives and lovers and their marriage stood out from his relationships with other women. As in his previous unions, Diego was never faithful, and Frida would also have affairs (with both men and women), but their relationship encompassed much more than their sexual lives. They were each the other's best supporter and most ardent fan. They shared political convictions, and perhaps most importantly, were both fiercely proud of being Mexican.

Accounts differ as to where the wedding party was held. Some recalled it being at the home of fellow painter Roberto Montenegro; others placed it on the rooftop terrace of Modotti's home. Diego and Lupe's daughter, Guadalupe Rivera Marín, describes the wedding dinner menu as consisting of oyster soup, huazontles (a green vegetable native to Mexico) in red and green salsa, two kinds of stuffed chiles, chicken in the spicy-sweet black mole sauce from Oaxaca, and pozole, a corn hominy soup from the state of Jalisco. Diego considered silverware to be bourgeois, so they provided simple enamelled spoons for the soup and the guests consumed the rest of the food using tortillas.[7]

It was a riotous affair. Lupe came to the party, appearing to hold no rancour, but during the course of the evening, suddenly strode over to the new bride and lifted her skirt, exposing Frida's legs. She exclaimed to the assembled guests: 'You see these two sticks? These are the legs Diego has now instead of mine!'[8] Then she stormed out. That was not the only commotion. Diego drank so much tequila he became rowdy, fought with some of the guests, and then argued with Frida. She left crying and went home to her parents' house. A few days later, Diego came for her and they went to live in their new home in the centre of Mexico City on Paseo de la Reforma #104.

It was a large Porfirian-era house with a French gothic facade, but Diego had placed pre-Hispanic sculptures in the entranceway.[9] They shared their home with a variety of people. Lupe and her two young daughters lived on the second floor. As active members of the Communist Party, they were expected to provide housing for other members on

occasion, and fellow muralist David Alfaro Siqueiros and his wife were their first house guests. They had a maid named Margarita Dupuy who helped with cleaning and cooking, but Frida was expected to run the household, a task for which she had little experience. They made do with an eclectic assortment of furniture that was given to them by friends and family: a narrow bed, a long black table, dining room furniture given to them by Frances Toor (a friend and editor of the magazine *Mexican Folkways*), and a yellow kitchen table from Frida's mother that they used to hold Diego's collection of ancient figurines.[10]

After their marriage, Diego paid the mortgage on the Kahlo family home in Coyoacán, and allowed his in-laws to continue living there. The property was changed to Frida's name in 1930.[11] Lupe reconciled with Frida and kindly showed her ex-husband's new wife how to prepare his favourite dishes. In return, Frida painted Lupe's portrait. The peace between them was transitory however, and Lupe later destroyed the painting in a fit of anger. One of Lupe's main points of contention was that Diego helped Frida's family financially, and although he gave her money to support their children, Lupe never felt that it was enough.

Shortly after their marriage, Diego was expelled from the Communist Party due to several disagreements with the official party line. Since the election, the party had become increasingly opposed to the government, and many members felt that it was hypocritical of Diego to accept government commissions. Diego had also expressed disagreement with some of Stalin's statements, and the party, which supported Stalin, accused him of being a Trotskyite, a fact he openly admitted after his expulsion. Although no longer a member of the party, he continued to identify as a Communist. He later wrote: 'I think my principal activity is painting, and what I can do for the revolution, given that I am neither a professional politician nor a "man of the party", I can do the same outside as inside of the organization.'[12]

Frida also left the party, in solidarity with her husband. This act meant leaving several important friendships and their social circle behind. Modotti turned on them both. In a letter to Edward Weston in September 1929, she wrote: 'Diego is out of the party . . . Reasons: That his many jobs he has lately accepted from the government . . . are incompatible with a militant member of the p[arty] . . . He will be considered, and he is, a traitor. I need not add that I shall look upon him as one too, and from now on all my contact with him will be limited to our photographic transactions.'[13]

The couple encountered challenges in their personal life as well. During their first year of marriage, Frida became pregnant. Three months into the pregnancy, Dr J. De Jesús Marín, Lupe's brother, performed a therapeutic abortion. Since Frida's pelvis was malformed, they believed she would not be able to carry the child to term. She mourned that she could not have a child, as she did after her accident. She wrote to a friend: 'We could not have a child, and I cried inconsolably but I distracted myself by cooking, dusting the house, sometimes by painting, and every day going to accompany Diego on the scaffold.'[14]

When he received an invitation from Dwight Morrow, the US Ambassador to Mexico, to paint a mural in Cuernavaca, Diego was happy to get away from the ambience of Mexico City, his comrades who had rejected him, and his failed stint as director of the arts academy. He left his work in the National Palace unfinished, and in January 1930, he and Frida left for Cuernavaca, some 85 kilometres south of Mexico City. At the time, it was a trip of about three hours on bumpy, unpaved roads.

Morrow was an unpretentious, amiable man with a deep appreciation for Mexican culture. His tenure as ambassador ushered in a period of positive diplomatic relations between Mexico and the United States. Morrow helped put an end to the Cristero War, acting as an intermediary in negotiations between the government and Catholic bishops. He and his wife Elizabeth were instrumental in fostering an appreciation for Mexican folk art in the United States. They organized the Mexican Arts Show, an exhibition that drew crowds to the Metropolitan Museum in New York and then travelled to twelve more US cities. He also invited Charles Lindbergh to make a goodwill tour to Mexico, and the famed aviator later married his daughter, Anne.

The Morrows were enchanted by Mexico and its art, but most of all, by Cuernavaca. They had stayed as guests of Sir Esmond Orey, a British diplomat who owned a house there, and decided they had to have their own weekend home. They bought a few adjoining

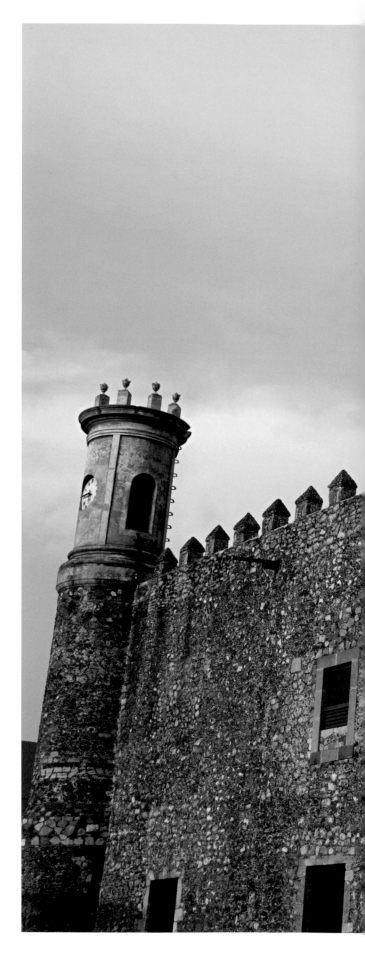

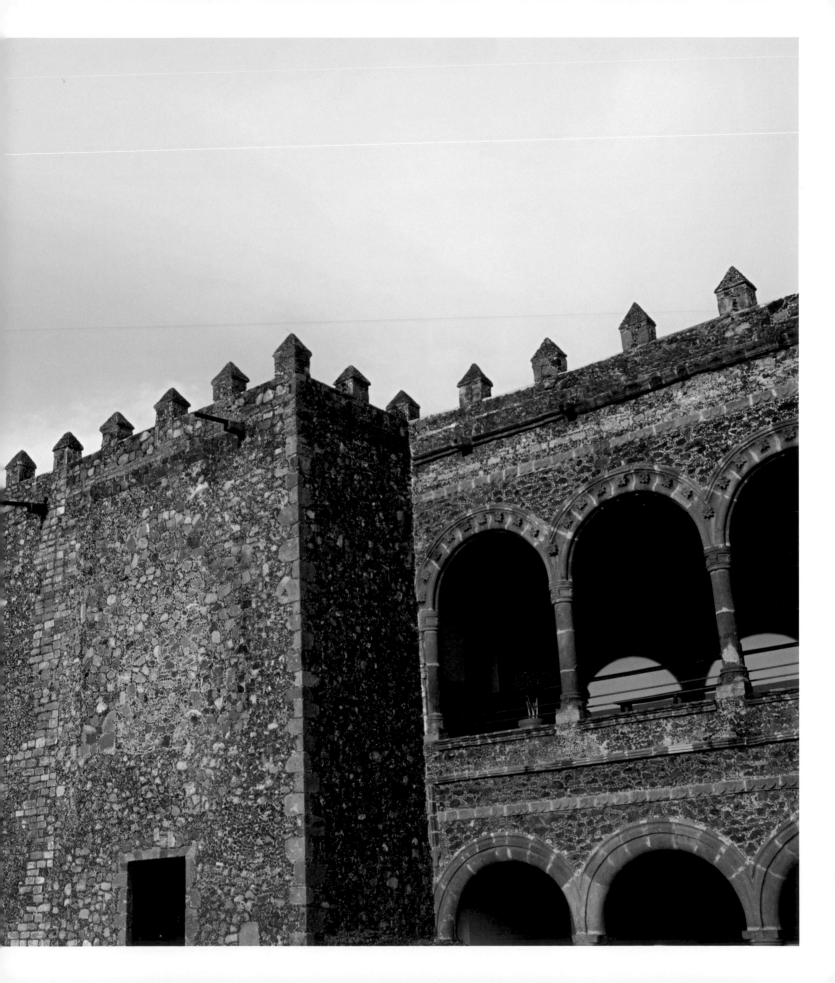

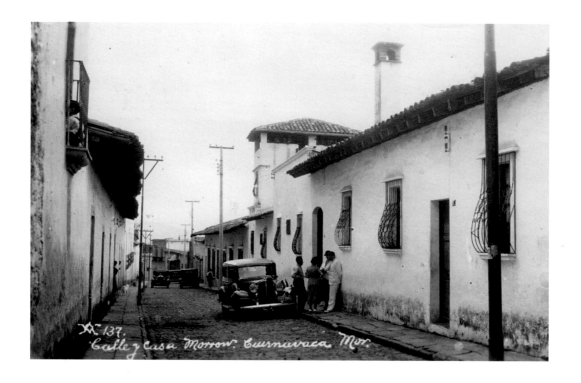

properties and built a rambling rustic house with thick adobe walls, terracotta tile roof and a succession of plant-filled patios where they and their guests would sit and enjoy the dappled sunlight through the foliage. Their home was decorated with Mexican folk art and furnished with equipales, handcrafted leather and wood furniture. They were inspired to give a gift to the people of Morelos state in gratitude for their hospitality. The mural was their gift: Diego would depict the state's history in a loggia on the western side of the stately Cortez Palace, a fortress-like structure located two blocks from the Cuernavaca town square. The palace is a prime example of colonial civic architecture from the 16th century. While in Cuernavaca, Frida and Diego stayed at the Morrow's home, which was called Casa Mañana. The Morrows gave the house this name because, while it was under construction, whenever they asked the head builder when a certain project would be complete, his response was always '*mañana*'.

PREVIOUS PAGE Cortez Palace, Cuernavaca

ABOVE Casa Mañana, Cuernavaca

RIGHT Diego Rivera, *Nude Portrait of Frida Kahlo*, 1930, lithograph

During their time in Cuernavaca, Diego did the only nude depiction he ever made of Frida, a lithograph showing her sitting on the edge of a bed. She is demurely looking down, while her hands are raised behind her head as she unfastens a heavy beaded necklace. Her legs are crossed, and her tiny feet are clad in dainty high-heeled pumps. Diego never rhapsodized about Frida's looks as he had about Lupe and some of his other models. He included her in a few different murals, depicting her as a Communist worker, as an artist, and as his companion, but never as a symbol of feminine beauty. Once while painting her, he reportedly told her: 'You have the face of a dog.' She was undaunted and could hold her own; she responded: 'And you have the face of a frog.'[15] If they rarely showed appreciation for each other's physical appearance, they made up for it in their regard for one another's work. They each thought the other was the best artist in Mexico, and their mutual support for their art was unequivocal.

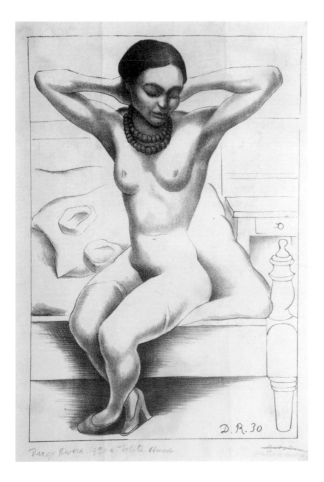

Frida painted the self-portrait *Time Flies* during the first year of her marriage. The background of heavy drapes pulled back with thick cords alludes to colonial era portraiture, but the aeroplane visible through the window places the work in the modern period. The aeroplane may refer to Lindbergh, whom Frida had likely met, but wings and the concept of flight were recurring themes in her work. To her left, a utilitarian alarm clock sits on top of a carved wooden column. The column beside her reaches the same height as her own problematic spinal column. Gone is the aristocratic air of the self-portrait she painted for Alejandro. Here, she is a Mexican girl, wearing a cotton peasant blouse with a bit of lace on each sleeve. She wears the same beaded necklace that Diego depicted in his sketch, as well as long, jewelled earrings. Her beaded necklace, possibly jade, refers to the ancient pre-Hispanic past, the jewelled earrings are in a style from the colonial period, and the aeroplane and clock stand as signifiers of the modern day. She began to identify herself as Mexican in her clothing and aspect, with the many layers of meaning that entails.

After her marriage, Frida began to wear indigenous Mexican clothing. She mixed items from different regions of Mexico, and sometimes added her own personal touches, but she favoured the clothing from the region of the Isthmus of Tehuantepec in the state of Oaxaca.[16] Her mother's family had roots in that area and a photo of her mother as a child, along with several members of her family, shows her wearing that type of dress. The women from that region are called Tehuanas and they are known as strong and independent women. It is a region that resisted Spanish rule during the colonial period and maintained a strong cultural identity. By choosing this type of clothing, Frida was making a statement about her Mexican identity and pride in her indigenous roots, a sentiment that Diego shared. The long skirts and embroidered tops also had the advantage of covering her legs and drawing attention to her upper body, masking her physical impairments. She wasn't the only Mexican woman in the intellectual and art world at that period to choose to wear this type of clothing, but over time it would become an integral part of her image.

Frida and Diego stayed in Cuernavaca for nine months. Diego's relationship with the US ambassador helped to facilitate obtaining a visa to go the United States. As a known Communist, he had previously been denied a visa, but with his expulsion from the Communist party and the support of Morrow and others, he and Frida were able to travel to the United States to embark on the next stage of their life together.

LEFT Frida Kahlo in 1929,
photographed by Guillermo Dávila

RIGHT Frida Kahlo, *Self-Portrait (Time
Flies)*, 1929, oil on board, 77.5 x 61 cm,
private collection

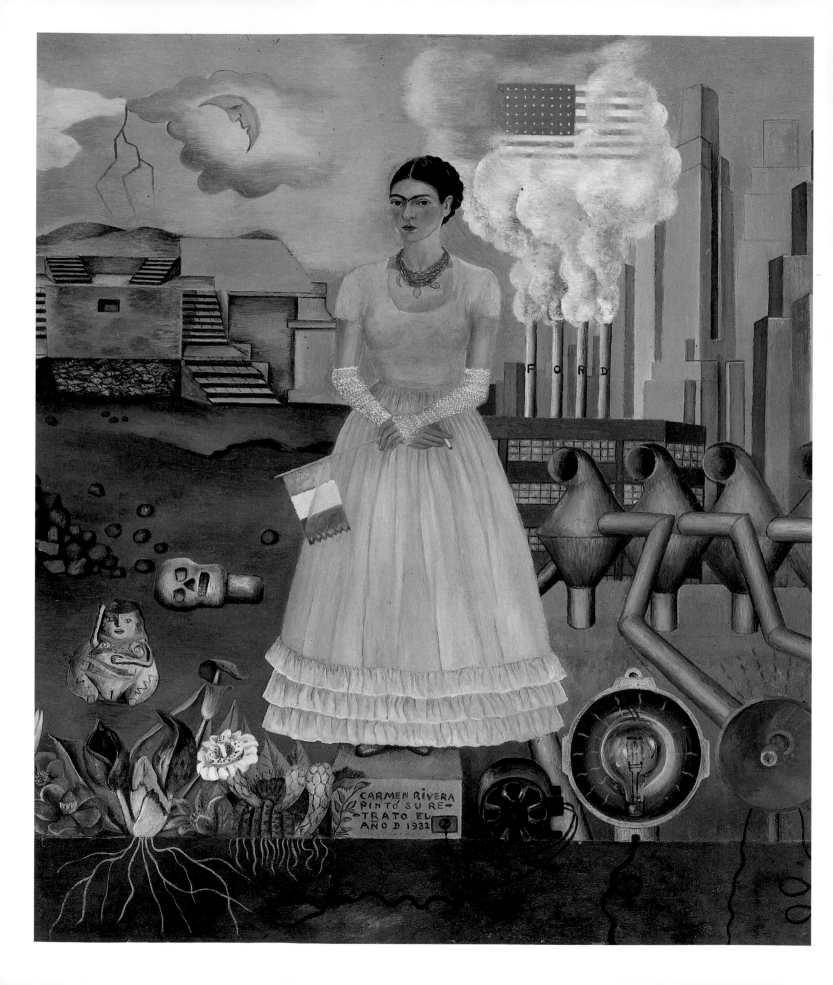

CARMEN RIVERA
PINTO SU RE-
TRATO EL
AÑO D 1932

MEXICANS IN GRINGOLANDIA

Frida Kahlo, detail from *Self-Portrait on the Borderline Between Mexico and the United States*, 1932

Their trip to San Francisco in 1930 was the first time Frida travelled outside Mexico. She had wanted to travel since her schoolgirl days and was excited to be venturing so far from home. Escaping the political repression of the Maximato in Mexico, which was increasingly intolerant of the left, she and Diego arrived in a United States that was in the grips of the Great Depression and Prohibition. Diego had wanted to go to the United States for quite some time. He was fascinated with technology and machinery and he felt the future was there. The United States did not hold the fascination for Frida that it held for her husband. Ultimately, living outside of Mexico gave her a deeper appreciation of her home country.

They arrived in San Francisco in November. Sculptor Ralph Stackpole, a friend of Diego's since his time in Europe, made the arrangements for Diego to paint two murals, one in the Luncheon Club of the San Francisco Stock Exchange in the financial district on Pine and Sansome Streets, and another in the California School of Fine Arts on Chestnut Street. Architect Timothy Pflueger had designed the new stock market building; he believed that art should be an integral part of a building, so he hired various artists to decorate it. Stackpole was creating sculptures for the front entrance and had recommended Diego for the job of painting a mural on the staircase. There was some public outcry that Rivera had been hired: many felt the commission should have gone to a local artist. Most agreed that it was a strange choice to hire a communist artist to create a mural in a capitalist institution. However, Diego and Frida were well received in general, and were invited to luncheons, receptions and parties. Diego was asked to give talks and was even offered a teaching position, which he declined.

Frida and Diego stayed in Stackpole's studio at 716 Montgomery Street, in an area that harboured a flourishing artists' colony. The building, sometimes referred to as the 'Ship Building' because it was built from the hull of a schooner, housed several artists' studios. It was located just a block away from the Montgomery Block building, another haven for artists and bohemians that was affectionately referred to as 'Monkey Block'. They made many friends among the local artist community. They didn't have a telephone so they were frequent visitors at their downstairs neighbours Arnold and Lucile Blanch, who loaned them their phone. Clara and Gerald Strang, and Clara's brother, John Weatherwax, were other new friends. Weatherwax was impressed by the Mexican couple and taken with

Frida. He wrote a play, *The Queen of Montgomery Street*, in which the main character was based on Frida.

Frida had been reading in English since preparatory school, and often peppered her letters to friends with words in English and German, as well as words of her own invention. Upon her arrival in the United States, she applied herself to mastering the language. In a letter she wrote to her father shortly after they were installed in San Francisco, she reported: 'I'm learning a little English every day and at least I can understand the basics, buying in shops, et cetera.'[1] It was not long before she was writing letters in English. Diego – who spoke French fluently, having lived in France for many years – never put any effort into perfecting his English. Frida often acted as his translator and secretary.

When Frida started wearing traditional Mexican clothing following her marriage, she began with an item or two: a rebozo, a jade bead necklace, a peasant blouse. She now donned full indigenous attire, causing a sensation in the United States. When photographer Edward Weston met her for the first time, he wrote in his diary: '. . . she is in sharp contrast to Lupe, petite, a little doll alongside Diego, but a doll in size only, for she is strong and quite beautiful, shows very little of her father's German blood. Dressed in native costume even to huaraches, she causes much excitement on the streets of San Francisco. People stop in their tracks to look in wonder.'[2] Frida was aware of the impression that she made and relished it.

Diego wanted to get a feel for the place before beginning his mural, so they began their stay by exploring the city together. They visited various sites in and around San Francisco, and made a trip 50 miles north to Santa Rosa, where they visited the home of Luther Burbank, the noted horticulturist who created hundreds of fruit and vegetable hybrids. Burbank had died five years earlier and, at his request, was buried on his property under the shade of a cedar of Lebanon tree that he had planted from a seed. He specified that no marker or gravestone be placed at the site, preferring the idea of a living memorial. He said:

BELOW Market Street in San Francisco, 1930

RIGHT Montgomery Street in San Francisco, 1930

'I would like to know that the strength of my body is going into the strength of a tree.'[3] On their visit, Frida and Diego met Burbank's widow and spoke with her.

Frida sent her mother a photo of herself and Diego standing in front of the tree where Burbank was buried. For the excursion she had foregone indigenous attire in favour of slacks and a button-up collared shirt with a scarf tied around her neck. On the back of the photo, she wrote: 'Dearest mamacita, here we are in front of the tree where Luther Burbank is buried. He was a wise man from here who grew fruits and flowers through thousands of grafts to produce even more wonderful ones. His home is very nice, just two hours from San Francisco in a small town called Santa Rosa. Your Frieducha.'[4]

The visit made an impression on both artists. Diego included Burbank in his mural *Allegory of California*, showing him pollinating a plant. Frida chose to depict the horticulturist in a much more original manner, showing how Burbank's essence was deeply embedded

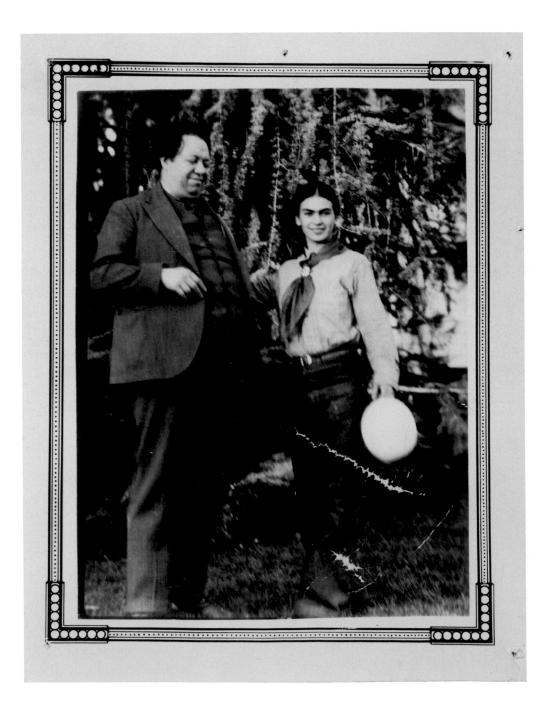

LEFT Diego and Frida visiting the home of Luther Burbank

BELOW Frida Kahlo, *Portrait of Luther Burbank*, 1931, oil on board, 86 x 61 cm, Museo Dolores Olmedo Patiño, Mexico City

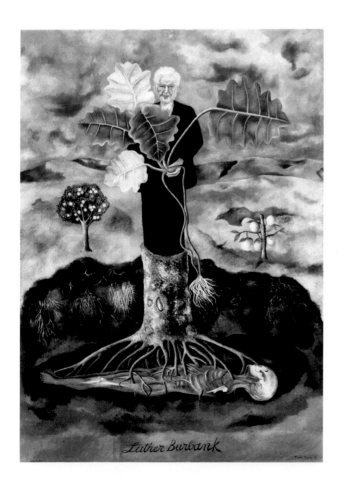

in the plants to which he devoted his life. Below ground, roots entwined around his decaying body take nourishment from him. The tree trunk emerges from the ground and morphs into the body of a living and vital Burbank who holds a Philodendron plant with the roots hanging down, ready to be grafted. Her painting perfectly illustrates Burbank's wish that his strength feed into the strength of a tree. In her depiction, the man who made plant hybrids is a hybrid himself, his dead body giving life power, and he lives on in the spirit of the tree. This painting marked a shift in Frida's art: instead of a true-to-life portrait, the symbolism reflects the deeper truth as she saw it. With this work she was also beginning to explore themes of the life cycle and hybridity.

Through their host Ralph Stackpole, Frida and Diego met champion tennis player Helen Wills Moody. Diego was enthralled by her. He went to see her play and sketched her in action. He asked her to pose for the main figure in his mural in the stock exchange building. Moody was intelligent, young, energetic and beautiful, and in Diego's eyes, she represented California better than anyone else.[5]

While Diego prepared and worked on the mural (and wooed the tennis champion, among others), Frida explored. She shopped, visited museums, and got to know Chinatown. She wrote to her childhood friend Isabel Campos: 'The city and bay are overwhelming . . . it did make sense to come here, because it opened my eyes and I have seen an enormous number of new and beautiful things.'[6] She began to have increased pain in her right foot and she consulted Dr Leo Eloesser at the San Francisco General Hospital. The pioneering thoracic surgeon and orthopedist had met Diego on a trip to Mexico a few years earlier. Besides being a ground-breaking doctor, he was a kindhearted person with a strong social conscience, a patron of the arts and a gifted musician. He was very good with languages and spoke German, French and Spanish. One of his favourite pastimes was sailing in the San Francisco Bay. He inspired Frida's trust immediately and became her lifelong friend and most trusted medical advisor.

Her medical records from this period note that she had increased pain in her right foot, and atrophy in her right leg up to her thigh. The tendons in her right foot had retracted, making it difficult for her to walk normally.[7] Frida also had a trophic ulcer on her right foot. Dr Eloesser diagnosed a congenital deformity of her spine, suggesting that at least some of her physical issues were not due to either polio or the accident. There was not much that could be done, but the doctor advised her to maintain healthy lifestyle habits.

To express her gratitude to Dr Eloesser for his friendship, kindness and attention, Frida painted his portrait. She went to his home at 2152 Leavenworth Street where he posed for her in his study. The portrait evokes the style of 19th-century portraiture, particularly the work of José Maria Estrada. Unlike the majority of her portraits, it is full length, the doctor standing at a three-quarter view with his elbow resting on a table alongside a model sailboat. She was not sure how to depict the sails and consulted with her husband who was not helpful: he told her that she must paint them however she thought they should be. The result is an unrealistic but charming rendering. On the side of the ship she wrote 'Los Tres Amigos', no doubt referring to herself, the doctor and Diego.

Diego completed the stock exchange mural in February 1931. Then, he and Frida took a respite away from the city, staying at the home of Rosalie Stern in Atherton for six weeks. While there, Diego painted a small mural, Still Life and Blossoming Almond Trees, as a gift for their hosts. He created the mural in the Sterns' dining room, but he painted it on a steel frame, which would allow it to be moved later. On their return to San Francisco, Diego got started on the mural in the School of Fine Arts. Diego deemed the wall they offered him too small. He suggested painting a larger one for the same fee, and they agreed. He again courted controversy as he painted The Making of a Fresco Showing the Building of a City. It was a suitable subject for an art school, but some were offended that he included himself in the mural, seated on a scaffold with his back to the viewer, his large backside hanging over the edge. Some felt this detail was evidence of the painter's lack of respect toward the city of San Francisco.

Near the end of their stay, Frida painted a portrait of herself and Diego and dedicated it to Albert Bender, a patron of the arts who had assisted them in obtaining a visa and in other matters. The painting is loosely modelled on their wedding photo and executed in a folkloric style. She wears a green dress and a red rebozo. Her head is tilted, her usually severe gaze uncharacteristically soft and with the hint of a smile. Just the tips of her shoes peek out from the bottom of her full skirt, and she seems to float, grounded only by her husband's hand

 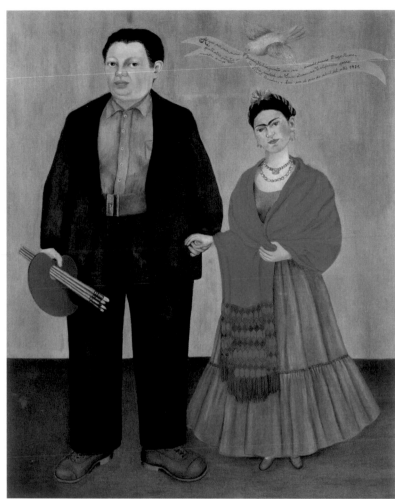

ABOVE LEFT Frida Kahlo, *Portrait of Dr Leo Eloesser*, 1931, oil on board, 85 x 60 cm, Collection of the University of California, School of Medicine, San Francisco

ABOVE RIGHT Frida Kahlo, *Frieda and Diego Rivera*, 1931, oil on canvas, 100 x 78.7 cm, San Francisco Museum of Modern Art

that is joined with hers in a light clasp. She is diminutive and dainty by her husband's side. The master of monumental works is monumental himself here, with legs like tree trunks, his enormous workman's boots set in a wide stance. He holds his painter's palette in his right hand, defining him by his work, whereas Frida's free hand holds her rebozo. In the upper section, a bird holds a banner in its beak that reads: 'Here you see me, Frieda Kahlo beside my beloved husband Diego Rivera. I painted these portraits in the beautiful city of San Francisco for our friend Mr Albert Bender in the month of April in the year 1931.' The painting contains a double message: although in the image she depicts herself simply as the wife of the great painter, the text makes it clear that she was the artist of this work.

Wilhelm Valentiner of the Detroit Arts Commission met Diego in San Francisco and spoke with him about the possibility of painting a mural for the Detroit Institute of Arts Garden Court. Edsel Ford, the chairman of the Arts Commission, would pay 10,000 dollars of his own money to fund the project. Diego was very interested in this plan, but it would have to wait. He would have liked to stay in the United States, but the Mexican

president, Pascual Ortiz Rubio, was pressuring him to return and finish the mural in the National Palace. Diego put off his return as long as possible, but when he had finished the mural in the art school at the beginning of June, it was time to head back.

Frida may have travelled ahead of Diego, arriving back in Mexico at the end of May. A letter she wrote to Nickolas Muray is dated May 31, 1931 in Coyoacán. The circumstances of their meeting are not recorded but they were probably introduced by mutual friends Miguel and Rosa Covarrubias. Muray was a Hungarian-born, New York-based photographer who was also a championship fencer. There seems to have been an immediate connection between Nick and Frida. The letter Frida wrote him, which is partially in Hungarian, reads 'I love you like I would love an angel, You are a Lillie of the valley my love. I will never forget you, never, never . . .'[8] Along with the note, she sent him a sketch of herself hand-in-hand with Diego, possibly a study for the double portrait, a mixed message that was perhaps intended to make clear to Nick where her priorities lay. They would not correspond again until a few years later.

Upon his return to Mexico, Diego immediately got back to work at the National Palace. During his absence, his assistants Ione Robinson and Victor Arnautoff had continued to paint, covering two arches and a sky section in an imitation of Diego's style, but he was not satisfied with their work and re-painted it. Diego often pushed himself and his assistants to work very long hours, but now he was outdoing himself, painting day and night, perhaps anxious to get the job done so that he could return to the United States and all the possibilities that awaited him there. In mid-June, Frida wrote to Dr Eloesser, expressing her concern about how hard Diego was working and asking the doctor to write her husband to tell him to take care of himself. In just three and a half months, Diego was able to complete the entire central panel of the National Palace staircase, a space that was 20 metres wide and nearly 14 metres in height.

While at work, he was approached by Frances Flynn Paine, a New York art dealer, who offered him a one-man retrospective at the New York Museum of Modern Art (MoMA). She was the director of the Mexican Arts Association and an associate of Abby Aldrich Rockefeller. The offer was a great honour: this was the institution's second retrospective; the only previous one had been for Henri Matisse. They agreed to hold the exhibition in December.

Someone else came to see Diego while he was working. Juan O'Gorman, a fellow artist who was also an architect, invited Diego to come and see a house that he had designed

The Barbizon Plaza Hotel, New York, where Frida and Diego stayed in 1931

in the San Ángel district of Mexico City. O'Gorman had built a house in a modern, functionalist style and hoped to convince Diego to hire him to design a similar house on a larger section of the same property. Diego agreed, and suggested that O'Gorman build two separate but connected homes, so that he and Frida could each have their own space.

Having completed a substantial section of the National Palace walls, Diego began to prepare for his show in New York. Since his most impressive work was in mural form and could not be transported, it was decided that he should travel to New York six weeks before the exhibition's opening to create several small frescoes on moveable steel frames. Frida and Diego sailed to New York in November, along with Frances Flynn Paine.

In New York, they stayed at the Barbizon Plaza Hotel on Central Park South and Sixth Avenue. The hotel had opened eighteen months before their arrival. It was a 38-storey building with an eye-catching hipped roof around its slender upper tower. The roof was constructed of narrow ribs of reinforced concrete alternating with glass tiles set on their edges so they sparkled in the sunlight during the day and were illuminated from within at night (this roof would be replaced just a few years later). The hotel had a total of 1,400 guest rooms with baths as well as three large concert halls, exhibition rooms, and a library. On their arrival, Frida and Diego found their room decked out in flowers sent by Mrs Rockefeller. Frida was not impressed by the hotel. The elevator boys, recognizing that she was not a high society lady, were rude to her, and she responded in kind. She wrote a note to Mrs Rockefeller thanking her for the flowers; she mentioned that the hotel was very ugly but the flowers improved things and reminded her of Mexico.[9]

Shortly after their arrival in New York, Diego's patrons hosted a luncheon in his honour. He was seated next to Lucienne Bloch, a young Swiss-born artist who had moved to the United States with her family as a child. She and Diego talked at length in French during the meal, arousing Frida's jealousy. Frida approached Bloch afterward to reproach her for the attentions shown to her husband, but she soon

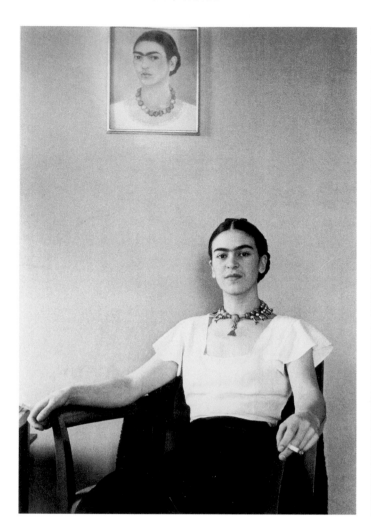

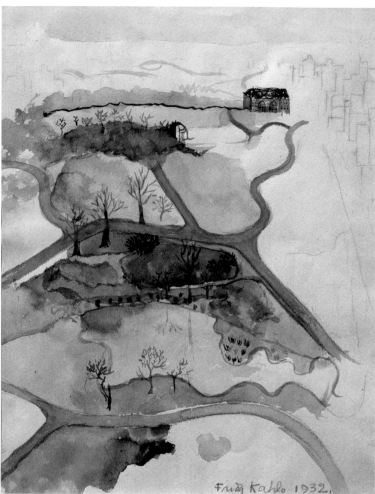

realized that Bloch was truly interested in art and had no romantic interest in Diego. Bloch found Frida's forthright manner refreshing, and the two soon became close friends. Bloch started working as one of Diego's assistants.

The museum provided studio space in which Diego worked around the clock with his assistants to create the portable frescoes. The majority were adaptations of details from some of his murals in Mexico City and Cuernavaca, with themes of revolution and social inequality. He would add another three murals after the opening that dealt with New York themes, looking at the city's social stratification and the urban working class. One of these was the piece titled *Frozen Assets*, depicting the extremes of wealth and poverty in Depression-era New York.

Diego, never a stranger to contradiction, was in his element in New York, associating with the high society, but Frida quickly wearied of the scene. In a letter to Dr Eloesser, she bemoaned having so many invitations to the homes of the New York upper crust. She disliked the food and the weather, and her social conscience was bothered by the great gap

ABOVE LEFT Frida photographed by Lucienne Bloch in New York, 1933

ABOVE RIGHT Frida Kahlo, *View over Central Park*, 1932, watercolour and pencil on paper, 27 × 20 cm, private collection

she witnessed between the rich and poor. She was appalled to see thousands of people in misery without even enough to eat while the rich enjoyed constant parties.[10]

Frida did not paint much. One of the main reasons for this was the lack of space in their hotel room; she found it difficult enough to eat and receive visitors in one room, she could not even contemplate trying to work there as well. When she got the flu and was shut in for a few days, she did a watercolour depicting the view of Central Park from their hotel window, even though it was not a view she enjoyed. She wrote to her mother: '. . . I spent a few days bored to death, stuck in this filthy hotel looking at Central Park so bare of trees it looks like a garbage dump, and listening to the roaring of the lions, tigers and bears in the Zoo across from the hotel.'[11] She did make friends, and was grateful for the kindness shown to her by Lucienne Bloch, Bloch's sister Suzanne, Ella Wolfe, and the Rockefellers, among others. They met Georgia O'Keeffe and her husband Alfred Stieglitz, and Frida reportedly flirted brazenly with O'Keeffe (and later implied that they had an affair[12]).

Diego's exhibition at MoMA opened on December 22 and ran until January 27, 1932. It was a great success, and the best attended exhibit in the museum's short history. Of course, it sparked controversy, with left-leaning journalists decrying the artist's association with capitalists, and conservatives complaining about the communist themes in his work. The debate generated more press coverage, which served as greater publicity. Rather than bothering Diego, he seemed to thrive on the attention.

Diego had been expected in Detroit in January, but he postponed their departure. He was working on another project that he wanted to complete before moving on, a ballet in which he had collaborated with Mexican composer Carlos Chavez. The show was presented on March 31 in Philadelphia's Metropolitan Auditorium. Diego and Frida travelled by Pullman car along with the New York elite to attend. Diego designed the costumes and the set, Carlos Chavez composed the music, and the two collaborated on the libretto. Put on by the Philadelphia Grand Opera, it was called *H.P.* (*Horse Power*). The message was that the natural assets of the south combined with the machinery and enterprise of the north would result in a richer life for all. Diego designed elaborate costumes of fish, fruit, mermaids, machinery and Mexican señoritas. The bulky costumes were interesting as art, but not particularly functional for dance. The event was proclaimed to be a good effort by all, and certainly commanded wide attention, though the show was not repeated.[13]

In April, Frida corresponded with Clifford and Jean Wight about finding them an apartment in Detroit. Clifford was one of Diego's assistants; he and his wife had arrived in Detroit ahead of them. Frida specified that they needed an apartment with enough room for them to work. She requested that they find an apartment with a bedroom, a kitchenette and a bathroom, as well as a separate room with enough light to paint. She mentioned that she definitely planned to work in Detroit because she was tired of 'doing nothing but lying on a cautch [sic]'.[14] Apparently Wight had already written to her about the Wardell Hotel which was very close to where Diego would be working, but from the description, Frida and Diego felt it would be too small. She asked them to find a larger apartment in the same hotel, or somewhere else nearby.

Before departing from New York, their friends threw a party for Frida and Diego. It was a farewell party, but they also took advantage of the occasion to 're-baptize' Frida. It is not clear whose idea this was, but with the rise of anti-German sentiment in the United States in the time leading up to the Second World War, it may be that she and Diego felt uncomfortable with her German name and wished to give her a name that sounded more Mexican. While on her birth certificate her given names were Magdalena Carmen Frida, she had usually written her name as Frieda, derived from the German word for peace. Now, in an effort to de-emphasize her Germanic roots, her friends re-baptized her as Carmen Rivera. For the rest of her stay in the United States, she would go by either Carmen or Frida but eventually settled on the latter, which is how she signed her name for the rest of her life.

LEFT Frida and Diego with editor of the *Menorah Journal* Henry Hurwitz, journalist Gilbert Seldes and Lee Simonson of the Theatre Guild at the Hotel Park Crescent in New York, May 1933

BELOW The Wardell Hotel, Detroit, 1935

Frida and Diego arrived in Detroit on April 21, 1932, just six weeks after the Ford Hunger March. On March 7, a few thousand protesters – including unemployed autoworkers, their families and union organizers – marched on the Ford Motor Company's Rouge River plant with a list of demands. When teargas and fire hoses failed to deter the crowd, the police and Ford company security guards opened fire on the protesters. Four people died and many were injured. Hundreds of thousands attended a funeral march on March 12, an event that was described as the largest parade in the US that had been organized by communists. Had they arrived earlier, Diego probably would have felt the need to address the situation, and possibly could not have justified his association with the Fords. Instead, he and Frida arrived after the drama had passed and never spoke of it publicly. Diego did get involved with the Mexican community of workers and donated a large portion of his earnings from painting the mural to the Mexican workers association.[15]

On their arrival, they were met at the train station by Wilhelm Valentiner of the Arts Council and some members of the press. Frida was photographed wearing a long rebozo, and when she was asked if she was also a painter, she replied tongue-in-cheek: 'Yes, the greatest in the world.' Evidently the Wights had been successful in finding them a larger apartment at the Wardell. The residential hotel was built in 1926 and designed for extended stays, and it was conveniently located across the street from the Detroit Arts Institute, where Diego would be working. Once there, they learned that the hotel had a policy of not admitting Jews. Diego loudly claimed that both he and Frida were Jewish and created a fuss. The hotel quickly changed its policy and offered them a discount for their stay. Lucienne Bloch stayed with them, sleeping on a Murphy bed in the living room.

Diego toured the Ford automobile factory at Rouge River, and then spent two months making hundreds of sketches. Valentiner's original plan was for murals on two large panels, one on each side of the museum's Garden Court, depicting the development of industry

in Detroit. Diego had a larger project in mind. His sketches showed murals covering the walls of the entire space, for a total of 27 panels, which he showed to Valentiner and Ford. They agreed to the plan. Edsel Ford increased his contribution to 20,889 dollars to cover Diego's fees and the materials. Diego would pay his assistants out of his fees.

Frida disliked Detroit. 'This city gives me the impression of an ancient and impoverished hamlet,'[16] she commented. She found some entertainment by going to the movies (she particularly enjoyed slapstick comedy and horror films), playing the Surrealist drawing game 'Exquisite Corpse' with Lucienne, and saying inappropriate things to the upper-crust society under the pretence that she didn't have a good grasp of English. She addressed Henry Ford (who was known to be anti-Semitic): 'Mr Ford, are you Jewish?' much to Diego's amusement. She painted little at the beginning of their stay, though she did complete *Window Display on a Street in Detroit*, a still life showing an odd assembly of a toy lion; a plaster-of-Paris horse; a framed picture of George Washington; and a red, white and blue decorative streamer, all set in the window of a nearly empty shop.

One of the reasons for Frida's discontent was that she was pregnant again and uncertain what to do. On the recommendation of Dr Eloesser, she consulted Dr Pratt at the Henry Ford Hospital. He gave her quinine and a castor oil purge to provoke an abortion. She later discovered that she was still pregnant. The doctor suggested she carry the pregnancy to term and have a cesarean delivery rather than having an operation to abort. Frida experienced a rush of contradictory emotions. She had been led to believe that she couldn't carry a pregnancy to term because of her pelvic injuries from the accident. She considered the practical aspects of having a child with Diego as well as her own feelings about the matter. She always said she wanted to have a 'little Dieguito', but the prospect of having a baby under their current circumstances was daunting.

Diego did not have a good track record as a father. He had had a baby with his first wife, Angelina Beloff. The boy died of pneumonia before the age of two and Diego was absent both at his birth and during his illness and passing. In fact, at the time of his son's birth, he had embarked on a months-long affair with another woman with whom he had another child, a girl named Marika. He never formally recognized his daughter, though he sent her money on occasion, acknowledging that he was her father. It's unclear whether Frida knew of the circumstances around those two children, but she was well aware that Diego had left Lupe alone to care for their two daughters. Lupe said that Diego was a good father except

that he never gave her enough money for their care. However, it was just after the birth of their second daughter that Diego had the affair with Tina Modotti that led to the end of their marriage. Ultimately, Frida was aware that her husband had little interest in having another child and preferred to have her undivided affection. Considering that she was far from her home and family, her health was poor, and her husband prioritized his work over everything, the prospect of having a child in the United States was fraught with difficulties.

She wrote to Dr Eloesser asking for his advice regarding whether or not she could safely carry a pregnancy to term. She presented her different options: should she have the baby in Detroit and then travel to Mexico, or travel to Mexico and have the baby there? She feared for her own health, as she made clear in her letter: 'any misstep and "*La Pelona*" could take me'.[17] (*La Pelona*, literally 'the bald one', is a Mexican slang term for death.) Even before she received his response, Frida decided to follow Dr Pratt's advice and continue with the pregnancy. She got used to the idea of becoming a mother, and was excited at the thought of having a child, a hope she had abandoned after her accident.

At the end of June, Frida had some bloody discharge. She consulted Dr Pratt, who told her not to be alarmed and that everything was fine. On July 4, Frida began to bleed profusely and was admitted to Henry Ford Hospital, where she had a miscarriage. She spent two weeks in the hospital. Although she had been conflicted about having a baby, the pregnancy loss was a traumatic experience for her. In a letter to Dr Eloesser she told him she had cried and cried, having become excited at the idea of having a 'little Dieguito'.

During her hospital stay, Frida asked the doctors to show her the fetus or, failing that, to lend her a medical textbook so she could picture its stage of development, perhaps already considering how she would depict the experience in her work. The doctors refused but Diego urged them to reconsider, telling them: 'You are not dealing with an average person here.'[18] Diego procured the textbooks and Frida later included the images of fetuses in her work. Diego may also have been moved to include their personal loss in his art: he painted a fetus in a bulb as a central image of his mural.

After the miscarriage, Diego asked Lucienne to keep Frida company and encourage her to get back to work, which he felt would help her move past the grief. They found a nearby art studio where they could do lithographs. Frida produced a print depicting her experience: she portrayed her nude body with the fetus visible on her belly. She is wearing the hair net she wore at the hospital and a necklace with two strands of beads. She has

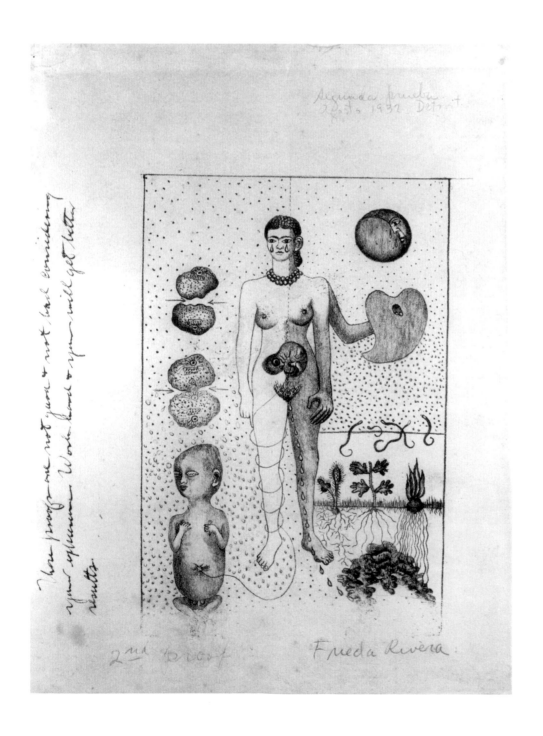

PREVIOUS PAGES Aerial view of the Ford Motor Company's manufacturing plant in Detroit

LEFT Frida Kahlo, *Frida and the Miscarriage*, 1932, lithograph, 22 x 14 cm, Museo Dolores Olmedo Patiño, Mexico City

BELOW Frida at the border in Laredo, Texas, travelling home from Detroit, photographed by Lucienne Bloch

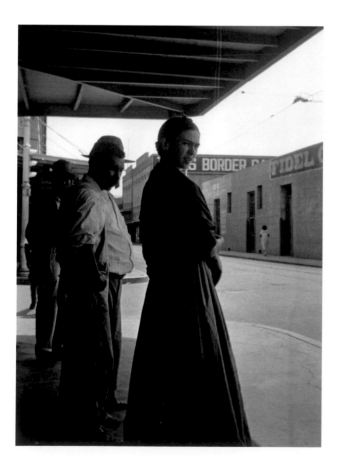

two left arms: one rests by her side, the other holds a painter's palette shaped like a heart. She is crying and the moon is also crying in the sky above. A line divides the composition and her body, of which one side is light and the other dark. An umbilical cord wrapped around her leg leads to a larger fetus on the left side and above the fetus she shows cells dividing. On the right, darker side, blood drips from between her legs onto the ground, out of which grow plants shaped like human hands and sexual organs. The lithograph is done in the style of early anatomy textbooks, but it was unprecedented to portray pregnancy loss in such a raw, graphic and personal way. The image underscored how she intended to surmount that loss: she now holds the palette that her husband held in the earlier double portrait.

Just two months after her miscarriage, Frida received a telegram from her family in Mexico: her mother was gravely ill. She longed to be with her family at this difficult time but worried about leaving Diego alone. Diego was also worried about Frida travelling so soon after her miscarriage, and was concerned that she might experience delays at the border because of protests. He asked Lucienne to accompany Frida to Mexico and offered to pay her expenses for the trip.

They went by train. They had to wait ten hours in Laredo. It was hot and Frida suffered from her distress over her mother and because she was still bleeding. Once they crossed the border into Mexico, she was transformed: she ordered food from vendors at the train stations and was so happy to be back in her homeland, eating the foods she loved. Lucienne said she seemed to return to life. They arrived in Mexico City on September 8. Frida was pleased to be reunited with her father and sisters, but her mother was in the hospital, in poor condition. She had a tumour in her breast as well as a liver problem. The doctors said that they needed to operate on her liver. On September 10, Frida wrote to Diego saying that her mother seemed calmer, but her condition was not improved. They operated on September 13, but to no avail; Matilde died two days later.

While they were apart, Diego uncharacteristically wrote to Frida nearly every day, and Frida responded at length about the situation at home. Their letters show their deep attachment. Diego wrote: 'I am really sad here without you, I can't even sleep without the little girl and I barely raise my head from work, I don't know what to do without being able to see you. I was sure that I hadn't loved any old lady like the Chicuita, but now that she left me, I know in reality how much I love her, she knows that she means more to me than life itself . . .'[19] Diego thoughtfully suggested that Frida ask her father to photograph his collection of pre-Hispanic idols one by one, to occupy Guillermo, keep his mind off of his loss, and make him feel useful. The assignment would also allow them to keep giving Guillermo money without bruising his pride.[20] However, Guillermo seemed to have given up on photography. A photo he took of Frida just before she returned to the United States is his last dated image.

While she was in Mexico, Frida went to San Ángel to check on the houses O'Gorman had built for them. The construction was completed just a few months prior. She confirmed they were finished, but had concerns about the houses. Diego suggested that they could be sold and O'Gorman could build new ones for them, taking her ideas into account, but that never came to pass.

Frida and Lucienne returned to Detroit at the end of October. They were distressed to see that Diego, having been put on a strict diet by a local doctor, had lost 100 pounds during the six weeks they were away. Frida didn't even recognize him at the train station until he spoke to her.

Frida turned to painting with renewed vigour. One of her most striking works is *Henry Ford Hospital*, which she originally titled *The Lost Desire*. Here she recurs to some conventions of ex-votos, depicting the devastating experience of her miscarriage in oil on a tin sheet with a simplified perspective. She shows herself on a hospital bed with the words 'July 1932' and 'Henry Ford Hospital' written at the foot and on the side of the bed. The bed is placed within a vast, desolate landscape with Detroit's industrial skyline in the distance. She is naked and crying, her hair loose and the sheet beneath her soaked in blood. At the level of her swollen abdomen, she holds the ends of several red strings that are tied to objects floating around her, symbols of her recent trauma: a fetus, a model of the female reproductive system, a pelvic bone, a snail, an orchid and a piece of machinery. She made use of the medical textbooks she had to depict the fetus and other medical images in

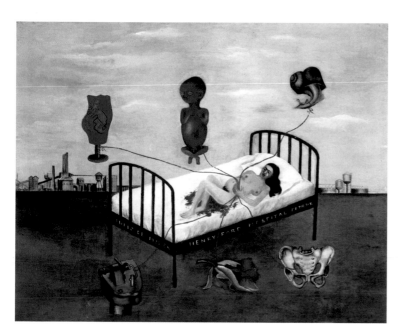

ABOVE Frida Kahlo, *Henry Ford Hospital*, 1932, oil on metal, 30.5 x 38 cm, Museo Dolores Olmedo Patiño, Mexico City

ABOVE RIGHT Frida Kahlo, *My Birth*, 1932, oil on metal, 30.5 x 35 cm, private collection

painstaking detail. In an interview, she explained the meaning of the objects. The snail represented the fact that the miscarriage was slow and 'soft, covered yet at the same time open'; the orchid was from Diego and symbolized sexuality and sentimentality; and the machinery addressed the mechanical part of her ordeal.[21]

The unconventional imagery subverts traditional forms and symbols, creating startling contrasts of meaning that shock and challenge viewers. The reclining female body is not an object of desire here, but a source of pain and loss. This painting has been described as an 'anti-Nativity scene',[22] since it depicts the loss of a child rather than a birth. Instead of the people and animals in a Nativity scene, she is surrounded by the lost fetus and objects that offer no comfort.

Another painting created shortly after Frida's return to Detroit is *My Birth*. A bed stands in the centre of an otherwise empty room. A sheet covers the head and torso of a woman lying on the bed, who is nude from the waist down. Her legs are spread wide and show Frida's head emerging from between them. Above the bed, there is a framed picture of Our Lady of Sorrows, who is known as 'Mater Dolorosa' (the grieving mother), referring to the Virgin Mary at the crucifixion. This painting contains all the elements of a traditional ex-voto: it is painted on tin, a religious figure appears in the upper portion of the composition, a person who needs to be saved is on the bed, and there is a scroll below, though the fact that it is empty conveys that the hoped-for miracle did not occur. In this painting, Frida seems to conflate three important events: her own birth, her miscarriage and the death of her mother. The mother can be seen as both Frida and her dead mother, the child as both Frida and the baby she lost. By combining images that relate to birth and death, she connects the two in a never-ending cycle.

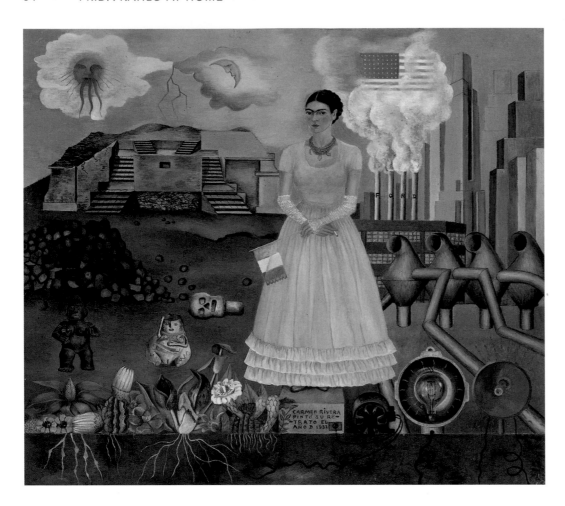

Frida broke taboos by depicting the harsh, raw reality of her private experiences in her art. The image of a woman in the act of giving birth, with legs spread wide and blood on the sheets, is shocking even now, but in the 1930s must have been exponentially more so. However, presenting a birth in this way is not completely unprecedented; it recalls some images from pre-Hispanic art, particularly depictions of the Aztec goddess Tlazolteotl who is shown in a squatting position with a head emerging from between her legs.

Perhaps as a response to her husband's belief that bringing together the natural riches and ancient cultures from the south with the modern technology and industry from the north would create a new and better American culture, Frida painted *Self-Portrait on the Borderline Between Mexico and the United States*. She stands on a pedestal between two starkly different worlds. On the left, Mexico is represented as a land of natural life and ancestral cultures characterized by ancient pyramids, the sun and moon together in the sky, a crumbling wall and vegetation with roots extending into the ground. Pre-Hispanic figures are strewn across the scene. On the right, the flag of the United States flies over a landscape of smog, skyscrapers and industrial machinery. An electrical cord snakes across the border

LEFT Frida Kahlo, *Self-Portrait on the Borderline Between Mexico and the United States*, 1932, oil on metal, 31 x 35 cm, Collection Manuel and Maria Reyero, New York

BELOW Frida painting *Self-Portrait on the Borderline Between Mexico and the United States*, Detroit, 1932

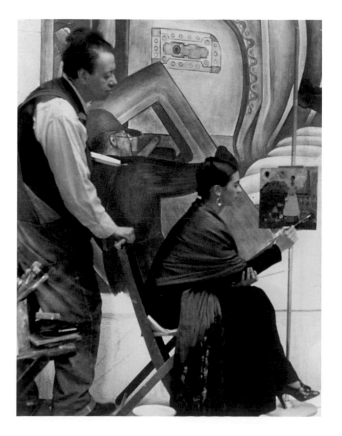

taking energy from the roots of the plants on the Mexican side to feed the industry in the US. Frida stands between the two, wearing a pink gown and long, fingerless white gloves. In one hand, she holds a small Mexican flag, in the other, a cigarette. On the pedestal are the words: 'Carmen Rivera painted her portrait in the year 1932.' Frida was a nationalist, but did not idealize either country, showing Mexico as fertile and chaotic, the United States as ordered and sterile. She clearly saw the countries as separate and contradictory; she presented their faults, in contrast with her husband, who depicted idealized images to convey his internationalist beliefs.

Although Frida was working more intensely than ever before, she continued to be very modest about her art and claimed that it was a pastime. In a letter to Mrs Rockefeller she commented that she was painting a little, not because she considered herself an artist, but because it kept her busy and helped to keep her mind off of the troubles she had had. An article about Frida appeared in a Detroit newspaper in February 1933. The headline read: 'Wife of the Master Gleefully Dabbles.' Despite the rather condescending title, within the article the author acknowledges Frida's talent: '. . . she has acquired a very skillful and beautiful style, painting in the small, with miniature-like technique, which is as far removed from the heroic figures of Rivera as could be imagined.'[23] The photo accompanying the article shows Frida wearing a frilly apron and painting her *Self-Portrait with Necklace*, one of the other pieces she completed in Detroit.

It took Diego ten months to paint the murals covering the Garden Court. In this mural cycle, he depicts a harmonious relationship between technology and biology, though he showed both the good and evil that could emerge from modern technology. He also presents an idealized version of the Ford automobile factory, with workers of many races working together. There was some controversy while he was painting, but when he finished there was great clamour. Some said the murals should be destroyed, others praised them. At the time, Diego said that

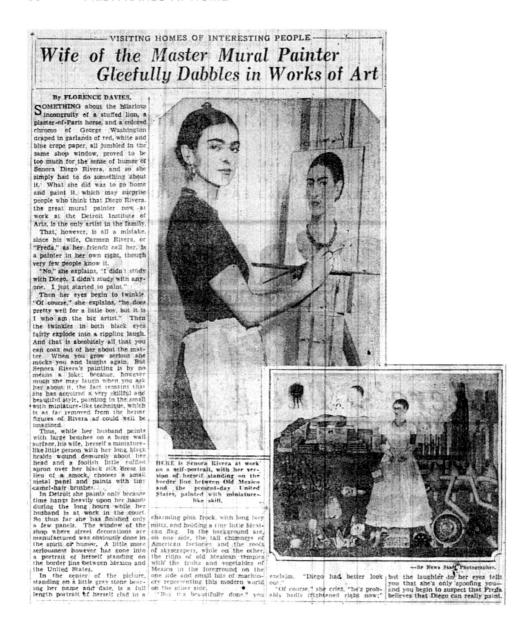

it was the greatest mural cycle he'd ever done. Edsel Ford simply said: 'I like them,' and formally accepted them as part of the Detroit Art Institute's collection.

Diego had his next step already planned. While he was working in Detroit, he was approached by Raymond Hood, the architect for the Radio City of America Building in New York City's Rockefeller Center. At the behest of Nelson Rockefeller, he commissioned Diego to paint a 93-square-metre wall. On March 18, the day after the Detroit murals opened to the public, Diego and Frida left for New York. They settled back in at the Barbizon Plaza. Frida was happy to be back in New York, which she vastly preferred to Detroit, but what she most wanted was to return to Mexico.

LEFT *The Detroit News*, February 1933

RIGHT Frida and Diego at the Detroit Institute of Arts

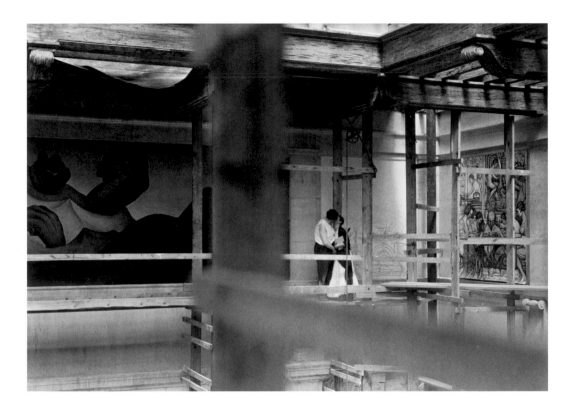

True to form, Diego got to work straight away on his mural, which was titled *Man at the Crossroads*. Nelson and Abby Rockefeller followed his progress closely and seemed pleased with how rapidly he was advancing. They were not offended by the subject matter. However, when the *New York World Telegram* published an article entitled 'Rivera Perpetrates Scenes of Communist Activity for RCA Walls – And Rockefeller, Jr. Foots Bill' on April 24, they showed some concern. A few days later, Diego added the face of Vladimir Lenin to the mural. The Rockefellers wrote to ask him to change Lenin's face to an unrecognizable worker as in the sketches he had originally done. Diego was in a difficult position. If he backed down, he would be seen to be compromising his artistic integrity. His assistants threatened to go on strike if he gave in to the Rockefellers. He stood his ground, but offered to add an image of Abraham Lincoln to balance out the portrayal. This was not an acceptable proposal for the Rockefellers, so they paid him in full and shut down the project on May 9. The mural was later destroyed.

The end of the project was a great blow to Diego. He decided he would use his fee from the cancelled commission to recreate the mural on another wall. He found no suitable options and instead painted a series of moveable frescoes for the New Workers School, completing 21 panels in total, which he entitled *Portrait of America*.

Shortly after Diego's dismissal from the Rockefeller project, he and Frida moved from the Barbizon Plaza to a two-room flat at 8 West Thirteenth Street, which was closer to

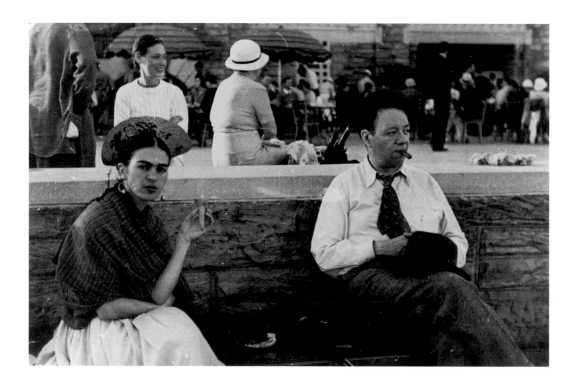

where he would be working. They were happy to leave the pretentiousness of the Barbizon behind. At their flat they enjoyed receiving guests day and night, with no doorman who would turn away their friends for not being the 'right type'. Louise Nevelson and her friend Marjorie Eaton took a flat in the same building and became Diego's assistants. Diego was soon spending a lot of time with Nevelson, and it wasn't long before his assistants were aware they were romantically involved. Frida's loyal friend Lucienne was incensed: 'Frieda is too perfect a person for anyone to have the strength to take her place,' she wrote in her diary.[24]

A few months later, they moved again to the Hotel Brevoort on Fifth Avenue, between Eighth and Ninth Streets in Greenwich Village. This stately hotel was built in 1845 and had long been a haven for artists and bohemians, with a Parisian-style café on the ground floor. These were not happy times. They argued for several months about

ABOVE Frida and Diego at Jones Beach, New York, 1933, photographed by Lucienne Bloch

RIGHT Lucienne, Diego and Frida at the New Workers School in New York, 1933

whether to go back to Mexico. Diego had been in negotiations to create a mural for the World's Fair in Chicago, but after the scandal with the Rockefellers, it fell through. At the end of 1933, with no money and no prospects on the horizon, Diego glumly agreed to return to Mexico. Their friends contributed the money for their tickets. On December 20th, they boarded a ship to go home. Diego was bitter and disappointed and Frida, although she had longed to return to Mexico, could not be happy while Diego was unhappy.

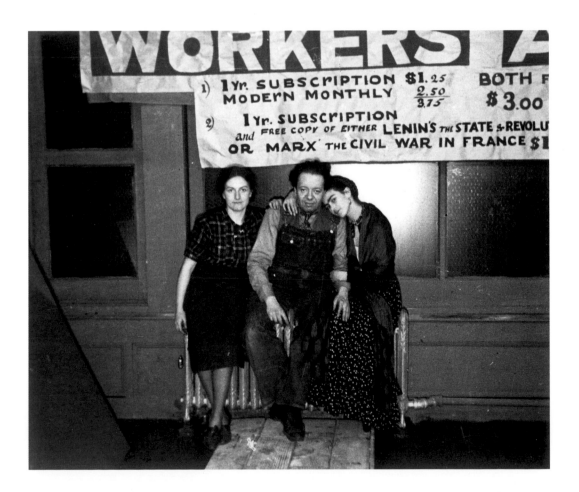

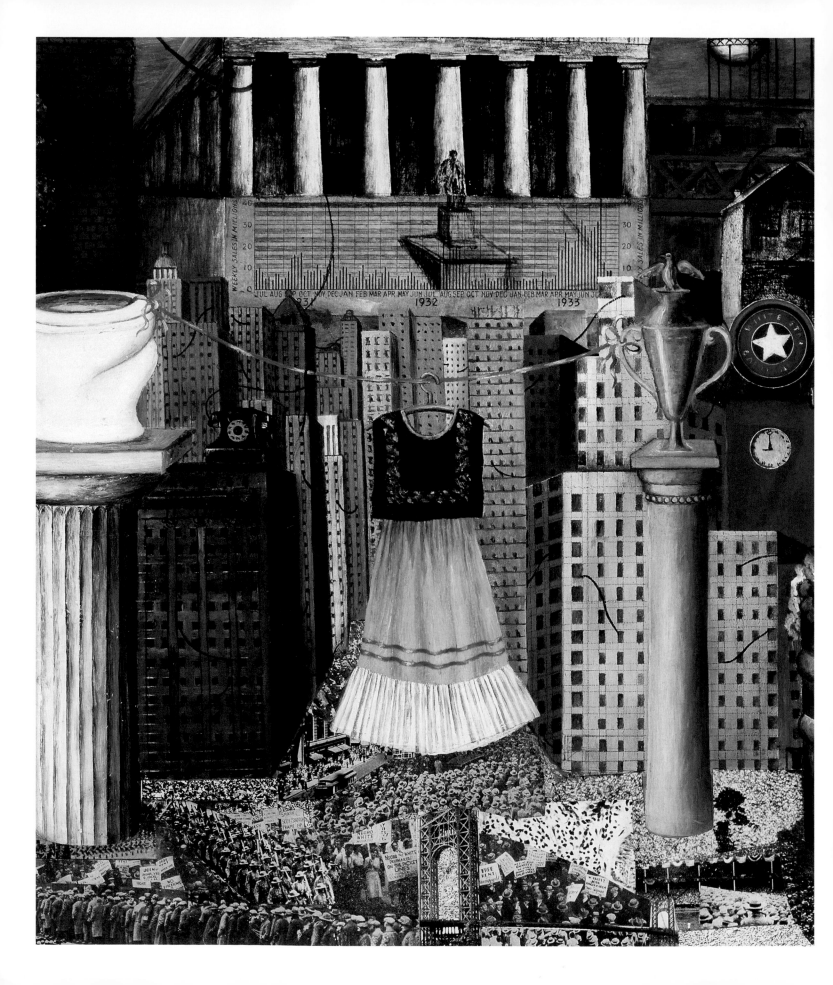

SEPARATE BUT CONNECTED IN SAN ÁNGEL

On their return to Mexico, Frida and Diego settled into the pair of home-studios that Juan O'Gorman had designed and built for them on the corner of Palmas and Altavista streets in the San Ángel district of Mexico City. Their new home was about four kilometres from Frida's family home in Coyoacán, where her father, Cristina and her children still resided.

Like Frida, O'Gorman had an immigrant father and Mexican mother, and had grown up in Coyoacán. He was close to her in age and the two had known one another in their youth. O'Gorman had also gone to the National Preparatory School and went on to study art and architecture at the National University of Mexico. He was a painter as well as an architect. He was deeply influenced by the work of Swiss architect Le Corbusier and his principles of modern architecture, which state that the form of a building should be determined by practical considerations such as use, material and structure. O'Gorman was eager to put these ideas into practice within the Mexican landscape.

O'Gorman was just 24 years old when he bought a large parcel of land from the Altavista tennis club from his earnings as an illustrator. Following Le Corbusier's philosophy, he designed and built what he deemed 'the first functionalist house in Mexico', intended for his father, Cecil O'Gorman. It is a boxy building made of unadorned reinforced concrete. The light-filled upper level studio has floor-to-ceiling windows on three sides and can be accessed from outside via an elegant curved staircase.

O'Gorman had invited Diego to come and see his creation. Diego liked the design and the ideas behind it. Although O'Gorman had rejected aesthetic considerations in favour of the practical, Diego thought the home was very aesthetically pleasing. They concurred that this type of architecture could be an agent for social and political reform: the efficiency and minimal cost would make it possible to provide schools and housing to more people. O'Gorman sold Diego another section of the property at cost with the agreement that Diego would hire him to build a house and studio in the same style. Diego requested that he build two separate houses, one for him, and one for Frida.

The property is surrounded by a line of organ pipe cactus, planted close together to form a natural fence. The houses look like two cement blocks side by side; they are connected only by a narrow bridge at the top level. The larger house is painted dark pink and white, the smaller one, dark blue. Diego's bigger house is in a more prominent position

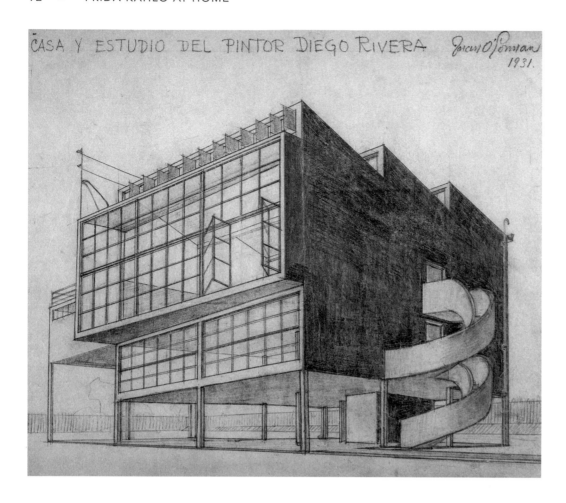

CASA Y ESTUDIO DEL PINTOR DIEGO RIVERA *Juan O'Gorman* *1931.*

on the street corner, and is designed to receive visitors and clients, whereas Frida's smaller house is set farther back on the property and is a more intimate space, though it has its own separate entrance. The houses are elevated on slender reinforced concrete columns, creating a shaded ground-level patio under each, with parking space in the shade, and room to display the large sculptures that the couple collected. The larger house has a service area on the ground floor, including a kitchen and dining room. A concrete helicoidal staircase adds a distinctive corkscrew shape to one side of the otherwise boxy structure. An interior stairway also allows for access between levels. The first floor has a large open showroom for Diego to display his paintings as well as his collection of pre-Hispanic art. There are also small bedrooms and a bathroom on this level.

Diego's huge studio is located on the second floor. The workspace was well thought-out and perfectly designed for a painter's purposes. Le Corbusier famously said that 'a house is a machine for living in', but this studio is conceived as a 'machine that seeks light'. O'Gorman drew on Le Corbusier's Maison Ozenfant in Paris, designed for the painter Amédée Ozenfant in 1922.[1] Diego's studio has a floor-to-ceiling window in a wall that juts out from the rest of the building on an angle; it is aligned to true North, assuring

ABOVE Sketch of the planned San Ángel house by architect Juan O'Gorman

RIGHT The house in San Ángel, photographed by Guillermo Kahlo

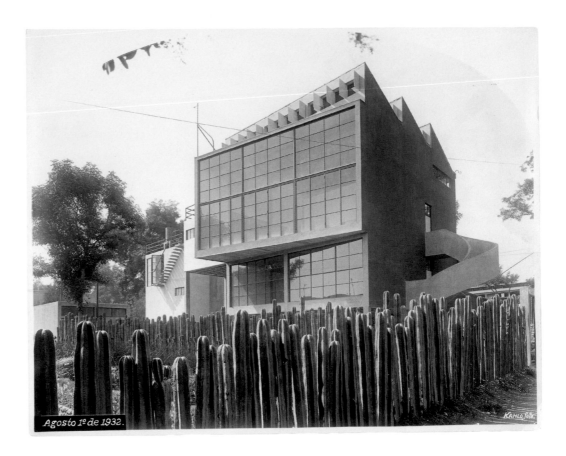

Agosto 1º de 1932.

diffuse natural light all day long and throughout the year. The studio's saw-tooth skylight roof allows for more light from above. At the far end of the studio, O'Gorman erected shelves for Diego to store his materials. The double height ceiling is very high on one side, providing the space for Diego to work in large formats, such as portable frescoes. There is an additional bedroom and bathroom on this level. On the top floor, a gallery looks out on the studio. There is a small office area and a door leading out to the terrace and the footbridge that connects to the roof terrace of the neighbouring house. From the roof of the blue house, a concrete cantilevered staircase with a tubular rail leads down the side of the wall to a large window that opens onto the second floor studio.

Frida's studio was also light-filled, with windows on three sides, but like her house, it was more compact than Diego's. Besides the studio, there was a living room, a bedroom, a bathroom and a tiny kitchen. Although it's a closer space, it has larger windows on the street side than Diego's house, somewhat reducing its privacy.[2] The houses are often referred to in Spanish as *casas gemelas* (twin houses), but although they are attached, they are not identical. Diego's house and studio were much larger and more prominent, reflecting his status and professional situation in comparison to Frida's. A third and much smaller building on the same plot of land was intended for Guillermo Kahlo to occupy as a studio and a darkroom,

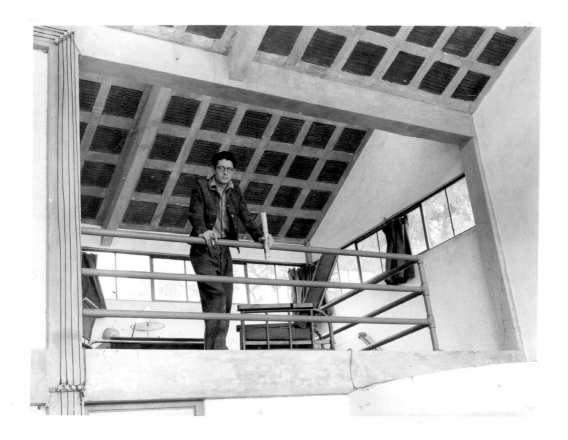

but he never used it; after his wife's death, his health declined and he gave up photography.

O'Gorman's approach to Functionalist architecture values economy in all senses: cost, material, space and time. The houses were made with inexpensive materials such as concrete, steel and asbestos. The plumbing and electrical installations are exposed and there is no extraneous decoration or embellishment. The shape of the houses, the saw tooth roof over Diego's studio, the water tanks on the roofs, and the railings of steel pipes all give the complex the look of a factory. O'Gorman added a few traditional Mexican touches: the cactus fence, commonly seen in the Mexican countryside but rare in the city, and the distinctive exterior colours that are found in pre-Hispanic art. He furnished the

ABOVE The architect Juan O'Gorman at the San Ángel house, in the gallery overlooking Diego's studio

RIGHT Frida in front of the distinctive staircase

home with some modern metal and tubular steel furniture, but Frida and Diego would soon exert their influences on the homes, adding traditional Mexican furniture, straw mats, giant papier-mâché figures and pre-Hispanic sculptures.

The neighbours were not pleased. The Functionalist houses stand out in the upper-class neighbourhood with predominantly colonial and neo-classical architecture. To make matters worse, the property is located on a very prominent corner, just across the street from San Ángel Inn, an upscale restaurant and hotel housed in a building that was originally a 17th-century Carmelite monastery. Many people derided the houses, saying they should be torn down, but a few people appreciated O'Gorman's modernist approach. He was later hired by Mexico's Secretary of Education to build schools using the same principles of economy and function in design.

Diego liked the austere simplicity of his home studio. He appreciated its modest beauty, and it also suited his political leanings to avoid the ostentatious. The factory-like architecture fitted with his notion that he was a member of the working class. He also saw numerous advantages in having 'his and hers' houses: Frida was close-by to attend to his needs and organize his personal and work affairs, while he was free to carry on as he wished, entertaining a continual stream of women guests in his own house. He told journalists that the reason for having two separate houses was to 'maintain domestic peace'.

Frida originally liked the idea of having her own space to work, but the house was not as well-suited to her as it was to her husband. The multiple levels and narrow staircases she had to climb in her living space aggravated her pain and physical issues. Her husband, besides being sullen since their return from the United States, was also physically distant: to visit him in his studio, she had to navigate several flights of stairs. The tiny kitchen in her house was completely inadequate for preparing the elaborate dishes Frida liked to serve to Diego and their guests. The house lacked a central patio that was

the heart of her family home in Coyoacán and brought people together; in contrast, the design of the San Ángel house studios was isolating. She made the best of the situation, but she would only live in this house for a few years.

Just a few weeks before Frida and Diego's return from the United States, a new president took office, one who shared their concern for the welfare of workers and peasants. Lázaro Cárdenas had been a protégé of Plutarco Elias Calles, the 'Maximum Chief of the Revolution' who had maintained control over Mexico's political affairs for the preceding decade. Calles had backed Cárdenas' candidacy, trusting he would continue to call the shots. Cárdenas had other plans: he weeded out Calles' supporters from government positions and formally broke with his mentor, eventually sending him to exile in the United States. He backed agrarian and workers' movements, and redistributed land to peasants on a large scale, handing out more than twice the amount of land than all of his predecessors combined. He also reclaimed the country's natural resources from foreign companies.

Although the politics of the country were heading in a direction that Frida and Diego agreed with, personally and professionally, things were difficult. The government mural commissions he received in Mexico were not as exciting, nor as well remunerated as the murals Diego had done in the United States. He still had walls waiting for him: two panels in the National Palace remained unfinished, and he was also offered a wall in the Fine Arts Palace. He still felt dissatisfied with how things had ended in the United States, and blamed Frida for their return to Mexico. Further, he suffered health troubles: his rapid weight loss in Detroit had left him saggy and lacking energy. They were both miserable.

Frida began painting *My Dress Hangs There* while they were still in the United States. She completed it back in Mexico. The painting offers a scathing criticism of capitalism. Her traditional Tehuana dress hangs on a line suspended between two columns in a decaying New York cityscape. A toilet sits atop one column and a golden sports trophy on the other. At the top of the composition, she depicted New York City landmarks Ellis Island and the Statue of Liberty, symbols of the promise of the American Dream, but the rest of the painting shows it to be an empty promise. Large skyscrapers and other buildings take up most of the composition. She depicted Trinity church, but its stained glass window shows a dollar sign wrapped around a cross, a cynical indictment of capitalist society's adoration of the almighty dollar. A peeling poster of Mae West shows her looking out over a building in flames. A garbage bin overflows with detritus and human body parts. Telephone lines

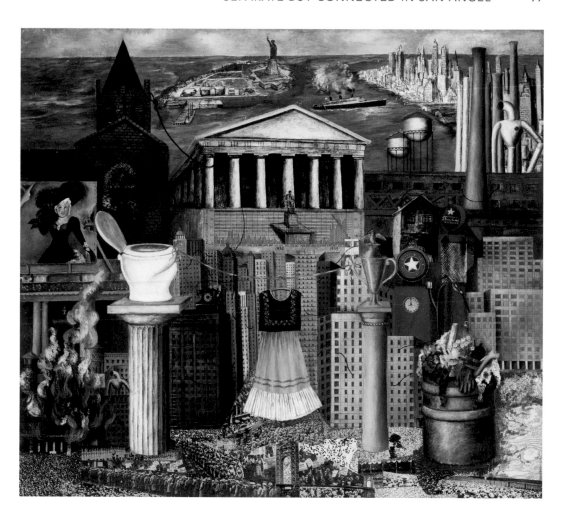

Frida Kahlo, *My Dress Hangs There,* 1933, oil and collage on board, 46 x 50 cm, private collection

weave in and around the scene, symbolizing the connections between government, industry and the church. At the bottom of the painting, Frida pasted newspaper images of faceless crowds of people standing in breadlines, picket lines and protests. Her message is clear: the wastefulness and materialism of capitalist society leaves the masses with their basic needs unmet. Above it all, her traditional Mexican dress hangs as a symbol of resistance.

Frida produced no new paintings in 1934 and was admitted to the hospital three times that year. She became pregnant again and had an abortion. The doctor performed a laparotomy and diagnosed her as having undeveloped ovaries. She had her appendix removed and also had an operation on her constantly troublesome right foot. Her doctor removed the tips of her toes, but the foot was slow to heal and continued to cause her pain.[3]

During the summer of 1934, Frida discovered that Diego was having an affair with her sister Cristina. She was devastated. It was the ultimate betrayal, by both her beloved husband and her closest sister. Compounding the hurt was the fact that it wasn't a fleeting affair: they maintained a relationship for several months. Frida initially hoped Diego's infatuation with her sister would fade or that she would be able to reconcile herself to

their relationship. She decided that she was to blame for trying to stand in the way of Diego's happiness. She attributed her emotional response to the situation to neurasthenia (a condition characterized by chronic fatigue). She decided she should forgive her sister, thinking that would allow her to move on, but although that made Diego happy, it just made her more miserable.[4] In early 1935, she decided the situation was untenable and she moved out of the San Ángel house, initially going to stay with her half-sister Maria Luisa for a short time, and then taking an apartment at 432 Avenida Insurgentes in the centre of Mexico City. She made some efforts to create a life for herself separate from her husband. She cut her hair short, spent time with friends, and tried to be independent, though she still maintained contact with Diego.

In the year that followed, Frida completed only two paintings. In *Self-Portrait with Curly Hair*, she gazes out at the viewer, her head turned slightly to the side. She wears a beaded necklace and silver hoop earrings. It is very similar to the self-portrait she painted in Detroit, just showing her head and shoulders and a plain background, but in contrast with the earlier portrait, her hair is very short with tight curls close to her head. The other painting she completed that year, *A Few Small Nips*, is executed in the ex-voto style with a simplified perspective, but instead of a miracle, we witness a murder scene. A man wearing a hat stands beside a bed on which lies the dead and bloodied body of a woman. His left hand rests casually in his pocket and his right hand holds a bloody knife with which he has stabbed the woman many times. Nude except for a stocking around the ankle and a black

LEFT Frida with her sister Cristina, Diego, and Miguel and Rosa Covarrubias

BELOW Frida Kahlo, *Self-Portrait with Curly Hair*, 1935, oil on metal, 19.5 x 14.5 cm, private collection

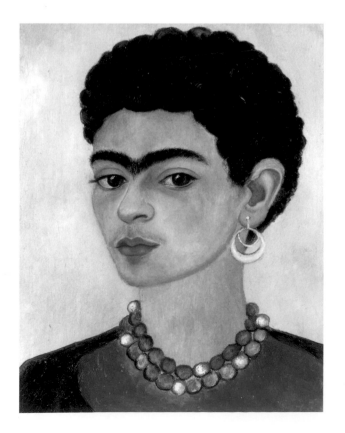

high heeled shoe on her right foot, the woman lies in a twisted position, her upper body turned toward the viewer and her lower body turned away. There is blood on the man's shirt, on the floor and all over the bed, as well as red splattering on the painting's wooden frame, bringing the gruesome scene closer to the viewer. Two doves, one white and one black, hold a banner over the scene that says 'A few small nips!'

Frida said that the painting was inspired by a news story she heard in which a drunken man stabbed a woman twenty times and when asked why he did it, responded: 'It was just a few small nips!' Besides drawing on the tradition of ex-votos, here Frida also references the work of José Guadalupe Posada, a prominent illustrator and engraver who depicted scenes that satirized politics and current events. This painting can be seen as an illustration of Frida's feelings at that time: she said she felt 'murdered by life'.[5] The killer's apparent lack of awareness of his actions and their effect mirror Diego's disregard for how his behaviour impacted on Frida. But the painting also holds a message about society's double standard for men and women. On the preparatory sketch for the painting, Frida wrote a line, possibly from a song: 'My sweetie doesn't love me anymore because she gave herself to another bastard, but today I snatched her away, her hour has come.' This addition shows that the victim was being punished for her infidelity. Whereas men were sexually free to have relations with whomever they wished, a woman who did the same risked severe repercussions.[6]

While Frida was distressed over her husband's actions, Diego regained his gusto for work. He started on the *Modern Mexico* panel on the left wall of the National Palace stairway. Cristina posed for him. He depicted her with glazed eyes, her children Isolda and Antonio beside her. Frida also appears, in the role of a teacher, standing behind Cristina, holding a book for a boy to read. When Diego finished his work in the National Palace, he moved on to the Palace of Fine Arts where he reproduced *Man at the Crossroads*, his destroyed mural from the Rockefeller Center. The wall in the Fine Arts Palace was much smaller than the original

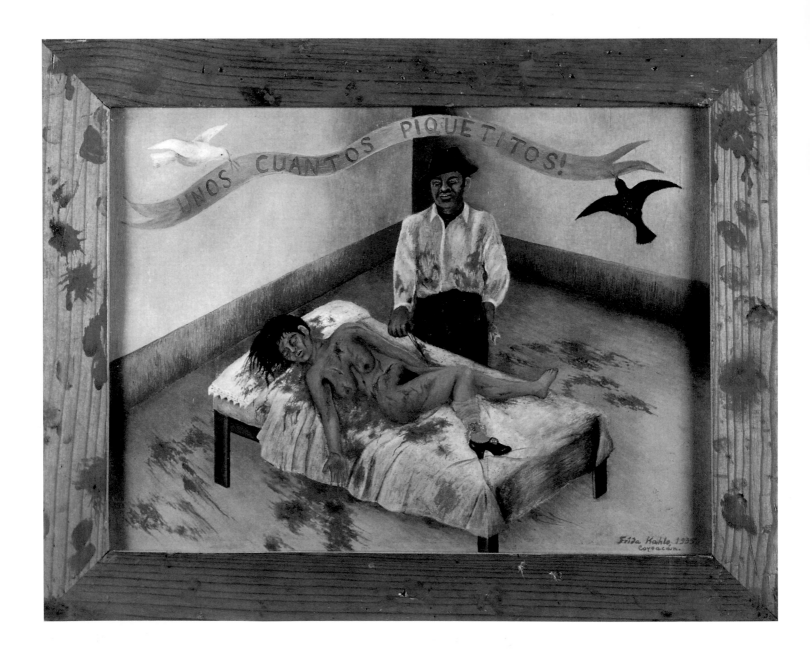

Frida Kahlo, *A Few Small Nips,* 1935, oil on metal, 30 x 40 cm, Museo Dolores Olmedo Patiño, Mexico City

wall, so he adapted it and changed the name to *Man: Controller of the Universe*. He was also asked to paint murals in the Abelardo L. Rodríguez market, but since he had some health issues, he decided to hire others to do the murals under his supervision.

On the spur of the moment, Frida travelled to New York with her friends Anita Brenner and Mary Shapiro. In New York she visited with Lucienne Bloch and Bertram and Ella Wolfe, and unloaded her troubles on these willing listeners who knew and cared for both her and Diego. In these discussions, Frida came to the realization that she still loved her husband and, even though he had hurt her terribly, she still wanted to be with him. She wrote to him in July from New York: '. . . all these letters, liaisons with petticoats, lady teachers of "English", gypsy models, assistants with good intentions, plenipotentiary emissaries from distant places, only represent *flirtations*, and that at bottom *you and I* love each other dearly, and thus go through adventures without number, beatings on doors, imprecations, insults (*mentadas de madres*), international claims – yet we will always love each other . . . All these things have been repeated throughout the seven years that we have lived together, and all the rages I have gone through have served only to make me understand in the end that I love you more than my own skin, and that, though you may not love me in the same way, still you love me somewhat. Isn't that so?'[7]

She forgave him and moved back to San Ángel. She eventually forgave Cristina, too. The sisters would become even closer in the following years, and Cristina was a constant by Frida's bedside when she had health troubles. Upon her reconciliation with Diego, Frida seems to have decided that it would be an open marriage and began to have more affairs of her own. According to their friend and Diego's biographer Bertram Wolfe, their affairs became more casual and frequent, while their mutual dependence and trust deepened.[8] Although Diego did not take pains to hide his affairs, Frida was discreet, usually receiving letters through her sister or another friend, using a pseudonym in her correspondence, and arranging meetings at the house in Coyoacán or elsewhere. Diego had no issues with her affairs with other women, but was not tolerant of her affairs with men.

She had a passionate but short-lived affair with the mural painter Ignacio Aguirre during the summer and early fall of 1935, and then a longer and more sentimental attachment to the Japanese-American sculptor Isamu Noguchi. Noguchi arrived in Mexico thanks to a fellowship he received for an arts project. He submitted a proposal to Diego for a 1.8-metre-high and 22-metre-long relief mural in the Abelardo L. Rodríguez market entitled *History as*

Seen from Mexico in 1936; Diego approved it. While working on the mural Noguchi met Frida and they became involved. Diego found out about their affair, went into a rage, and brandished his pistol at the sculptor.[9] Frida ended the affair, but they remained friends. Noguchi later gave her a butterfly collection that she attached to the canopy of her bed.

In 1936, Frida produced only one painting, *My Grandparents, My Parents and I*. That year, the Spanish Civil War broke out and Frida renewed her political involvement. With other sympathizers, she founded a solidarity committee to aid the Republicans in their struggle against Franco's Nationalist forces. Their political activities helped to bring Frida and Diego close again.

The couple continued to add to their collection of folk art. Diego was especially fond of pre-Hispanic art. He had started a collection many years prior. In fact, his spending on his 'idols' had caused conflict with his previous wife, Lupe. The Kahlo house in Coyoacán already housed many pieces, but with the two houses in San Ángel to decorate, Frida and Diego began collecting in earnest. Her predilection was for ex-voto paintings, but they both liked popular art of all types. They enjoyed being surrounded by these objects and liked supporting the artists who created them.

While supervising the murals in the Abelardo L. Rodríguez market, Diego came across a woman selling large papier-mâché figures. Her name was Carmen Caballero Sevilla, but she was known to all as Doña Carmen. She made 'Judas' figures that are used in traditional Mexican Holy Week celebrations. They are wrapped with garlands of firecrackers and then exploded. The figures are made to look like a devil or sometimes a current politician, serving as a political criticism. Doña Carmen also made giant skeletons, called *calaveras*, for Day of the Dead celebrations. Diego was impressed with how each of her creations was unique. He placed custom orders with her for several pieces to decorate his studio. Doña Carmen preferred selling to Frida however, because she said that Frida paid a bit more (her friends commented that

BELOW Isamu Noguchi in New York, 1940

RIGHT Diego and Frida with a Judas figure

FAR RIGHT Frida holding a sculpture by Mardonio Magaña, photographed by Guillermo Dávila, 1930

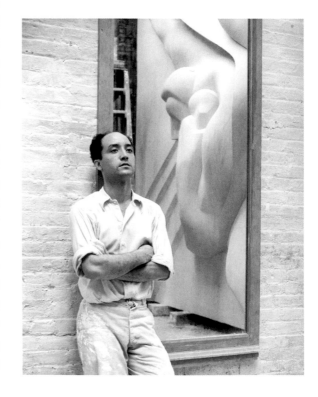

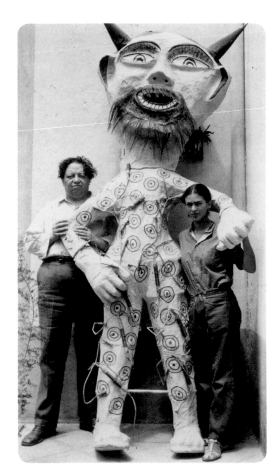
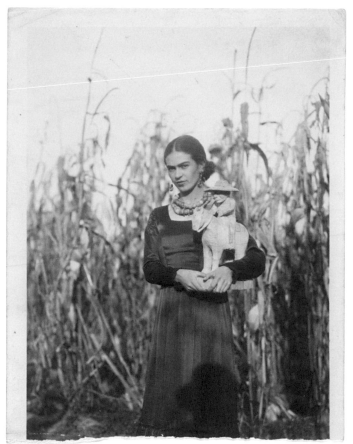

she never bargained with vendors), and when Doña Carmen had an altercation and her teeth were knocked out, Frida bought her some new gold teeth.[10]

Another folk artist that Frida and Diego supported was the sculptor Mardonio Magaña. Known affectionately as 'Magañito', he was in his fifties and working as a porter at the open-air art school in Coyoacán when the couple first encountered his work. The self-taught sculptor worked in wood and stone, depicting the everyday working life of Mexican peasants and farmers. He had enjoyed carving as a hobby since he was a small boy. Diego proclaimed him to be the 'best contemporary sculptor in Mexico', bought many of his pieces, and helped organize a show for him at the Fine Arts Palace. Magaña went on to become a teacher at the art school.

In September 1936, Diego joined the Mexican section of the Trotskyite International Communist League. A few months later, he appealed to President Cárdenas to give Leon Trotsky asylum in Mexico. The leader of the Russian Revolution had been in exile since 1929. He had lived in Turkey, France and Norway, but his options were running out. Cárdenas agreed to accept him in Mexico, and in January 1937, Trotsky and his wife arrived on an oil tanker at the Tampico harbour. To his distress, Diego was ill and hospitalized at the time of their arrival, but Frida was there to greet them.

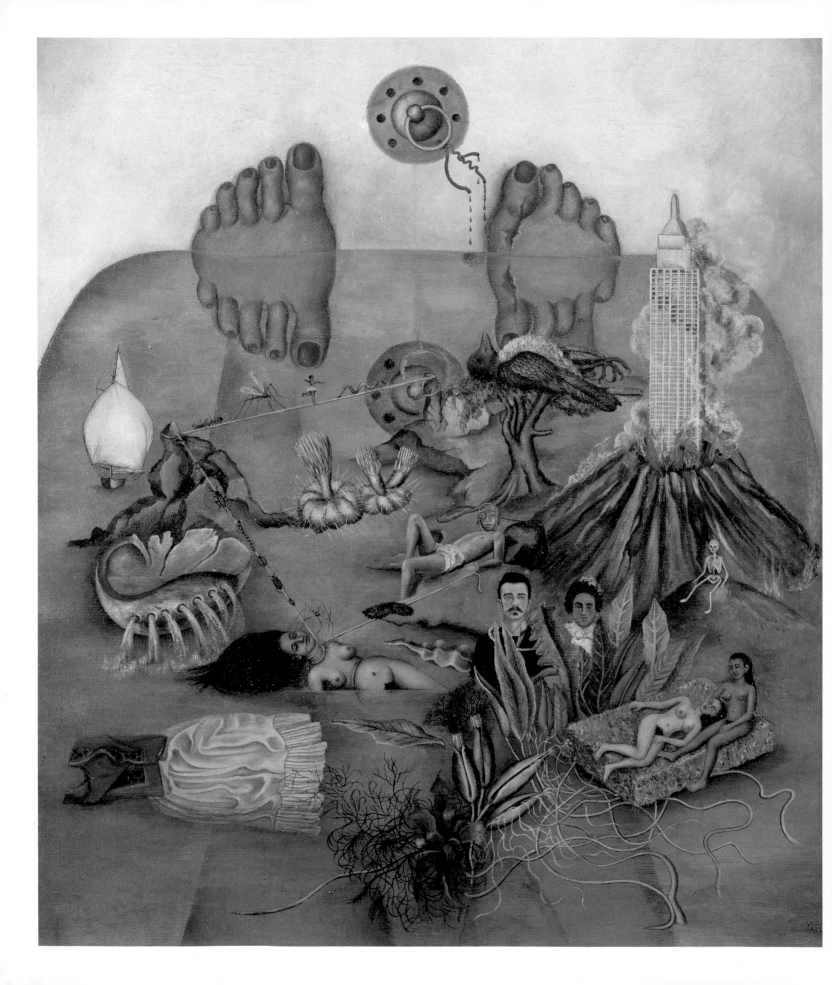

CLAIMED BY THE SURREALISTS

Frida offered Trotsky and his wife, fellow revolutionary Natalia Sedova, hospitality in her family home in Coyoacán. The house was unoccupied. Guillermo had gone to stay with Adriana, and Cristina and her children were living in a house on Aguayo Street a few blocks away. Trotsky and Sedova were relieved to find themselves in beautiful surroundings. The airy rooms filled with art and handicrafts and the spacious, sunlit patio with abundant plants made a welcome change from their previous circumstances in Norway where, for the final months of their stay, they had been kept under house arrest. They were soon joined by a substantial entourage made up of secretaries, translators and bodyguards who were eager to support the Russian revolutionary and his cause.

Trotsky and his wife feared attacks from Stalinists, so their safety was a major concern. Before their guests' arrival, Frida and Diego took steps to fortify the house. They hired builders to remove the exterior cast iron balconets and replace them with full-length protective grilles over the windows, and build a sentry gate and watchtower by the entrance.[1] They also made stylistic changes to the house, plastering over the exterior facade to remove the original decoration, leaving the fretting on the upper level, which extended along the tops of the windows. The house was painted its distinctive shade of blue and began to be referred to as *la Casa Azul* (the Blue House). When Trotsky expressed concern that the neighbouring wall could be used to stage an attack, Diego magnanimously purchased the adjoining lot, doubling the size of the property and creating space for a large garden.

Stalin's purges of his enemies had led to the deaths of many of Trotsky's allies in the Soviet Union. In the Moscow Trials, Stalin accused Trotsky of conspiracy and espionage; he was found guilty in absentia and sentenced to death. Many of Stalin's supporters were eager to carry out the sentence. The American Committee for the Defense of Leon Trotsky organized a commission to make an inquiry into the proceedings of the Moscow Trials and take Trotsky's testimony. Referred to as the Dewey Commission because it was headed by noted philosopher and educator John Dewey, the sessions were held from April 10 to 17, 1937. The intended venue was a large hall in Mexico City, but due to security concerns and cost, they opted to meet at the Blue House instead.[2] Around fifty people attended each day to hear Trotsky's testimony. Security was tight: armed guards patrolled outside the

house and six-foot barricades of sandbags and bricks protected the attendees, who were searched before entering the premises. Trotsky was questioned at length and held forth in faltering English. Several months later, the Commission concluded that the Moscow Trials had been a frame-up and published their findings in the book *Not Guilty*. However, the commission's findings held no sway with the Communist Party and Stalinists, and Trotsky continued to face attempts on his life.

Frida and Diego were living in San Ángel, but visited their guests in Coyoacán frequently. Diego and Trotsky conversed in French, but with Frida, Trotsky spoke in English, a language that neither of their spouses spoke well. Before long, their mutual admiration turned to intimacy: Frida and Trotsky began an affair. They passed each other notes in books, arranging secret meetings at Cristina's home. The affair lasted a few months, coming to an end in July 1937.[3] Diego seems to have been oblivious to their involvement, but Sedova was aware, and her remonstrations, as well as fear that Diego would find out and cause a scandal, led them to end their liaison. In any case, it seems that Frida had become bored with '*el Viejo*' (the old man), as she called Trotsky, and went on to have a fling with his secretary, young and handsome Jean van Heijenoort. Trotsky requested that Frida return his letters, which he destroyed.

Diego remained unaware of the goings-on between his wife and their guests, and relations between the two couples stayed on friendly terms, except for a certain coolness from Sedova. In November of that same year, Diego and Frida organized a fiesta for Trotsky's birthday, which coincided with the anniversary of the October Revolution in the Gregorian calendar. They arrived at the house in Coyoacán, their arms full of red carnations. Spreading the petals on a white tablecloth on a long table, they wrote a message with the flowers: '*ARRIBA LA CUARTA INTERNACIONAL*' (Up with the Fourth International) and '*VIVA TROTSKY*' in large letters. A cake with red icing and a hammer and sickle decoration was the centrepiece. Representatives from local labour unions attended the party and musicians entertained the crowd throughout the day.[4] For the occasion, Frida gave Trotsky a self-portrait which she dedicated to him. She depicted herself wearing a pink dress and a golden brown rebozo, and clutching a small bouquet of wildflowers. There was a note with the dedication: 'To Leon Trotsky with great affection, I dedicate this painting November 7, 1937. Frida Kahlo, in San Ángel, Mexico.' As in the self-portrait *Time Flies*, she presents herself between two drawn curtains, but instead of depicting herself as a simple Mexican

RIGHT The table at the house in Coyoacán laid out for a celebration of Leon Trotsky's birthday

FAR RIGHT Frida with Trotsky and his wife, Natalia Sedova, and Max Schachtman, leader of the American Communist Commitee, 1937

BELOW RIGHT Trotsky presents the publication *Behind the Moscow Trial* by Max Shachtman, in Coyoacán, 1937

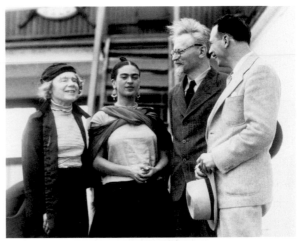

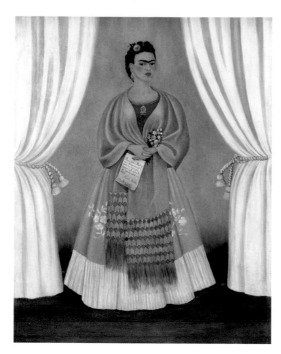 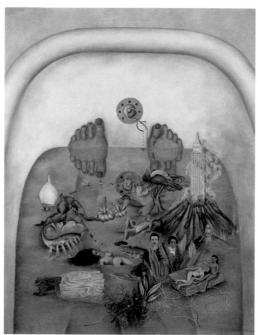

girl, her elegant attire indicates that she is a member of the bourgeoisie. Although her gift of this painting to her former lover appears on the surface to be a memento of their relationship, it may also contain a subtle political criticism that Trotsky's movement was increasingly becoming a concern of the privileged class.[5]

Frida was very productive in 1937 and 1938. Among the numerous paintings from this period is *My Nurse and I*, which she regarded as one of her finest works. It shows Frida with the body of an infant and the head of an adult in the arms of her indigenous wet nurse. Frida is wearing a European-style, white lace dress. The wet nurse is nude from the waist up and is wearing a pre-Hispanic stone mask. Milk ducts are visible on the woman's left breast and drops of milk fall toward Frida's mouth, but Frida's gaze, as always, is directed toward the viewer. In the background there are lush plants. Among them is one particularly large leaf which is white and has veins in a pattern that is similar to the milk ducts on the nurse's breast, a pattern that is repeated on Frida's lace dress. The sky is grey and there are white drops in the background, appearing to be milk falling as rain from the sky. This image draws on depictions of the Madonna and Child and the Nursing Madonna from Christian iconography, which Frida transposed to her life by adding symbols from indigenous Mexican culture. In Christian art, Mary's milk is a symbol of nourishment and salvation, and serves a similar role as the blood of Christ. In this image, the nurse's face is covered by a mask: instead of representing an individual, she stands for all of Mesoamerican culture nourishing Frida. With this image, she identifies herself as a milk sibling of all the indigenous people of Mexico.[6] The bottom of the painting features a blank scroll, as in *My Birth*. These paintings were part of a series chronicling her life. In the

ABOVE LEFT Frida Kahlo, *Self-portrait Dedicated to Leon Trotsky*, 1937, oil on canvas, 87 x 70 cm, National Museum of Women in the Arts, Washington DC.

ABOVE RIGHT Frida Kahlo, *What the Water Gave Me*, 1938, oil on canvas, 91 x 70.5 cm, private collection

RIGHT Frida Kahlo, *My Nurse and I*, 1937, oil on metal, 30.5 x 35 cm, Museo Dolores Olmedo Patiño, Mexico City

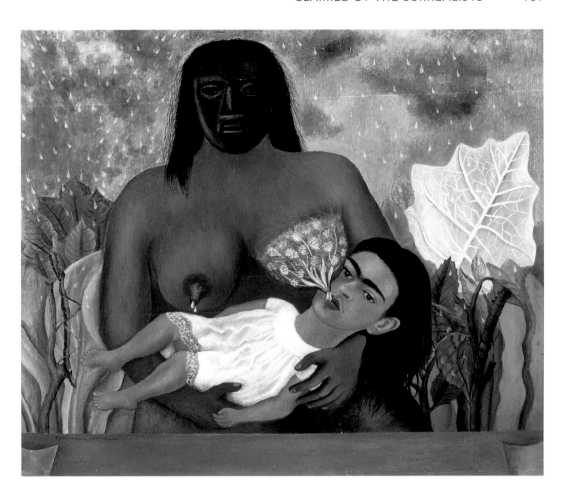

personal mythology that she constructed, the three paintings *My Birth*, *My Nurse and I*, and *My Grandparents, My Parents and I*, tell Frida's creation story.

Edward G. Robinson, an actor, art collector and leftist correspondent of Trotsky's from the United States, became one of Frida's first patrons. He and his wife Gladys went to Diego's studio to see his work and Diego took advantage of the occasion to show them some of Frida's work as well. Robinson bought four of her paintings for two hundred dollars each. Frida was pleased and excited at the idea that she could be financially independent from Diego. The sale marked a turning point in seeing her art as work and not just a hobby. It encouraged her to be more disciplined and paint regularly.

André Breton, the leader of the Surrealist movement, travelled to Mexico in 1938 with funding from the French government to give a lecture series about French art and literature. During his stay, he was eager to make Trotsky's acquaintance. He also met Frida and Diego, who invited him and his wife, artist Jacqueline Lamba, to stay with them in San Ángel. Upon seeing Frida's work, Breton was thoroughly impressed and proclaimed her a Surrealist painter. According to him, as an authentic Mexican artist, the Surrealist style came to her naturally without any prior awareness of the movement. In fact, Frida was

certainly familiar with Surrealism. She probably visited the Surrealist Group Show at the Julien Levy Gallery during her stay in New York in January 1932, and the Surrealist drawing game 'Exquisite Corpse' was one of her favourite pastimes since her stay in the United States.

In Breton's opinion, Frida's painting *What the Water Gave Me* was a perfect example of Surrealist art. She was inspired while bathing in her small bathroom in the San Ángel house. The painting shows the view of the bather, looking down at her feet, the tops of which emerge from the water with toenails painted bright red. An open sore between the toes of her right foot is the same colour as her polish. Her feet are reflected in the water and her legs are just barely visible. Blood drips from the overflow drain above her feet into the bathwater, and dream-like scenes take place in the water around her legs. A skyscraper emerges from a fiery volcano, a bird lies dead on a tree, a nude woman reclines half submerged in the water with a rope around her waist and neck. The rope extends on either side, and a masked man wearing a white loincloth holds one end as a procession of spiders, snakes, insects and a tiny ballerina make their way across it. Frida's Tehuana dress floats on the water, her parents peek out from behind some plants, and two nude women appear atop a bath sponge. One of the women is light-skinned and reclines with her head in the lap of the darker-skinned woman, who is seated. This last scene is the only peaceful one in the entire landscape. The two women may be representative of Frida's sexual relationships with other women, or might signify two parts of herself, in an acknowledgement of her mixed heritage. Whatever their connotation, they seem to present an alternative to the death and destruction taking place around them. Frida painted the same two women in the same pose the following year in the piece *Two Nudes in a Forest* (its original title was *The Earth Itself*). Frida gave this second painting to her friend, the actress Dolores del Rio.

In his 1924 manifesto, Breton defined Surrealism as 'Psychic automatism in its pure state, by which one proposes to express . . . the

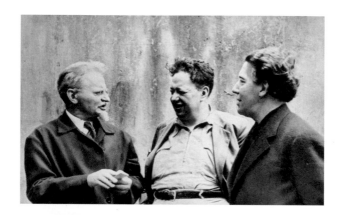

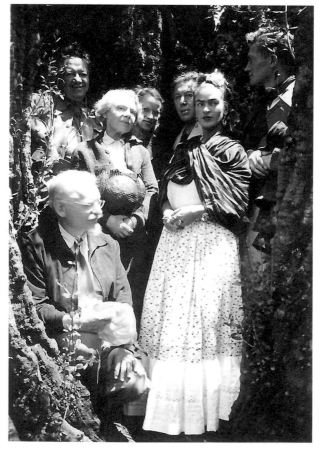

LEFT Leon Trotsky, Diego Rivera and André Breton, 1938

BELOW LEFT Trotsky, Rivera, Natalia Sedova, Reba Hansen, Breton, Frida and Jean van Heijenoort on a visit to Chapultepec Park, 1938

actual functioning of thought. Dictated by the thought, in the absence of any control exercised by reason, exempt from any aesthetic or moral concern.'[7] Frida, who had no patience for pedantry, described Surrealism in more concrete terms: 'Surrealism is the magical surprise of finding a lion in a wardrobe where one is sure of finding shirts.'[8] Considering the startling combinations of elements and traditions Frida drew on in her art, it is easy to see why Breton categorized her work as Surrealist. Although she never labelled herself as such, emphasizing that she painted her own reality, she enjoyed the recognition that the association with Surrealism brought her at this point in her career. She would later distance herself more firmly from the movement, perhaps becoming uncomfortable with its mainly male and European approach. She wrote: 'I do not consider myself a Surrealist . . . I detest Surrealism. To me it seems a manifestation of bourgeois art. A deviation from the true art that the people hope for from the artist . . . I wish to be worthy, with my paintings, of the people to whom I belong and to the ideas which strengthen me.'[9]

Breton, Trotsky, and their wives, along with Frida and Diego, travelled together around the Mexican countryside and to Cuernavaca, Guadalajara and Pátzcuaro. The men shared their ideas about art and politics. These discussions were held in French, so Frida could not take part, but it seems that she did not mind because she disliked Breton and his long-winded speeches. She preferred spending time with Breton's wife Jacqueline; they became intimate friends. As a result of their discussions, Breton, Trotsky and Diego produced 'Manifesto for an Independent Revolutionary Art', which was signed by Breton and Diego, though it was mainly written by Breton and Trotsky. Trotsky did not sign it, as he had promised to refrain from political engagement during his stay in Mexico. The manifesto expresses the compatibility of independent art and social revolution. Unlike the manifesto that Diego signed in 1923 along with the Syndicate of Technical Workers, Painters and Sculptors – which commended public art and derided easel painting as bourgeois – this manifesto called for complete freedom in art. This change came at a time when Frida's art, which was done on a small scale and explored a wide variety of themes, was gaining precedence, and she may have appreciated this as an affirmation that her art was valid to the revolutionary struggle.

Nickolas Muray made regular trips to Mexico during 1937 and 1938. He stayed with his friends Miguel and Rosa Covarrubias and renewed his relationship with Frida. She

may have also seen him on her visits to New York, but there are no records to confirm this. He was enjoying increasing success as a celebrity and commercial photographer: his work had been featured in *Harper's Bazaar*, *Vanity Fair* and *Ladies Home Journal*. On his trips to Mexico, Nick took many photos of Frida and their group of friends. In her letters to him, Frida signed her name Xóchitl, which is the word for flower in the Nahuatl language. She made a painting in 1938 that she titled *Xóchitl*; it may refer to their relationship. It is a depiction of a red trumpet flower, but instead of a realistic depiction according to a textbook drawing or a real life plant, Frida embellished it to look like human male and female genitalia engaged in intercourse. This was the first of many still lifes that Frida would imbue with a sexual subtext.

Julien Levy, the owner of a gallery in New York that specialized in works by Surrealist artists, invited Frida to do a show. She was concerned about leaving Diego. Although they both had numerous affairs, she managed the organizational details of his life and was concerned that her absence might make things difficult for him. She may have also worried that he would take advantage of her absence to become more intimate with other women. Diego encouraged her to avail herself of the opportunity that would certainly advance her career. He helped make a list of people to invite to the opening, and wrote letters to his art world contacts in New York to inform them of her show. To art critic Sam A. Lewisohn he wrote: 'I recommend her to you, not as a husband but as an enthusiastic admirer of her work, acid and tender, hard as steel and delicate and fine as a butterfly's wing, loveable as a beautiful smile, and profound and cruel as the bitterness of life.'[10] Nick Muray was in Mexico in September and he assisted Frida in her preparations; he helped select paintings, photograph them and prepare them for shipping.

Frida departed for New York in October. She may have had an affair with Levy; he took some photos of her in which she is nude to the waist, removing ribbons from her hair. But at the same time, her involvement with Nick was becoming deeper.

Her show at the Julien Levy Gallery on 57th Street ran from November 1 to 15, 1938. It contained twenty-five paintings. An essay by André Breton appeared in a handout, along with the list of the pieces. Breton declared that Frida's work was 'a ribbon around a bomb'. To Frida's dismay, the essay was published in the original French; she feared that would seem pretentious. Everything else about the exhibition went well. Members of the New York

Frida Kahlo, *Xóchitl, Flower of Life*, 1938, oil on metal, 18 x 9.5 cm, private collection

elite and artists attended the opening, including her friends Isamu Noguchi and Georgia O'Keeffe. About half of the paintings sold. She received commissions for others, including one from Clare Booth Luce, who asked Frida to paint a tribute to her friend Dorothy Hale who had committed suicide.

Following her success in New York, Breton offered to arrange a show for Frida in Paris. Again she hesitated, worried about spending more time away from Diego. In his letters, Diego urged her to go, telling her that under no circumstances should she miss out on the opportunity because of concern for him. He advised her to enjoy all of life's gifts and to not turn away from interesting and pleasurable experiences.[11] Frida travelled from New York to Paris in January 1939. Upon her arrival, she was disappointed to learn that her paintings were still in customs and that Breton had not made the arrangements for the exhibition. She initially stayed at the Bretons' home on Rue Fontaine. She was happy to be reunited with Jacqueline, but was repulsed by the family's living conditions. Their home was small, cramped and unclean. She was expected to share a room with the couple's three-year-old daughter, and she was not pleased with the arrangement. She wasn't even able to bathe, she told Diego in a letter, because they had run out of coal and the coalman hadn't come. She lasted three days with the Bretons, and then left for the Hotel Regina, near the Louvre.[12] She soon became ill and was admitted to the American Hospital in Paris, where she stayed for a week, receiving treatment for a bacterial stomach infection that led to an inflamed

LEFT Frida arriving in New York

RIGHT Frida and Nick Muray

BELOW RIGHT Frida in her magenta rebozo, photographed by Nick Muray, c. 1938

kidney. Upon release from the hospital, Mary Reynolds, the girlfriend of artist Marcel Duchamp, took her in at her home at 14 rue Hallé. Frida found Duchamp and Reynolds to be a delightful couple and was very pleased with their hospitality. 'Mary Reynolds, a wonderful American woman who lives with Marcel Duchamp, invited me to stay at her home and I accepted delighted because she really is a lovely person and has nothing to do with the stinking Breton's "artists" group. She is very nice to me and cares for me wonderfully,' she wrote to Nick.[13]

In February, the exhibition arrangements were still up in the air. Once she had retrieved her paintings from customs, Frida took them to the Pierre Colle Gallery where the show was to be held, but they found many of her pieces to be too disturbing. In particular, they deemed *My Birth* and *A Few Small Nips* to be too gruesome for them to exhibit. Marcel Duchamp helped her out and came through with the arrangements for the exhibition at a different gallery. It finally opened on March 10 at the Renou et Colle Gallery. Although Frida's work was the main attraction, they titled the show 'Mexique', and included Mexican folk art, ex-votos, photographs by Manuel Álvarez Bravo and pre-Hispanic art along with seventeen of Frida's paintings. The opening was well attended and overall the exhibit was well received, though it did not lead to many sales. Frida reported to Diego that the opening was a success, with even more people than the New York show, with prominent artists in attendance. Miró and Kandinsky congratulated her heartily. Picasso did not attend the opening because of a rift with Breton, but he was also impressed with her work and gave her a pair of earrings shaped like hands, which she treasured and included in at least two self-portraits.

One significant purchase came from the exhibition: the French government acquired Frida's self-portrait *The Frame*, a creative piece executed in mixed medium. Frida painted her image and the blue background on a sheet of aluminum, and a piece of glass laid on top bears a border of flowers and birds in the style of Mexican folk art.

This was the first work by a 20th-century Mexican artist in France's public art collection. It was originally displayed in the Musée Jeu de Paume and later in the Centre Pompidou. Frida also received a positive review in *La Flèche* by L.P. Foucaud, who said that her work was a 'door opened on the infinite and on the continuity of art'.[14]

During her stay in Paris, Frida spent time with Jacqueline. They visited the Louvre and the flea market, where she bought some used dolls. She also visited a commission to aid refugees from the Spanish Civil War. She was upset to see the refugees' deplorable living conditions, and organized funding for four hundred of them to travel to Mexico.

Frida was in Paris for two and a half months. She had originally planned to travel to England to do a spring show at Guggenheim Jeune, Peggy Guggenheim's gallery in London, but with the difficulties she had in Paris and war looming, she decided not to go through with the plan. Instead, she returned to New York to be with Nick. From Paris she had written: 'I want to go back to you. I miss every movement of your being, your voice, your eyes, your hands, your beautiful mouth, your laugh so clear and honest. YOU. I love you my Nick. I am so happy to think I love you – to think you wait for me – you love me.'[15] Despite her declarations, Nick sensed that Diego was always foremost in her heart, and continued to see other women, just as she had flings with other men. On her return to New York, she discovered that he had a serious relationship with another woman. She hastily departed for Mexico at the end of March.

During Frida's absence, Diego and Trotsky had a falling out. The motivations seem to be political, but the characters of the two men were so different that those who knew them felt it was inevitable. Trotsky was intellectual, precise and methodical; Diego was gregarious, prone to exaggeration and politically inconsistent. Trotsky recognized that Diego had passion, courage and imagination, but these were not the qualities that he most admired. Trotsky disliked Diego's involvements with the local labour groups and tried to convince him to focus on his art and the movement on an international level. Diego was offended and without Frida there to tone down his blustering, the situation deteriorated. Trotsky offered to pay rent because he no longer felt comfortable accepting Diego's hospitality. Diego refused to accept it, saying that it was Frida's house and he would have to work it out with her. Trotsky appealed to Frida in a letter, but she was busy with her own concerns and did not respond. At the beginning of May, Trotsky and his wife moved out of the Blue House to another home just a few blocks away.

Frida Kahlo, *The Frame*, 1937, oil on metal, fixed wooden frame, 28.5 x 20.5 cm, Centre Pompidou (MNAM), Paris

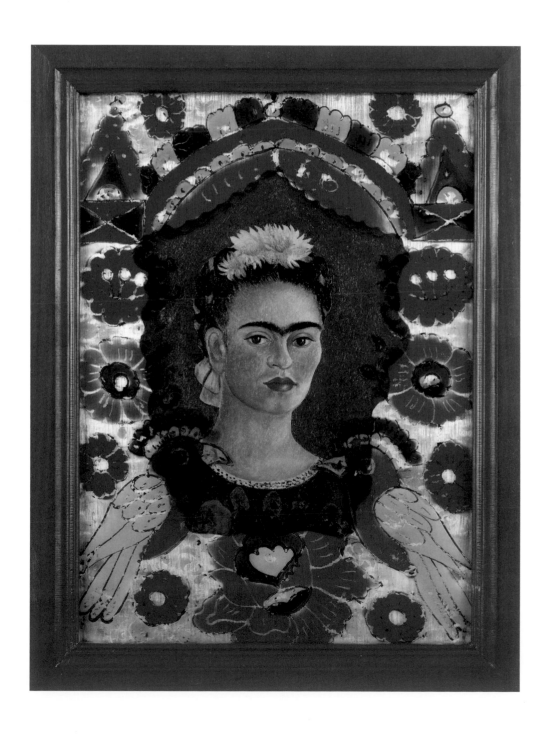

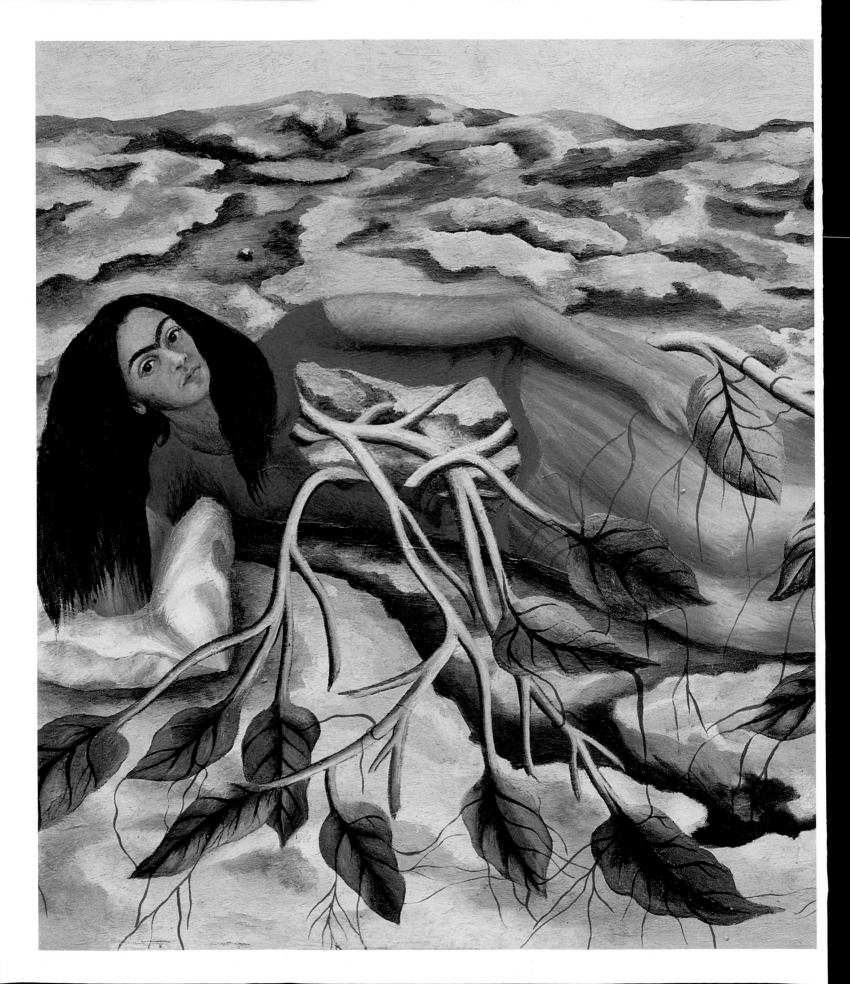

RETURN TO THE BLUE HOUSE

Frida Kahlo, detail from *Roots*, 1943

On Frida's return to Mexico, her relationship with Diego quickly deteriorated. She moved out of their San Ángel home and returned to live in the Blue House in Coyoacán. Shortly after, Diego said he wanted a divorce. They were both vague about the reasons. Diego told the press that it was a matter of legal convenience and that their relationship was as good as ever. Frida reported that they had not been getting along well and that the divorce was for personal, intimate reasons. Their relationships with other people may have been a cause, although their ten-year marriage had survived numerous infidelities on both sides. At the time, Diego was rumoured to be involved with both his assistant Irene Bohus and the actress Paulette Goddard, who was staying at San Ángel Inn, across the street from his studio. He may have learned of Frida's affairs with Trotsky and Muray, and could have been lashing out in response. He was happy for her success and told the press: 'I count her among the five or six most prominent modernist painters,'[1] but he no longer wished to be married to her.

Frida was crushed, but determined that she would not depend on Diego financially. She continued to paint consistently. This was her most prolific period; Diego later commented that their divorce had been good for her art. He said that during the time they were apart, 'Frida turned out some of her best work, sublimating her anguish in her painting.'[2] She also sought out buyers more actively and, at the suggestion of their friend Carlos Chavez, applied for a Guggenheim fellowship. She persisted in exploring difficult themes in her work and never changed her subject matter or style to make her paintings more commercial. She did, however, create two pieces on a much larger scale than her other work: *The Wounded Table*, which is over one metre in height and nearly two and a half metres long; and *The Two Fridas*, which is 1.73 metres square. Both of these paintings were included in the International Exhibition of Surrealism in January 1940 at the Gallery of Mexican Art in Mexico City. The show also contained work by Diego and many of their contemporaries. In a letter to Nick, Frida commented that 'everyone in Mexico has become a Surrealist because we are all going to take part in it'.[3]

In *The Two Fridas*, she depicted herself twice. The two Fridas sit on a bench, holding hands under a dark and stormy sky. Their clothing points to her dual heritage. The Frida on the right wears the traditional clothing from Tehuantepec, while the Frida on the left wears a white high-necked Victorian blouse, the kind favoured before the revolution. In her left hand, the Tehuana Frida holds a medallion with a small photo of Diego as a child. A vein emerges from the medallion, winds around her arm, and leads to her heart, which is exposed on her chest. Another vein connects her heart to the other Frida's heart, also exposed, but bisected as well, showing the ventricles. From this heart, another vein leads down her opposite arm to a surgical clamp in her right hand. It slows but does not stop the flow of blood that is dripping onto her dress and adding to a pattern of flowers on the hem of her skirt.

Frida's explanations of the painting varied. To art historian MacKinley Helm, who was visiting with Frida when she received the divorce decree, she explained that the two Fridas were the one that Diego loved and the one he did not. In a letter to the editor of a magazine who wished to publish a photo of the piece, she wrote that it was 'a representation of solitude. That is, recurring to myself, seeking my own aid. For this reason, the two figures are holding hands.'[4] The painting speaks of Frida's personal pain and feelings of being divided within herself, but it can also be seen as an allegory for Mexico, a country made up of both indigenous and European components. The exposed heart is a common symbol in Catholic religious art, as in depictions of the Sacred Heart of Jesus or the Immaculate Heart, but also appears frequently in pre-Hispanic art, where it represents the life force. In Frida's conception, the two different parts both of herself and of the country are interdependent, but indigenous culture, represented by the Tehuana, gives strength to its European counterpart.[5]

Frida learned that Nick was getting married, which added to her despair and loneliness. She wrote asking him to return her letters, and suggested that he move the photo of her that was displayed prominently in his home to a less visible location. She promised to stop writing and leave him alone, but Nick was still full of affection for her and said: 'Caring for you will never end. It can't! I just as well get rid of my right arm – or my brain . . . I also know I've hurt you. I will try to heal this hurt with a friendship that I hope will be as important to you as yours is to me.'[6] He proceeded to do exactly that and remained a friend to Frida, writing to her, sending her money, visiting her and photographing her again on several occasions.

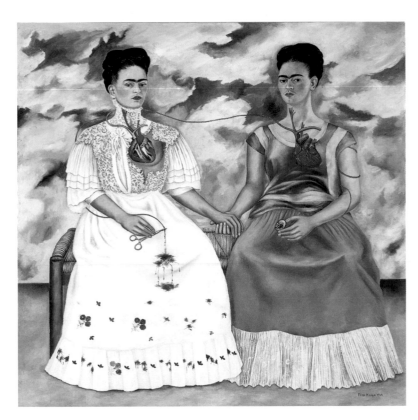

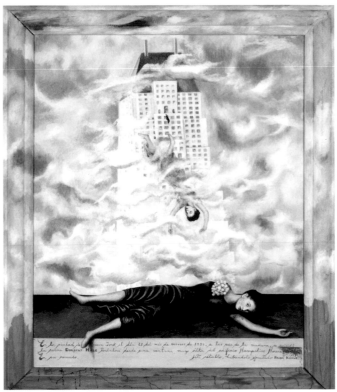

ABOVE LEFT Frida Kahlo, *The Two Fridas*, 1939, oil on canvas, 173.5 x 173 cm, Museo de Arte Moderno, Mexico City

ABOVE RIGHT Frida Kahlo, *The Suicide of Dorothy Hale*, 1938–9, oil on board with painted frame, 50 x 40.6 cm, Phoenix Art Museum

FOLLOWING PAGES Mexico City, 1944

Frida completed *The Suicide of Dorothy Hale* for Clare Boothe Luce, which she had begun in New York. Luce had expected a fairly standard portrait and was completely shocked at what Frida produced instead: a graphic representation of her friend falling to her death from a New York skyscraper. Frida met both Hale and Luce on previous trips to New York. Hale, a widow in her thirties, had worked as a showgirl and actress, but was down on her luck and having problems making ends meet. She hosted an event the night before her death, ostensibly a going-away party for herself. The next morning, donning her favourite black formal gown and a corsage of yellow roses given to her by Isamu Noguchi, another mutual friend, she threw herself from the window of her 16th-floor apartment. Luce suggested that Frida paint Hale's portrait so that she could give it to her friend's grieving mother.

Frida portrayed Hale in three different sizes and positions, adding movement to the composition and making her appear gradually closer to the viewer. She is upright and tiny near the top of the building, then larger as she falls head-first through dense clouds, and finally, dead on the ground with blood dripping over her still-beautiful face. A trompe l'oeil effect makes her foot seem to hang off the edge of the pavement, casting a shadow on the banner at the painting's base that reads: 'In New York City on the 21st of October 1938, at 6:00 in the morning, Dorothy Hale committed suicide by throwing herself from a very high window in the Hampshire House. In her memory [. . .], this retablo was executed by

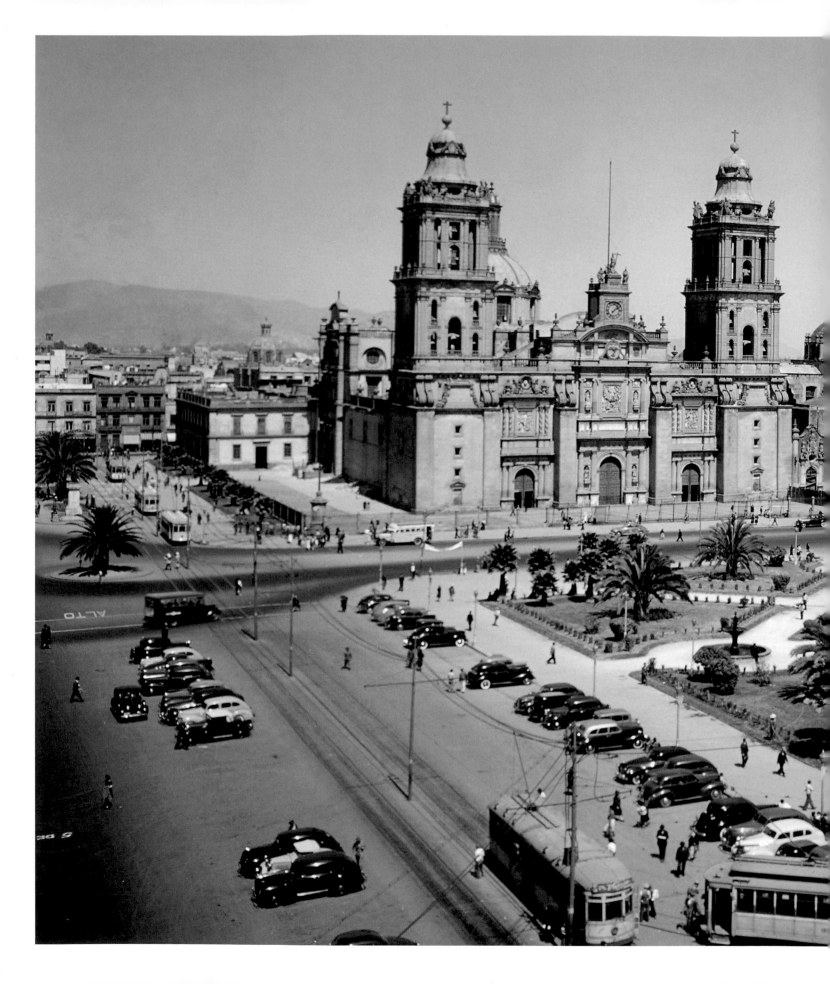

Frida Kahlo.' The empty space in the dedication mentioned that Luce had commissioned the piece. In this painting, Frida confronts the taboo subjects of death and suicide in her usual no-holds-barred manner. By showing the beautiful young woman dead and bleeding on a New York City street, she subverts usual images of beauty and incriminates the values of western society, which appreciated Hale only for her feminine beauty but left her without the means to support herself.[7] Upon receiving the portrait, Luce considered destroying it, but a friend convinced her not to. She had her own name removed from the dedication and gave it to a friend who left the painting in storage, where it remained until thirty years later.

Following their divorce, Frida and Diego renewed their close contact and communication. She handled his correspondence and financial affairs. In February, she wrote to a friend: 'I see Diego very often but he doesn't want to live in the same house with me anymore because he likes to be alone and says I always want to have his papers and other things in order and he likes them in disorder.'[8]

Trotsky, living about five blocks away from Frida, was facing increasingly serious attempts on his life. In May 1940, a group of twenty armed assailants entered his home. Trotsky and his wife ducked for cover and were unharmed. Their grandson, who had come to live with them after his father's death, was grazed by a bullet. Diego's break with Trotsky was public knowledge and he fell under suspicion in the attack. Police surrounded his home in San Ángel. Paulette Goddard spotted them from her hotel across the street and called Diego to tip him off, and his assistant Irene Bohus hid him in the back seat of her car under canvases, giving the police the slip. The two women collaborated and kept him in hiding for a few days until he could get a visa to go to the United States. Conveniently, Timothy Pflueger, the architect with whom he had worked on the San Francisco stock exchange building, commissioned him to paint another mural in San Francisco for the Golden Gate International Exhibition. By appealing to friends in the government, Diego was able to get a visa within a few days and travel to the United States accompanied by Goddard and Bohus. For about ten days, Frida had no idea where Diego was or what was happening. She was worried and felt hurt that Diego had sought the assistance of other women, leaving her in the dark. 'Now that I would have given my life to help you, it turns out other women are the real "saviours".'[9]

Three months later, Ramon Mercader, a Spanish communist posing as a Canadian by the name of Frank Jacson, managed to infiltrate Trotsky's inner circle. On August 20, 1940, he entered the Russian revolutionary's office and sunk a mountaineering ice axe into

Trotsky's skull. Trotsky died the following day. Frida had met the killer in Paris and he had been a guest at a dinner party in her home. Both Frida and Diego came under suspicion. The police searched the house in San Ángel and held Frida and her sister Cristina for questioning for two days. They were extremely rattled by the experience and worried about Cristina's children who were left unattended. They were released and no charges were brought against them.

While Diego was away, he rented out his San Ángel house to a couple of women from the United States. He asked Frida to have his pre-Hispanic idols packed up and put in storage. She insisted on taking on the task herself. She felt that no one else would do it properly, although Cristina urged her to hire someone to do the job or at least let her help. Frida was adamant, but by the time the huge collection was packed into 57 crates, the exertion and her low spirits brought on new health problems. Her doctor recommended she go to the countryside to rest. She followed the advice and stayed in Cuernavaca with Cristina for a month, but she later wrote to Diego: 'I've followed all the doctor's instructions and I still feel as badly as before I went to see him.'[10]

Along with her health troubles, she was despondent over Diego. She wrote to him: 'Since you've been gone everything has lost its colour. Everything, life itself, from the leaf of a tree to a mountain, every moment, all the colours, all the shapes, every single thing is linked to you.'[11] Her successes in New York and Paris felt far behind her. She did not receive the Guggenheim fellowship she had applied for. She discovered that Diego had bought one of her paintings, pretending it was for someone else. It seemed like Diego was the only one who truly appreciated her work. Even Nick, who always supported and encouraged her, sent her money and asked her to send him a painting, but 'he tells me in his latest letter that I shouldn't paint such gloomy and personal things like pelvises, hearts, etc. What the hell does he want me to paint? Angels and seraphim playing the violin?'[12] She was aware that many people found the content of her paintings disturbing, and with the eruption of the Second World War, people preferred to see soothing images in art, but she felt compelled to remain true to her artistic vision.

Frida's health deteriorated further. She was drinking excessively to combat her pain and despair. She consulted many doctors, and all advised her that an operation on her back would be necessary. Dr Farill recommended complete bed rest and spinal traction. Nick travelled to Mexico and photographed her in the hospital. Unlike most of her photos,

which show her with an impassive gaze, in these, her eyes are full of pain. Diego learned of Frida's health issues and consulted with Dr Eloesser, who encouraged Frida to come to San Francisco so he could evaluate her health.

Frida travelled to San Francisco in September. Dr Eloesser disagreed with her Mexican doctors' diagnosis and treatment plan. He said that she was suffering from a severe kidney infection as well as anemia, exhaustion and alcoholism. He admitted her to St Luke's hospital, put her on complete bed rest, ordered her to stop drinking, and made sure she ate a healthy diet. He also engineered a reunion between her and Diego. Diego decided that he wanted her back and made efforts to woo her. The doctor encouraged her to remarry. At the same time he emphasized that Diego would never be monogamous and that, if she decided to be with him, she had to accept that.

While Frida was still in hospital considering Diego's proposal, he came to visit her accompanied by Heinz Berggruen, a young German. Berggruen spoke French and had been assigned to look after Diego and translate for him during the World Art Fair. The young man was instantly charmed by Frida. Upon her release from the hospital, she travelled with him to New York for a month-long fling. While there, she met with Julien Levy to discuss another show and provided testimony for a lawsuit that Lupe Marín had brought against Diego's biographer Bertram Wolfe. When her affair with Berggruen had run its course, Frida decided to accept Diego's proposal, although she set two conditions for the remarriage: they would remain financially independent, with each of them contributing equally to household expenses, and they would not have sexual relations. Diego amicably agreed, although ultimately it seems that neither condition was met. Frida returned to San Francisco and she and Diego were married for the second time on his 54th birthday, December 8, 1940. Their union would continue to be marked by mutual affection, respect for each other's work, and rampant extramarital affairs.

Diego included Frida in his mural titled *Pan-American Unity*, painted for the Golden Gate International Exposition on Treasure Island. She appears in her Tehuana dress holding a painter's palette. He depicted himself with his back to her, holding hands with Paulette Goddard. In this mural, Diego again expresses his belief in an intersection of the ancient and modern represented by the different American cultures, affirming his vision that multicultural artistic expression will eventually form into a unified cultural entity. He presents a contrasting perspective from that of his wife – Frida remained a staunch nationalist.

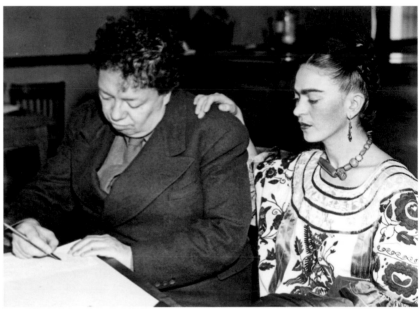

ABOVE LEFT Diego Rivera, detail from *Pan-American Unity: The Plastification of the Creative Power of the Northern Mechanism by Union with the Plastic Tradition of the South,* 1940, fresco on 10 connected panels, City College of San Francisco, California

ABOVE RIGHT Frida and Diego marry for the second time in December 1940

Frida spent two weeks in San Francisco with Diego and returned to Mexico in much better spirits. Diego stayed behind to finish the mural and to wait until the intrigue surrounding Trotsky's death cleared. Frida prepared the Blue House to receive Diego and his assistant, Emmy Lou Packard, who would come to stay with them for ten months. They had met Emmy Lou during the early days of their relationship when she visited Mexico with her family as a teen. They felt protective of the artist, who was a widow with a young son. Frida wrote to Emmy Lou asking her to look after Diego while they were in the United States, make sure he followed doctor's instructions, and ate well, and expressed her desire to have them both with her in Mexico.[13]

Frida drew a plan of her house that was most likely intended to give Emmy Lou an idea of where she would be staying.[14] The whimsical depiction shows the joy Frida took in her home, garden, and its inhabitants, and offers insight into how the house was arranged at that time. She labelled the rooms and furniture. The long room with windows on Londres street was Diego's studio: here Frida showed where his easel was located, the straw mats on the floor, and shelves containing his 'Aztec idols'. The smaller room on the corner of Londres

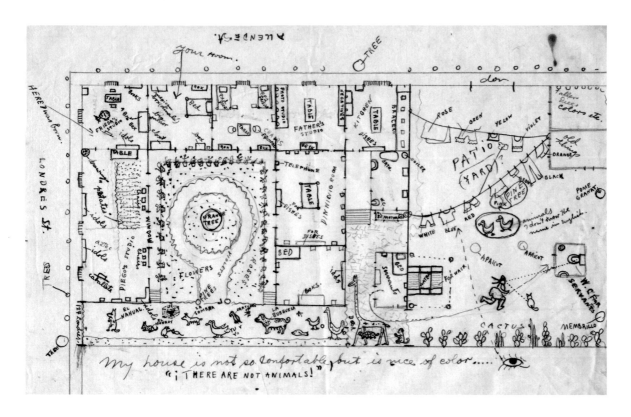

and Allende streets was Frida's studio; she wrote 'HERE I was born' with an arrow pointing to her studio. One of the bedrooms is labelled 'Your room', next to a room with twin beds labelled 'Frieda' and 'Diego'. The space that was occupied by a bathroom, hallway and pantry in the original plan of the house was now a studio for Frida's father. The dining room and kitchen remained in their original locations. She drew the plants and pets in the garden and even included a clothesline in the yard. The lot to the north that Diego had purchased during Trotsky's stay had two small structures probably used for storage; they are labelled 'old things' and 'colours etc.' The orange tree still had its place in the centre of the inner garden. She labelled the other plants: roses, violets, a pine tree, as well as various fruit trees including apricot, pomegranate and membrillo (quince). She drew a procession of animals along one side of the house featuring a monkey, a turtle, a fish and a giraffe along with several dogs, birds and a cat. Frida did not have a giraffe; perhaps it was meant to stand in for her pet fawn, Granizo, but all of the other animals she depicted were a part of the household. At the bottom of the plan, she wrote: 'My house is not so confortable [sic], but is nice of colour,' next to which she drew a picture of an eye with an arrow pointing toward an item on the clothesline that was marked 'blue'. She also wrote in block letters: 'THERE ARE NOT ANIMALS!' Since she had carefully drawn a complete menagerie in the diagram, this might have been either a tongue-in-cheek comment or a statement about her pets being a part of the family.

Diego and Emmy Lou arrived in Mexico in February. Frida had the house in perfect order for their arrival. 'The pine floors were washed and freshly stained with *polvo de congo* – a bright,

ABOVE Frida's sketch of the house in Coyoacán

RIGHT Frida and Diego, photographed by Emmy Lou Packard

BELOW RIGHT Frida and Emmy Lou in the garden at the Blue House

pale, yellow powder . . . used to stain the floors of modest homes. Diego was clearly elated, as he moved slowly through the rooms which he and Frida had made into their own museum of folk art, dark Colonial paintings, retablos . . . pre-Columbian sculptures, white sugar-skulls and towering paper-mache Judases . . .'[15] Diego maintained his studio in San Ángel and would go there to work, and carry on his romantic liaisons away from Frida's eyes. Frida wrote to Dr Eloesser a few months later: 'Remarriage is working well. Small amounts of arguing, greater mutual understanding, and on my part, fewer obnoxious-type investigations regarding other ladies who suddenly occupy a preponderate place in his heart.'[16]

Their life settled into a pleasant routine, sharing meals at the Blue House, and Diego going off to work at his studio in San Ángel. In the mornings, Frida would paint or go to the market and return to prepare for the afternoon meal, always taking care to make an attractive table setting of flowers, fruit and clay dishes. Meals were often livened up by one of her pets at the table, a chipmunk in a cage, or her pet parrot Bonito who would make his way around the table until he found the butter dish. Sometimes Frida's back hurt and she had to walk around the room during the meal. On one such occasion, as she was pacing the floor, she stopped to caress Diego's head, which he obviously enjoyed. Emmy Lou asked them to stay still while she took their photo, capturing their affectionate display.

Diego decided to expand the Blue House garden further and purchased the plot of land to the east of the house. He supervised as workers tore down the wall between the properties and built a stepped pyramid with a thatched roof on which he displayed some of his collection of pre-Hispanic art. They later added a small building that was conceived as a temple to Tlaloc, the Aztec rain god, with pre-Hispanic figures encrusted in it. A fountain with ancient stone sculptures and a stone bench beside it provided a pleasant place for contemplation. They gradually transformed their garden into a tranquil green space ideal for enjoying nature. It held deep meaning for them both.

LEFT Frida and Diego in the garden at Coyoacán, in front of the stepped pyramid housing some of his collection of pre-Hispanic art

BELOW Frida Kahlo, *Self-Portrait with Thorn Necklace and Hummingbird*, 1940, oil on canvas, 63.5 x 49.5 cm, Muray Collection, Harry Ransom Research Centre, University of Texas at Austin

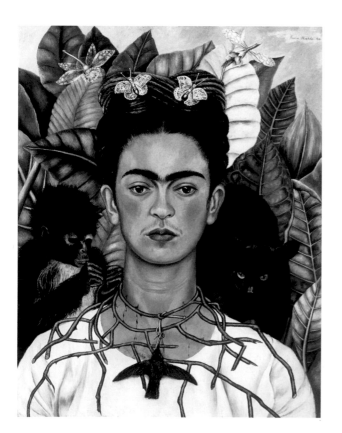

Frida had promised a painting to Nick, but sold it to someone else because she needed the money. She painted another to replace it, and it turned out to be one of her best realized self-portraits: *Self-Portrait with Thorn Necklace and Hummingbird*. In this painting, Frida is accompanied by a monkey on one shoulder and a black cat on the other. She stands before a background of exuberant foliage of large leaves. She wears a plain white blouse and has vines with thorns entwined around her neck and shoulders. The monkey tugs on the vine, causing the thorns to dig into her neck and draw blood. A dead hummingbird, whose wings echo the shape of Frida's eyebrows, hangs as a talisman from the vine around her neck. A purple ribbon arranged in a crown on her head has two silver filigree butterflies on it, and two flowers with silver wings flutter above her. In this self-portrait, as in many others, she includes symbols derived from both Christian religious iconography and ancient Mesoamerican cultures, which often have different meanings, defying facile interpretation. The white clothing and blood make her appear like a Christian martyr; the necklace of thorns may refer to Christ's crown of thorns, and the butterflies signify rebirth, another allusion to Christ. Thorns were used in bloodletting rituals performed in ancient Aztec religious practices, and butterflies were believed to represent the spirits of dead warriors. The hummingbird could represent the Aztec war god Huitzilopochtli, but in Mexican folk traditions, amulets made of dead hummingbirds are believed to restore a lost love. Her animal companions also represent contrasting attitudes: the monkey is playfully tugging at the vine around her neck, and the cat, like Frida, faces forward, but has an arched back, as if ready to pounce. These contrasting symbols intermingle around Frida's constant gaze.

Frida sold the apartment she owned on Insurgentes, where she had stayed during her separation from Diego in 1934. With the funds, she purchased a plot of land about five kilometres south of Coyoacán in the village of San Pablo Tepetlapa, on the volcanic fields of El Pedregal, an area she and Diego loved. The vast lava fields cover 70 square

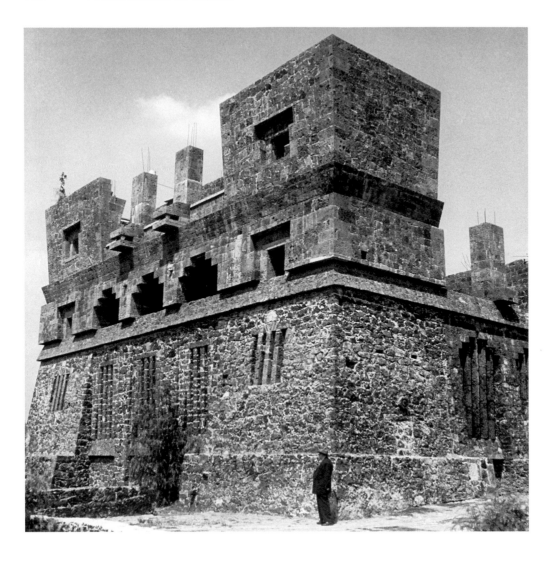

kilometres and date to the eruption of the Xitle volcano in the fourth century, which wiped out the ancient city of Cuicuilco. Cacti and other endemic plants grew in the crevices of the volcanic rock, but there were large barren areas as well. The uneven terrain and interesting rock formations appear in a few of Frida's paintings. She had always found the landscape intriguing: she loved going to walk there as a young girl,[17] but by the 1940s, it had also captured the imaginations of many of her contemporaries (most notably Dr Atl and Luis Barragán) as a quintessentially Mexican landscape that dated to ancient times. It had previously been unoccupied and was considered a new frontier that was full of possibilities.

When Mexico entered the Second World War in 1942, Frida and Diego decided they should be self-sufficient, so they started a little farm on their land in El Pedregal. They built a stable to keep their animals and planned to grow vegetables and produce milk and honey.[18] Diego's real dream, however, was to build a museum to display his huge collection of antiquities. He envisioned it in the style of an ancient temple, and he was also intent

ABOVE Diego Rivera at Anahuacalli, the museum to house his large collection of pre-Hispanic art, 1955

FOLLOWING PAGES The landscape of El Pedregal

that it blend harmoniously with the landscape. He set about designing the building, which was to be constructed of the local basalt, so that it looked like an extension of the natural terrain. Diego got in touch with Frank Lloyd Wright and discussed some of his ideas for the construction, and he also consulted Juan O'Gorman, who had abandoned the Modernist and Functionalist principles of his earlier work and now embraced an organic Mexican aesthetic, emphasizing harmony of form, colour and material with the natural surroundings.

Diego called the project '*Anahuacalli*', which means House of the Valley of Mexico. He envisioned it as a 'City of the Arts' that would integrate spaces for music, dance and theatre. The ground floor was to be a museum, and the second floor contained a large studio that, like his studio in San Ángel, had huge north-facing windows allowing for the best diffuse light throughout the day. The third floor terrace would offer panoramic views of the natural surroundings. A large plaza in front of the building could be used for gatherings and performances. The landscape was vital, as he also planned for this to be an ecological park, and he purchased more land surrounding the initial property. The building was constructed of reinforced concrete surfaced in stone excavated from the lava bed on which it was erected. Diego playfully called the style of architecture Aztec/Maya/Rivera: it was his modern adaptation of the ancient style of construction, but with large interior rooms that were not present in ancient Mexican architecture. He began the project in the 1940s and it would be one of his priorities for the rest of his life.

In 1943, Frida was offered a position as a teacher at the Education Ministry's School of Painting and Sculpture known as 'La Esmeralda'. Since she had never studied art formally, she felt awkward assuming the title of teacher. She told her students from the outset that she would be learning along with them. She took on the task with aplomb, excited about teaching young people to look at art and the world differently. On the first day, Frida asked her students what they would like to paint, and one responded that he would like to paint her. She said if that's what the group wanted, she would be happy to pose for them. Her students were charmed by her and enjoyed her unusual teaching style. She took them on outings to the countryside and they sketched and painted in many locales. Frida made any excursion an event and an adventure. They would go to the market to buy food, and then have a picnic in the countryside. They visited the ancient city of Teotihuacan and the National Museum of Anthropology, at that time located on Moneda Street in

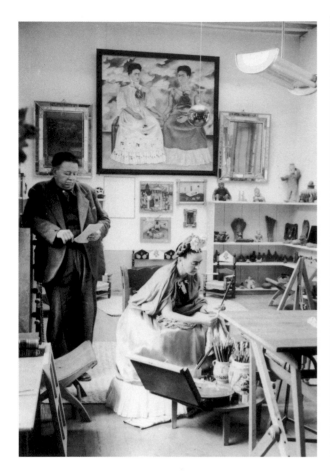

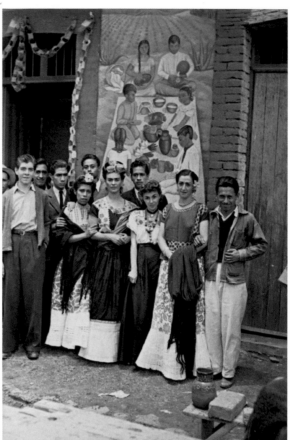

the historical centre of Mexico City, and they often went to El Pedregal, which Frida considered an inspiring landscape.

Unfortunately, her health began to fail again, and she soon found it difficult to go to the school to teach. Frida invited her students to come to the Blue House so she could instruct them there. One of the students, Guillermo Monroy, described entering the house for the first time: 'I received one of the most impressive experiences of my life. I had never entered such a beautiful house: the flowerpots, the corridor around the patio, the sculptures by Mardonio Magaña, the pyramid in the garden, exotic plants, cacti, orchids hanging from the trees, the small fountain with fish in it . . .'[19] Several students came at the beginning, but the group soon whittled down to four dedicated pupils: Arturo Garcia Bustos, Fanny Rabel, Guillermo Monroy, and Arturo Estrada. These four would study with Frida over several years, and became known as '*Los Fridos*'.

Frida enjoyed making her home and surroundings attractive and she tried to instill this appreciation for everyday aesthetics in her students. In one of her unusual lessons, she invited them to share a meal with her. She had the table set attractively as always, but before inviting them to sit down and eat, she asked them to look at the arrangement. She then moved the items on the table around and asked one of the students to rearrange them

ABOVE LEFT Diego and Frida read and work in the studio at Coyoacán, 1945

ABOVE RIGHT Frida and her students

RIGHT Frida Kahlo, *Roots*, 1943, oil on metal, 30.5 x 50 cm, private collection

in a pleasing manner.[20] She wasn't just interested in their artistic technique; she stimulated their artistic senses and helped them see the world in a different way. Besides learning about art, Frida's students 'were given a way of living, of being, and of thinking that was much different from the usual, such as concern for the national and social order, a vision of solidarity with the Mexican people, and in addition, a delicious sense of humour, coarse and refined at the same time.'[21]

In 1943, Frida painted *Roots*. It shows her stretched out on the volcanic rock at El Pedregal, wearing her Tehuana dress. A thick root with leafy branches emerges from a large hole in her chest and spreads out over her and the ground around her. What appear to be capillaries issue from the leaves and extend into the ground. This piece bears a striking similarity in theme to Frida's *Portrait of Luther Burbank*, but here Frida herself is the human/plant hybrid, giving life to the land around her. Frida disavowed religion, but held a strong belief in the interconnection of all living things. This image makes evident her desire to nourish the earth and become one with the land she loved, a place that represented Mexico's enduring character.

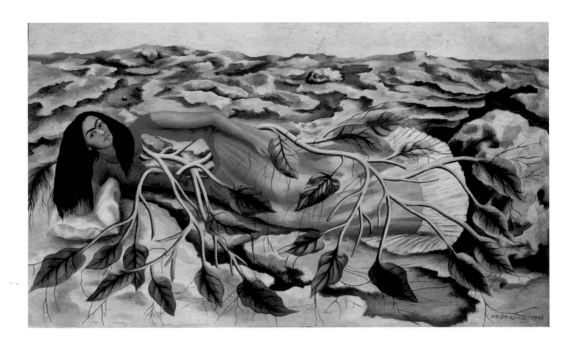

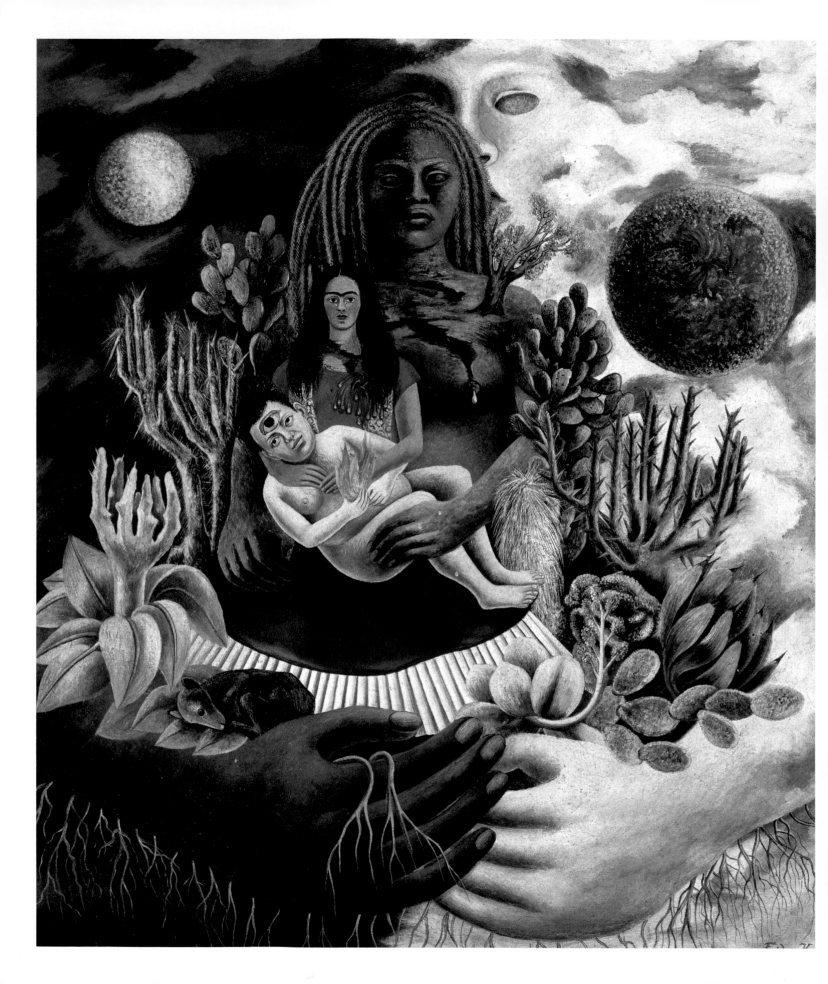

AT HOME IN THE BLUE HOUSE

Frida Kahlo, detail from *The Love Embrace of the Universe, 1949*

Frida made the Blue House her sanctuary, transforming her childhood home into a work of art. It brought her joy to spend time there, decorating and arranging, making it into a beautiful space full of colour and life. The plants and animals in the garden, the objects she and Diego collected, and their welcoming attitude toward visitors worked together to create the special, unique world of the Blue House.

Frida decorated with folk art and preferred traditional Mexican furniture, linens and dishes. She and Diego continued to add to their collections, filling their home with objects made by Mexican hands. Large Judas figures hung in the corners of the rooms, and a calavera skeleton rested on the canopy above her bed. Throughout the house, chairs and beds had cushions embroidered with sweet messages such as '*Despierta corazon dormido*' (Awake, sleeping heart). Fresh flowers cut from the garden were arranged in earthenware vases, bringing the colours and scents of the garden inside the house. They stored their belongings in Olinalá boxes and chests, decorative lacquer ware from the state of Guerrero. Paintings by artists they admired, as well as some of their own works, were displayed on the walls. The photograph Nick Muray took of Frida in her magenta rebozo hung in her bedroom. Frida owned hundreds of ex-votos, and she also collected toys and dolls. Whenever one of her friends went on a trip, she asked them to bring back a toy for her collection. Diego continued to amass pre-Hispanic artifacts, which filled any previously unoccupied space in the garden and house.

The kitchen was the busiest room. When she was well, Frida met with the household staff there to plan the meals and tasks for the day. The cheery room had bright yellow floors and white walls with blue wainscoting. A wooden table and chairs painted the same vivid yellow as the floor stood in the centre of the kitchen, and shelves the same colour held serving dishes. All the implements of a typical Mexican country kitchen were artfully displayed: a selection of metates (grinding stones); clay cooking pots and serving dishes of various shapes and sizes; and wooden spoons, spatulas and whisks – many of the smaller items

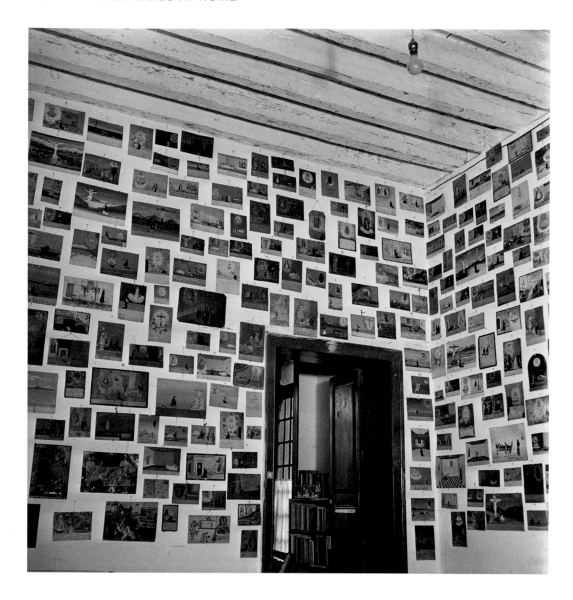

hanging from hooks on the wall. Although gas stoves were common at the time, in the Blue House kitchen, cooking happened over a wood fire. The traditional range was decorated with blue and yellow Talavera tiles, which continued up the wall in a decorative pattern.

The blue and yellow motif extended to the dining room. Frida owned a variety of intricately woven or embroidered tablecloths from different regions of Mexico to cover the large dining table that could accommodate numerous guests. Various folk art paintings from the 19th century hung on the dining room walls, as well as masks from around the country. Large ceramic vases stood in the corners. The yellow shelves here held folk art pieces, including two ceramic clocks from Puebla that are identical except for an inscription added by Frida. On one she wrote 'The hours were broken September 1939', and on the other 'December 11, 40 at eleven', commemorating her divorce and remarriage.

ABOVE The walls of the Blue House decorated with ex-voto paintings

ABOVE RIGHT Frida at home in Tehuana costume, 1940

RIGHT Ceramic clocks from Puebla commemorating Frida and Diego's divorce and remarriage

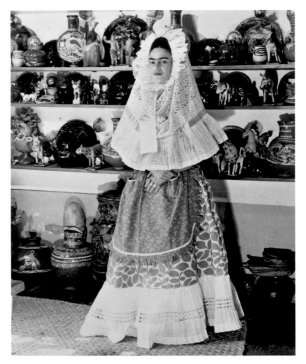

Outside, the large garden was a leafy haven with abundant greenery, a trickling fountain, and numerous inhabitants. Among them were the spider monkeys Fulang Chang and Caimito del Guayabal, Granizo the fawn, an eagle called Gertrudis Caca Blanca, the parrot Bonito, and several xoloitzcuintle dogs. Of the dogs, Frida's favourite was Señor Xolotl, who sometimes shared her bed and kept her feet warm. Frida was the queen of this realm and ruled over it with kindness and humour. She received visitors gracefully, including many photographers who came to capture the enchanting artist in her beautiful home. Lola Álvarez Bravo, Gisèle Freund, and of course, Nickolas Muray, among others, photographed her in the Blue House and its garden.

Cristina helped Frida run the household and her children also spent a lot of time there. Cristina's daughter Isolda had a particularly close relationship with her aunt. In her memoir, she recalls Frida's mischievous sense of humour. Frida was a good listener and gave sound advice, so the teenage Isolda often went to her when she had problems. She would have to make sure her uncle was nowhere in sight, though, because Frida was inclined to invite him to comment on the situation. With a captive audience, Diego could expound for hours on a variety of topics. While her husband talked, Frida would excuse herself and go to the next room, and make faces at her niece from the doorway behind Diego's back while Isolda struggled to keep a straight face and Diego droned on and on.[1]

Diego's daughter Guadalupe lived with Frida and Diego for two years. Although Frida expressed some resentment in a letter to friends Burt and Ella Wolfe, lightheartedly complaining that she and Diego had never lived alone since their marriage, she had a good relationship with her stepdaughter. Guadalupe, at the time a young law student, was astounded at the care Frida put into everyday tasks such as buying produce in the market or setting the table. Guadalupe had lived a rather sheltered life and by taking her to the Plaza Garibaldi to hear the mariachis, as well as to street fairs and community celebrations, Frida introduced her to a world that was previously unfamiliar to her.[2]

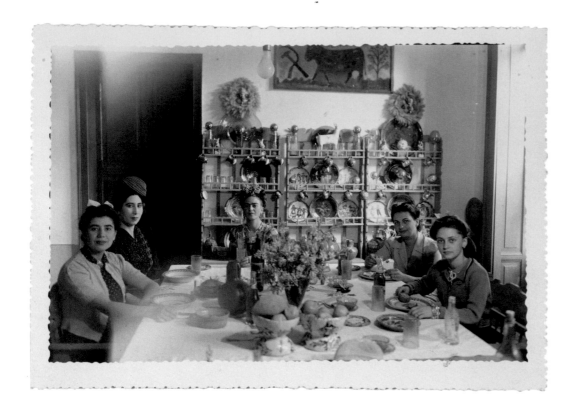

Many of the domestic workers at the Blue House had been with Frida's family since she was a child, and her relationship with them was warm and informal. She had an especially affectionate bond with Chucho, her 'milk brother'. Chucho was tall and strong: one visitor described him as a 'smiling giant'.[3] Frida called him Nano Chucho (a play on words, since he was the son of her 'Nana') and he called her Niña Frida. He looked after Frida her whole life and when she was infirm, he cared for her and carried her like a small child up the steps to her room.[4] Cruz, the cook, was affectionately called 'Crucita'. Their driver Sixto, known as 'El General', drove them wherever they needed to go in their old green station wagon. When he was otherwise occupied, Cristina took the wheel. Although Frida had tried to learn to drive years earlier, neither she nor Diego drove. Some of the workers' families lived on site, and their children would often play in the garden near the pyramid. All of the staff looked after Frida with care and attention, especially when she was unwell.

Unfortunately, those times became more and more frequent from the mid-1940s on. She had severe back pain and consulted several doctors. Each of them seemed to recommend a different course of treatment. She wore corsets and a variety of devices to help keep her spine straight and hold her decaying body together. In 1944, she painted *The Broken Column*, in which she depicted herself standing in El Pedregal. She maintains an impassive gaze, but her face is covered with tears. A white cloth is draped around her lower body; on her upper body she wears only an orthopedic brace. Her torso is split open, showing a crumbling Ionic column where her spine should be. Nails pierce her face and body. This

LEFT Guadalupe Marín Rivera, a friend, Frida, her sister Cristina and Cristina's daughter Isolda in the dining room at the Blue House, c. 1942

RIGHT Frida with her dogs in the garden at the Blue House, photographed by Gisèle Freund

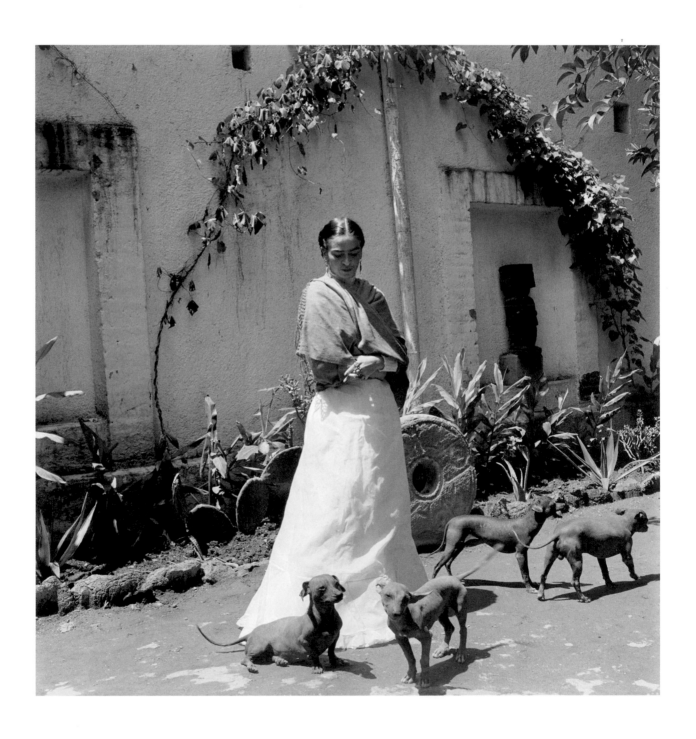

piece, like many of her paintings, is profoundly unsettling. Her exposed breasts seem to invite a voyeuristic gaze, but her ravaged body, evident pain, and constant gaze back are disconcerting.[5]

In 1944, she also painted several portraits of family members of Eduardo Morillo Safa, an agricultural engineer and diplomat who was a major patron during her lifetime. Frida's portrait of his mother, Doña Rosita Morillo, is at once extremely realistic and depicted with great tenderness. Besides these commissioned portraits, Morillo Safa also purchased other paintings, collecting over 30 of her works, including ones that dealt with difficult subjects such as *A Few Small Nips* and *My Nurse and I*.

Another patron, José Domingo Lavin (Frida had painted his wife Marucha years earlier), gave Frida a copy of the book *Moses and Monotheism* by Sigmund Freud, and suggested she make a painting reflecting the book's message. The resulting piece, titled *Moses* (sometimes referred to as *The Birth of a Hero* or *The Nucleus of Creation*), stands out from the rest of Frida's oeuvre. Although, like much of her work, it is executed on a small scale (just 61 x 76.5 centimetres), its composition resembles that of a mural. She depicted Moses as a baby with a third eye on his forehead, floating in a basket on the river. Since Freud said that the basket represented the womb, she depicted a fetus in utero, in the final stage before birth, above the baby. A huge sun burns brightly above the uterus, with hands extending from its rays. On the shores of the river below, a conch spurts liquid into a scallop shell. On either side, the composition is divided into three levels. At the top she painted gods related to the sun. On the top left are Mesoamerican and Eastern gods, on the right, Roman and Egyptian gods. Below the gods, she depicted historical figures: heroes, great thinkers and founders of religions including Gandhi, Lenin, Stalin, Marx, Mohammed, Buddha, on the left, and Christ, Alexander the Great, Caesar, Mohammed, Napoleon and 'the lost son', Hitler, on the right. Below the heroes are crowds of people, the masses. Among them on the left hand side, she included a larger figure representing man as creator, and on the right, a woman who stands for the universal mother.

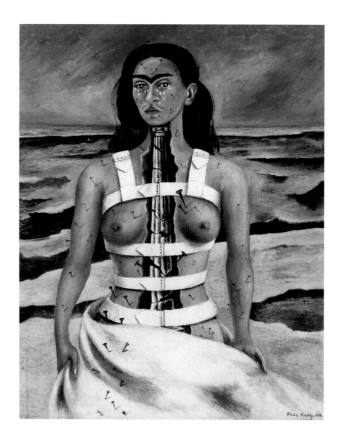

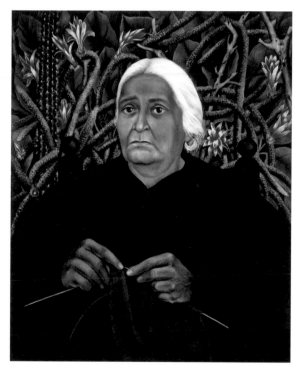

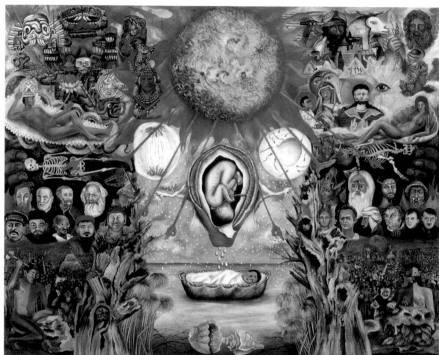

LEFT Frida Kahlo, *The Broken Column*, 1944, oil on canvas, 40 x 30.5 cm, Museo Dolores Olmedo Patiño, Mexico City

ABOVE LEFT Frida Kahlo, *Portrait of Doña Rosita Morillo*, 1944, oil on board, 77.5 x 72 cm, Museo Dolores Olmedo Patiño, Mexico City

ABOVE RIGHT Frida Kahlo, *Moses*, 1945, oil on board, 61 x 75.5 cm, private collection

Although the purported purpose of the painting was to illustrate Freud's message about the origins of monotheism, Frida instead took the opportunity to express her beliefs that were based in Marxism but also incorporated ideas about renewal, reincarnation and the interconnectedness of all living things. The painting can also be seen as a response to Diego's mural *Creation*, which she watched him paint when she was a student in the National Preparatory School, as it contains several references to that work. Whereas the message in *Creation* was the elevation of human nature through the arts, Frida's message is about how religion represses the masses. Frida felt that deities were created by those in power to suppress the will of the people. In a talk she gave about the painting, she explained: '. . . the reason why people need to make up or imagine heroes and gods is pure fear . . . fear of life and fear of death.'[6] The central panel offers the alternative: a reverence

for life, fertility, and the natural world. The Mexican Ministry of Education awarded Frida second place in the 1946 National Award for Painting for this piece, which came with a cash prize of 5,000 pesos.

Despite her general preference for everything Mexican, Frida was suspicious of the advice given to her by her doctors in Mexico. Her friend Arcady Boytler recommended Dr Wilson in New York who had performed his back surgery successfully, so she decided to travel to New York to consult with him. Dr Wilson performed a bone graft and spinal fusion surgery on her, taking bones from her pelvis and fusing them to her spine. The incision became infected and her recovery took longer than anticipated, so Cristina travelled to New York to be by Frida's bedside, leaving her children in the care of their other sisters. While Frida was recuperating, Nick came to see her and took photos of her and Cristina on the hospital's rooftop terrace. Initially the surgery appeared to be a success, but after a few months, she suffered another relapse. From this time, her health seemed to deteriorate more rapidly.

During this stay in New York, Frida met José Bartolí, a Spanish artist and refugee, with whom she began an intense love affair. He visited her in Mexico and they exchanged passionate letters for several years, but her health troubles kept the relationship from developing further.

In the mid-1940s, Diego undertook a substantial modification to the house. In consultation with Juan O'Gorman, he designed the addition of a new wing with a large studio for Frida, an additional bedroom and bathroom, as well as some novel outdoor spaces. The addition to the house extended over the area that was originally the servants' quarters and into the yard to the north that Diego purchased during Trotsky's stay.

Frida's new second-floor studio had windows covering two walls, providing ample natural light for her to work by and offering views out over the garden. The studio was elevated on columns; the space below became their garage. At the bottom of the steps leading down from the new wing, they placed a fountain with frogs (Diego's symbol) depicted in its depths. In the area that had been the service patio, they built an elevated terrace that is partially roofed over, with a mosaic decoration of a clock and communist symbols on the ceiling. A stone table in the centre of the terrace, niches in the walls, and encrusted clay figures give it the feeling of an ancient temple. This terrace was connected to the kitchen and they often used it as an outdoor dining area.[7]

BELOW Frida and her sister Cristina on the hospital rooftop terrace in New York, photographed by Nick Muray, 1948

FOLLOWING PAGES Frida and Diego in the garden at the Blue House, photographed by Agustin Estrada

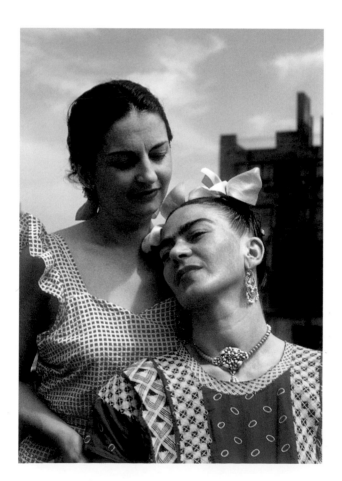

They also made a few changes to the older section of the home at this time, widening the corridor around the central patio and removing the brick latticework wall that had surrounded it. Diego designed a fireplace made of basalt for his studio shaped like a pre-Hispanic temple, recalling the design of Anahuacalli.

As in Anahuacalli, the exterior of the new addition to the Blue House is completely covered in volcanic rock from El Pedregal, contrasting with the original construction. The dark rock is inset with clay pots, conch shells and pre-Hispanic figurines. The decorations incorporate themes related to water, fertility, duality and the underworld.[8] The architecture of the new wing shows O'Gorman's transition from the Functionalism of the San Ángel homes toward a more traditional Mexican aesthetic, with a reliance on local materials in the construction.

In 1948, Frida requested to be readmitted to the Communist Party and was accepted; Diego would have to wait a few more years. Her political convictions shifted toward Stalinism. This should be understood in the context of the aftermath of the Second World War, in which Stalin's Soviet Union fought along with the US and England to defeat Nazi Germany. In Communist circles at that time, criticism of Stalin was seen as supporting fascism and betraying real socialism.

The same year marked some drama with Diego. He had an ongoing relationship over several years with Emma Hurtado, his agent, who accompanied him to social events when Frida's health prevented her from doing so. Frida was aware of the relationship and tolerated it. However, she became livid when Diego took her beloved dog Señor Xolotl to Hurtado's home for several days. She exploded at Diego and referred to his mistress as 'la hurtadora', the usurper.[9] In 1948, Diego also had an affair with the actress María Félix and, wishing to marry her, asked Frida for a divorce. She was heartbroken and relived the emotions of their earlier marital strife. Eventually the fling with Félix ended and he returned to Frida, who was happy to have him back. Frida befriended Félix, who then became a frequent visitor at their home.

Frida painted *The Love Embrace of the Universe* in 1949. In this piece, Frida cradles a naked Diego in her arms like a baby. He has a third eye on his forehead and holds a flame in his hand. Frida wears a red Tehuana dress. She has a wound in her neck and chest that spurts blood. In turn, she is embraced by a Mexican Mother Earth figure that also has a wound in her chest, resembling the creviced earth at El Pedregal. A drop of milk falls from Mother Earth's exposed breast. Numerous plants sprout on either side of Frida and Diego, and Frida's dog, Señor Xolotl, lies curled up at the bottom of Frida's skirt. The painting is divided into night and day, with a moon in the night sky on the left and the sun in the daytime sky on the right. A larger universal goddess embraces all the other figures with one dark-skinned and one light-skinned arm. Roots from the plants hang down from her arms.

With this piece, Frida again explores themes of duality and the connectedness of all living things. She is rooted in the landscape, personified as a nurturing mother who, like her, is willing to endure pain to protect her loved ones. It is a radical image representing feminine divinity, although it seems the entire purpose of the female figures is to shelter the male genius who holds the creative fire and the third eye of wisdom, requiring sacrifice from the female protectors.

Frida began keeping a diary in the late 1940s. She used it to express her thoughts and ideas in a free association manner, recording pain and grief as well as memories and artistic insights. In her everyday interactions with those around her, she remained animated and thoughtful through her declining health. Photographer Gisèle Freund met Frida for the first time in 1950 and wrote: 'Her entire personality radiates a lively intelligence, a profoundly human spirit, and an exuberant vitality.'[10]

Frida spent most of 1950 in the American British Cowdray Hospital in Mexico City, where she underwent multiple operations on her spinal column. Her room at the hospital was converted into an extension of the Blue House. It was decorated with drawings, a Soviet flag and sugar

BELOW Frida Kahlo, *The Love Embrace of the Universe*, 1949, oil on canvas, 70 x 60.5 cm, the Jacques and Natasha Gelman Collection of Modern and Contemporary Mexican Art

RIGHT Page from Frida's diary, which she began keeping in the late 1940s

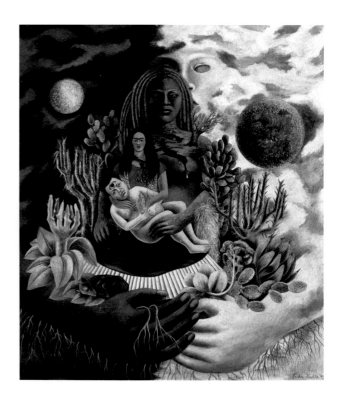

skulls. They even set up a screen and projector so Diego could show movies. She always had her paints and brushes nearby, ready for when inspiration struck, but she mostly drew and wrote in her diary. Cristina or Chucho would bring a large basket of food every day for the doctors, nurses and numerous friends who gathered there, but Frida ate very little. She painted a self-portrait with her doctor, Juan Farill, whom she credited with giving her back her life, although she mostly was confined to a wheelchair.

When Frida returned home, Cristina was ever-present by her side. When Frida could no longer care for herself, Cristina bathed her, helped her dress, combed her hair and supervised the household staff. After this time, Frida painted little: some still lifes depicting fruit, and a few politically themed paintings, such as *Marxism Will Give Health to the Sick*. The quality of her work diminished and her tiny, precise brush strokes gave way to thicker paint application and less careful brushwork.

In April 1953, she had her only solo exhibition in Mexico during her lifetime at the Gallery of Contemporary Art on Amberes Street in Mexico City's fashionable Zona Rosa. It was her friend Lola Álvarez Bravo's gallery. Sensing that Frida would not be with them much longer, Bravo resolved to honour her friend while she was still alive. Frida's doctor told her she could not attend the vernissage because of her poor health. She did not want to miss this event, which she considered the culmination of her career. She arrived in an ambulance and was carried in on a stretcher and transferred to a bed in the middle of the

gallery from which she enjoyed the limelight throughout the evening. The exhibition ran from April 13 to 27, 1953.

Doctors had removed the tips of a few of Frida's toes several years earlier, but the circulation to her right leg and foot remained poor. By August 1953, her leg was infected with gangrene. The doctors told her they would have to amputate her leg at the knee. This was a terrible blow for Frida. She wrote in her diary: 'Feet, why do I need them, if I have wings to fly?' She was putting on a brave face, trying to reassure herself, but the thought of losing her leg horrified her. Just before the amputation, she wrote, 'In my entire figure there is only one and I want two. For me to have two they must cut one off. It is the one I don't have the one I have to have to be able to walk the other one will be dead! I have many wings. Cut them off and to hell with it!!'[11] She depicted herself as a Winged Victory.[12] Like the Winged Victory of Samothrace, a statue she saw at the Louvre, she has no head and no arms. In her drawing, she wears a wide belt that holds a rod in place of her spinal column, and a wire encircles her right leg, which has no foot. Instead of her head, a dove is perched at the top of the figure's neck. Underneath, she wrote a line from a folk song: '*Se equivocó la paloma*' (the dove made mistakes). After the amputation, Frida became demoralized, and seemed to have lost her will to live.[13] Several pages of her diary are missing from the period after the amputation. The next entry was written six months later. She wrote: 'It seemed to me centuries of torture and at times I nearly went crazy.'[14]

They added ramps in the house to facilitate Frida's access to her upper level studio and rooms, though she rarely used her studio. She requested that a bed be moved to the small room at the top of the stairs leading down to the garden, which became her 'day bedroom' from which she could see the plants and hear the fountain through the window while lying in bed.

She avoided wearing the prosthetic leg initially because it caused her pain. She eventually learned to walk short distances with it, but

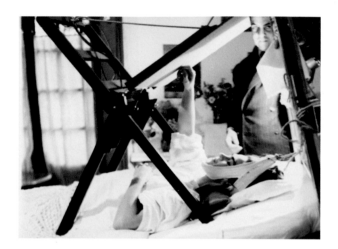

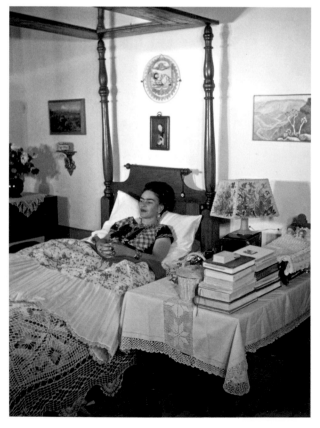

LEFT Frida's health
deteriorated and
she endured several
operations, often taking
to painting in bed whilst
recovering and trying
to rest

BELOW LEFT Frida in
bed, photographed by
Gisèle Freund, 1951

RIGHT Frida's desk, 1951

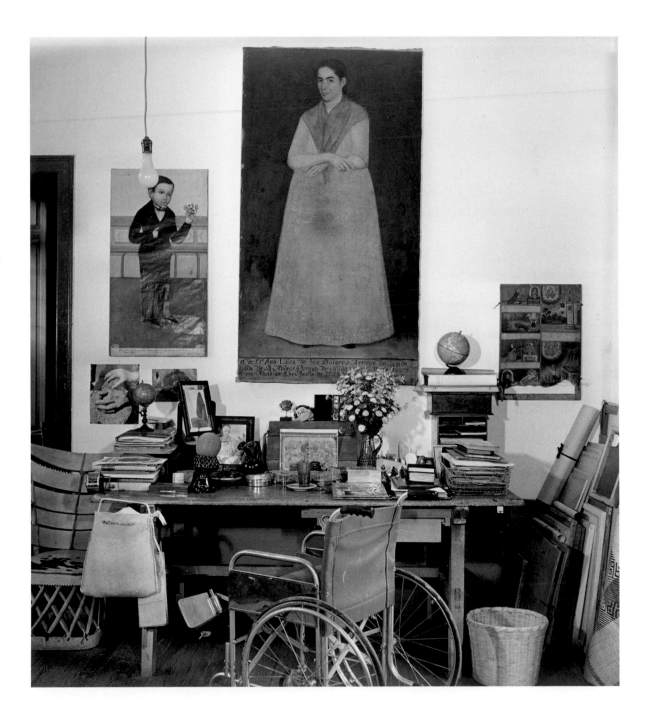

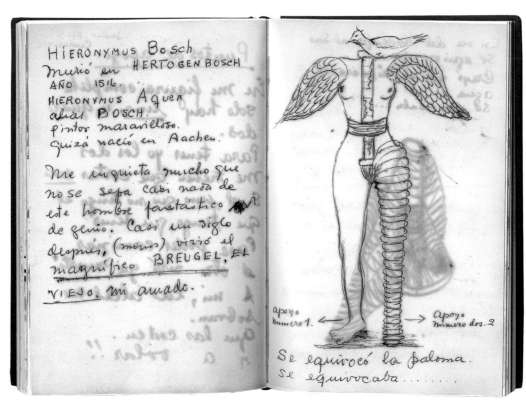

LEFT Page from Frida's diary just before the amputation of her leg below the knee, depicting herself as Winged Victory

BELOW LEFT Frida Kahlo, *Viva La Vida*, 1954, oil on board, 52 x 72 cm, Museo Frida Kahlo, Mexico City

BELOW Frida and Diego together with Juan O'Gorman at a rally protesting US intervention in Guatemala, 1954

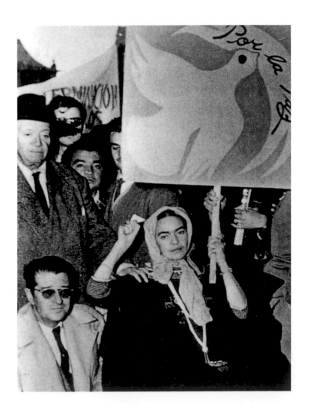

never became fully accustomed to it. Despite the steep decline in her morale, she still expressed joy and humour with her visitors. Bertram Wolfe wrote: 'Even in her decline, there were occasional flashes of incomparable gaiety, festive humour, tenderness, thoughtfulness for those dependent on her, infectious laughter, which would communicate itself to all who surrounded her bed of pain.'[15]

The last written passage in her diary reads: 'I hope the exit is joyful – and I hope never to return.' It has been suggested that the line was written while she was in hospital waiting to be discharged, and was referring to leaving the hospital, but since it is the final written text, it is usually interpreted as referring to her death.

Although she had been suffering from pneumonia, Frida attended a protest rally against the US intervention in Guatemala on July 2, 1954, against her doctor's orders. She and Diego joined over ten thousand other Mexicans in a march in the centre of Mexico City from Santo Domingo Plaza to the Zócalo. Instead of her usually elaborate hairstyle, she wore a scarf tied over her hair. Diego pushed her wheelchair. They both look haggard in the photos, but her determination to support the revolutionary cause was undiminished.

Five days later, Frida celebrated her 44th birthday, though she was, in fact, 47. She had a grand party with many guests. At 8 p.m. she retired to her bedroom, but a few guests came to see her there and she received them. At the end of the evening, Frida gave Diego an antique gold ring to commemorate the 25th anniversary of their first marriage, which they would have celebrated the following month.

On a still life of juicy watermelons she had painted some time before, she wrote in red paint: 'VIVA LA VIDA, Frida Kahlo, Coyoacán 1954 México.' Frida died in her bed at the Blue House in the early hours of the morning on July 13, 1954. The cause of death listed on her death certificate is pulmonary embolism, but many speculate that she committed suicide.

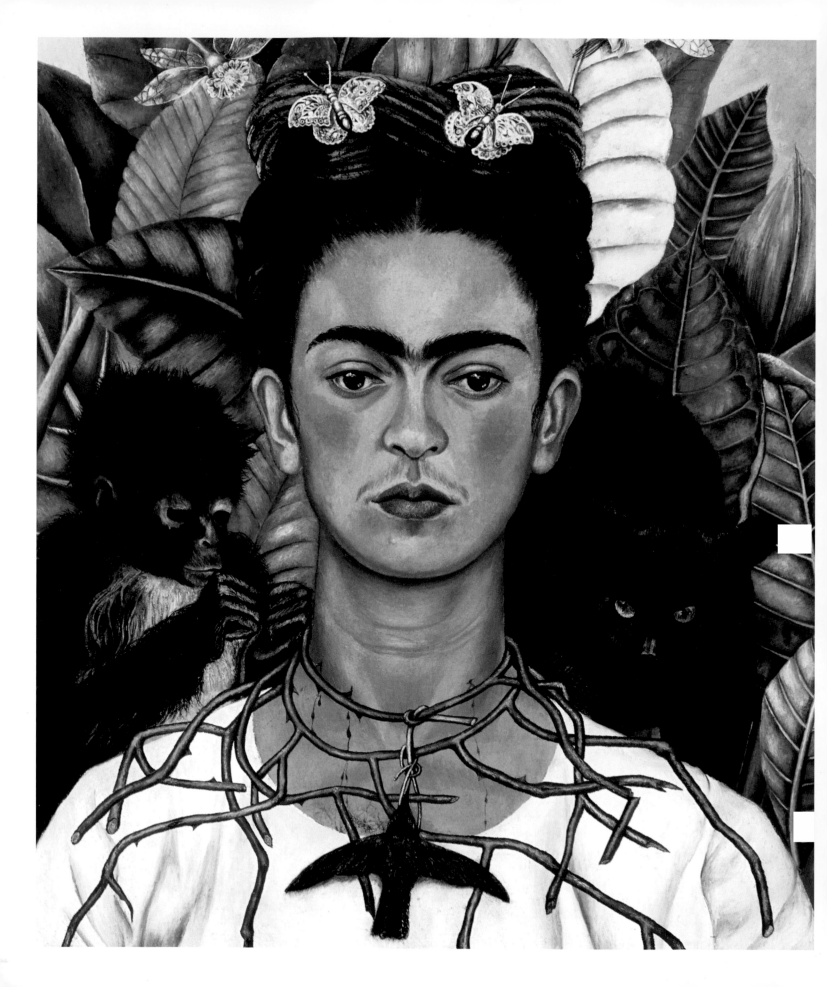

LEGACY

Although Frida's health and morale had been in a downward spiral for years, her death still came as a surprise to her loved ones. It was especially difficult for Diego, who, upon losing her, became keenly aware of how important she had been to him. A friend who arrived at the house shortly after Frida's death said that Diego seemed to age suddenly, becoming an old man before his eyes, and uncharacteristically had nothing to say to the press.

The director of the Fine Arts Institute, Andrés Iduarte, who had been a schoolmate of Frida's at the National Preparatory School, gave the authorization for her body to lie in state at the Fine Arts Palace, with the stipulation that there be no political displays. Hundreds of friends and admirers paid their respects, including two former presidents, Lázaro Cárdenas and Emilio Portes Gil. Frida's student Arturo Garcia Bustos draped the Communist flag over her casket, causing a huge scandal in the press; Iduarte lost his post because of it.

The following day at noon, a large crowd accompanied Frida's body to the Dolores cemetery, where she was cremated, as she had requested. 'I've spent too much time lying down', she had commented to a friend. Her ashes were placed in a pre-Hispanic urn shaped somewhat like a frog. The urn now rests on a dressing table in her bedroom at the Blue House.

A year after Frida's death, Diego married his long time mistress Emma Hurtado. He had little money and had been diagnosed with cancer, but he was intent on ensuring his and Frida's legacy. He created a trust through the Bank of Mexico, leaving the Blue House and Anahuacalli, as well as their contents, to the people of Mexico. He named Dolores Olmedo director of the trust. Olmedo, a long time friend of Diego's, was a successful businesswoman and patron of the arts. She had modelled for Diego several times since she was a young girl. Olmedo and Frida had a rivalry since their schooldays

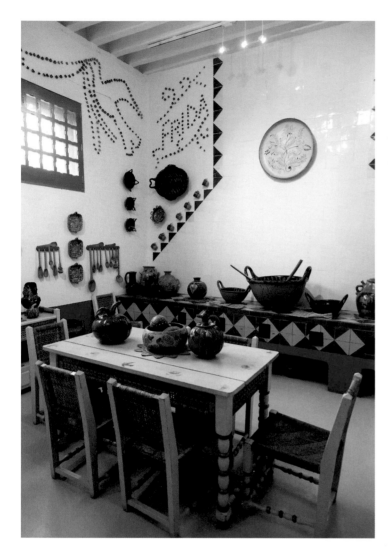

when Olmedo had expressed a romantic interest in Frida's boyfriend Alejandro. Olmedo owned a great many of Diego's paintings, and bought several of Frida's at Diego's request, though she openly did not care for Frida or her work.[1] Diego requested that some areas of the Blue House, including the bathroom off of his bedroom and some storage spaces, remain closed until fifteen years after his death.

Diego died on November 24, 1957 at home in his San Ángel studio. In his will, he stated that he wanted to be cremated and have his ashes mixed with Frida's.[2] This wish was not respected. Upon Diego's death, President Adolfo Ruiz Cortinez honoured Diego by having his remains interred in the Rotunda of Illustrious Men[3] in the Dolores Cemetery, and his family agreed.

The Blue House opened to the public as the Frida Kahlo Museum on July 12, 1958. Mexican poet Carlos Pellicer, a good friend of Frida's, was the first director and curator.

ABOVE, CLOCKWISE FROM LEFT
The Blue House kitchen, garden and Frida's studio

RIGHT Frida's bedroom

He was charged with turning the house into a museum. When visitors enter the Blue House, they get the impression that everything remains as Frida and Diego left it. However, by necessity, Pellicer rearranged things quite a bit. He had the shelves fitted with glass to protect their contents, displayed artwork on the walls, and tidied Frida's paints, brushes, and personal effects. The exterior windows had been closed up during Trotsky's stay, but several more windows and doors were then closed off to increase security and facilitate the flow of visitors through the house. When he had finished, Pellicer wrote a letter to Frida in which he described his actions and expressed his hope that she would approve of the decisions he had taken: 'I finished arranging your house yesterday; we'll see if you don't pick a fight with me about it when you come back. In the room that you used to use as your studio and in which you painted so many marvellous things, I hung some of your paintings . . .'[4]

Raquel Tibol, who stayed with Frida for a time in 1953, wrote: 'Things remained almost where they had been, but instead of keeping the order of those who had lived in the house, they acquired an order from the visitor's point of view . . . The extreme disorder of daily living solidified into a definitive order, where the truth was altered only as much as was necessary to stress certain meanings.'[5] Tibol rightly commented that there was one oversight on Pellicer's part: he had neglected to include any of Guillermo Kahlo's photographs in the exhibit.[6] As the original owner of the house, an important artist, and one of Frida's major influences, some of his work deserved to be featured.

Anahuacalli was only about one third complete at the time of Diego's death. Work on the building continued under the supervision of Juan O'Gorman, and Diego's daughter, Ruth, who was also an architect. It was inaugurated as a museum in 1964. Beyond the building and the massive collection of pre-Hispanic pieces it contains, there is the surrounding ecological reserve of over 46,000 square metres of wild territory, allowing visitors to discover the landscape of El Pedregal that the artists held dear.

At the time of her death, Frida was for the most part unknown outside of art circles. Within them, she was still identified mainly as the wife of Diego Rivera. No one, perhaps Frida least of all, could have predicted the heights her international renown would reach. Twelve years after her death, a low-budget documentary entitled *The Life and Death of Frida Kahlo as Told to Karen and David Crommie* made its debut at the San Francisco International Film Festival. The film introduced Frida to a public that was ready for her and her message. Feminist and Chicano artists saw Frida as a symbol of feminine strength and resilience, and her image began to be referenced in works by other artists. In 1983, Hayden Herrera published the weighty tome *Frida: A Biography of Frida Kahlo*. From that time onward, Frida gained more and more popular recognition.

In 1985, the Mexican government passed a law stating that because of its 'unquestionable aesthetic value and the recognition it has achieved in the artistic community' all of Frida's work is considered an artistic monument and as such there are restrictions regarding its sale. Exportation is forbidden except in the case of temporary exhibits, for which special permission from the National Institute of Fine Arts is required.

Adding to Frida's cachet, in the late 1980s and early '90s, pop star Madonna professed an interest in her work; the singer owns the 1940 *Self-Portrait with Monkey* as well as *My Birth*. In a 1990 interview with *Vanity Fair*, she claimed to use the latter painting as a litmus test for new friends: 'If somebody doesn't like this painting, then I know they can't be my friend,' she said. She also made public her intention to produce a biopic of the artist's life. Mexican actress and producer Salma Hayek beat Madonna to the punch and produced and starred in the 2002 movie *Frida*, directed by Julie Taymor, which helped to make Frida a household name.

In recent decades, Frida Kahlo has become an internationally known artist, and her fame extends into popular culture. Her image has become nearly as ubiquitous as the Virgin Mary: her face appears on T-shirts, calendars, coffee mugs, refrigerator magnets

and mobile phone cases. She is widely recognized, even by people who have no idea what she accomplished. She was featured on a US postage stamp in 2000. In 2010, the Mexican government issued a newly designed 500 peso note with Diego on the front and Frida on the back.

Dolores Olmedo remained the director of the Frida Kahlo and Diego Rivera Trust until her death in 2002. The bathroom and storage areas that Diego had requested she wait to open remained untouched. In 2004, museum staff entered those spaces and opened the closets and trunks that had been closed and they found hundreds of documents, photographs and works of art, as well as some 300 articles of clothing and personal objects that had belonged to Frida and Diego, offering new information and insight into their lives and personalities.

In 2007, on the 100th anniversary of Frida's birth, a national tribute was held for her: the largest-ever exhibition of her work ran from June 14 to August 19 at the Fine Arts Palace in Mexico City. It included pieces on loan from private collections around the world, as well as photos and correspondence that had never been displayed. The show received over 360,000 visitors, breaking attendance records. Since then, major shows of her work around the world have also drawn unprecedented crowds.

Frida lived during a time of great change in Mexico, from the paternalistic rule of Porfirio Diaz, through the Mexican Revolution and the 'Mexican Renaissance' that came about in its wake, prompting a revaluation of Mexican culture and traditions, and then to the institutionalized revolution that purported to incorporate revolutionary aims within the government. Her life was deeply affected by these events and she played a part in shaping them as well. Although women did not have the right to vote in Mexico until the year before her death, Frida's adult life was characterized by political involvement. From the first march she attended in 1929 to the demonstration against US intervention in Guatemala eleven days before she died, she was determined to effect change.

The other constant throughout her life was Diego. Through the highs and lows of their relationship, she remained devoted to him. Their unconventional marriage brought together two forceful and distinct personalities who shared a love for art, Mexico and revolutionary causes. Although Diego's wish that his ashes be mixed with Frida's was not honoured, the couple remains forever linked in the minds of the public as one of the turbulent and passionate love stories that fascinate and capture the collective imagination.

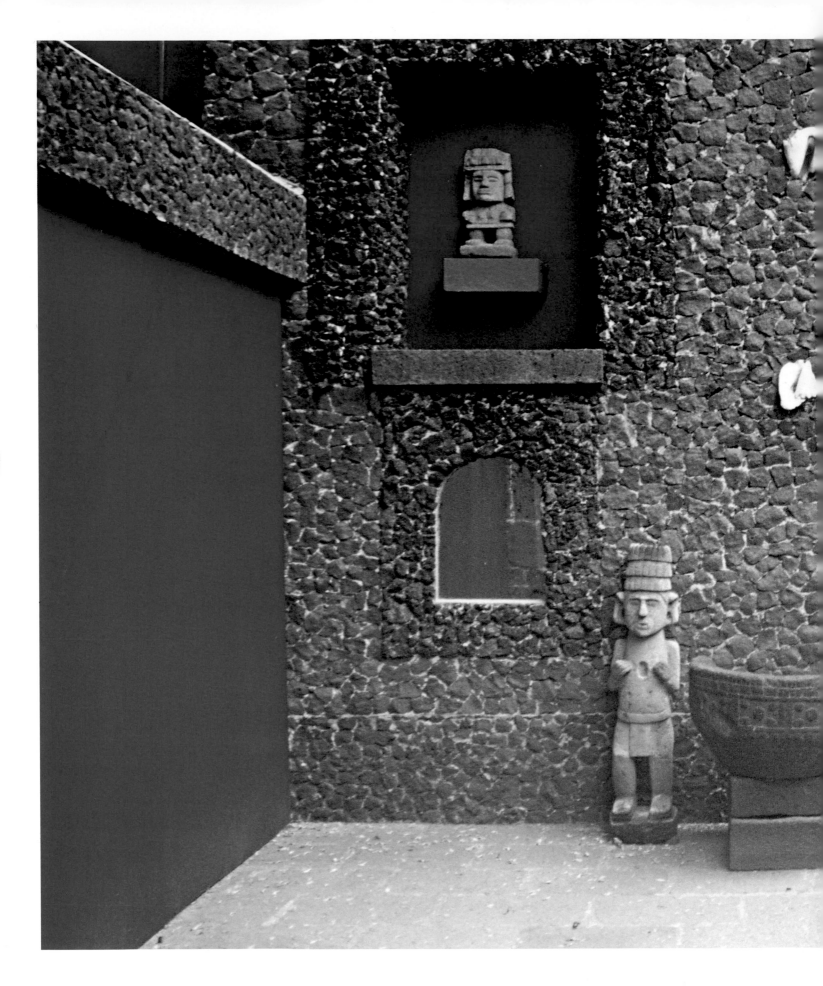

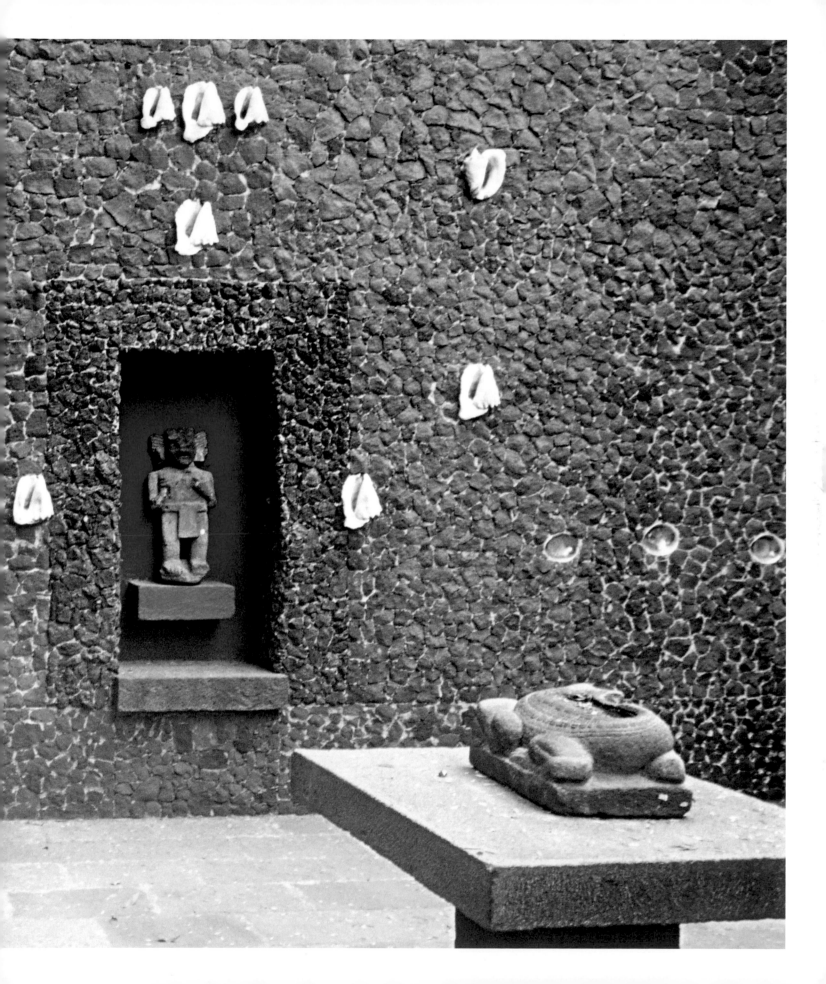

Frida created some 200 works of art during her lifetime. She drew almost exclusively from the forms of Mexican popular art, including portraiture, ex-votos and still lifes, most often working in small format and on tin sheets rather than canvas. Nearly a third of her body of work is made up of self-portraits. By depicting herself over and over again using the forms and rich symbolism of religious, pre-Hispanic and popular art, Frida made herself into a secular saint. She created a mythology around her life, surrounding herself with symbols and totems, and adjusting facts to convey her version of the truth of herself. In doing so, she opened herself up to further mythologizing. Her image and ideologies have been used by individuals and groups to broadcast their messages. She is an icon for women's rights, disabled people, gay people, and those who do not fit into prescribed gender categories.

Neither Frida nor anyone else could have foreseen how pervasive she would become in popular culture, but by repeatedly depicting herself, she set the stage for her future fame. Although she was very much a woman of her time, her work remains astoundingly relevant. In the age of selfies and oversharing, her many self-portraits speak to us on a level that is very contemporary. She depicted her intimate life and the harsh, raw reality of her pain, externalizing that which is usually kept private, often breaking taboos in doing so.

During her lifetime, the upper classes in Mexico generally judged Frida as crude and vulgar. She is still derided by many who feel that her popularity is overrated, that she was narcissistic and lacked talent, and that the spotlight on her detracts from other important Mexican and women artists. It is no doubt inevitable that her unprecedented popularity would generate backlash. But ultimately, her influence persists. Her work is unmistakable, and her creativity and personality continue to appeal to a wide range of people.

The homes where Frida lived are some of the most well visited sites in Mexico City. The San Ángel houses and Anahuacalli draw visitors, but the Blue House in particular is a place where people go to feel a connection with Frida, to gain some insight into her life and her world. This place, where she was born, lived, celebrated, suffered, loved and died, has become a pilgrimage site for those who appreciate her art and feel inspired by her life. The house reflects what was important to her and communicates it to all who visit. It seems to contain a part of her spirit; she left an imprint on the space that is still felt today.

PREVIOUS PAGES Courtyard of the Blue House, now the Frida Kahlo Museum

RIGHT Frida in the garden of the Blue House, photographed by Gisèle Freund, 1951

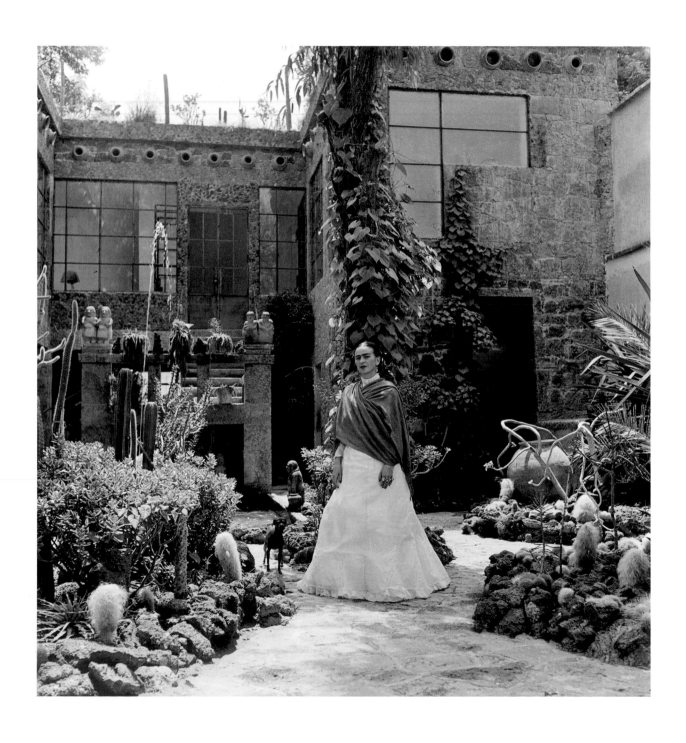

ENDNOTES

Origins & Childhood in Coyoacán

1 Guillermo and Matilde's marriage certificate, reproduced in Luis-Martín Lozano's *Frida Kahlo El Círculo de los Afectos*, Cangrejo Editores, 2007, p. 36, states that Antonio Calderón was deceased at the time of the marriage.
2 Herrera, Hayden, *Frida: A Biography of Frida Kahlo*, Perennial, 2002, p. 7
3 Cody, Jefrey W., *Exporting American Architecture 1870–2000*, Routledge, 2003, p. 16
4 Safa Barraza, Patricia, *Vecinos y Vecindarios en la Ciudad de Mexico*, Centro de Investigaciones y Estudios Superiores en Antropología Social, Universidad Autónoma Metropolitana-Iztapalapa, 1998, p. 85
5 Everaert Dubernard, Luis, 'The Coyoacán of Frida Kahlo' in *La Casa Azul de Frida*, Banco de Mexico, 2007
6 Mexican historian Beatriz Scharrer Tamm points out that in the early black and white photographs of the house, it is much lighter than the blue it is now known for. She suggests that the walls were 'white or some pastel tone' and surmises that the trim may have been red ochre or sepia tone. *La Casa Azul de Frida*, p. 161
7 Grimberg, Salomon, *Frida Kahlo: Song of Herself*, Merrell, 2008, p. 58
8 Fuentes, Carlos, *The Diary of Frida Kahlo: An Intimate Self-Portrait*, Abrams, 2005, Plates 153, 154
9 Tibol, Raquel, *Frida Kahlo: An Open Life*, UNM Press, 1993, p. 31
10 Grimberg, *Frida Kahlo: Song of Herself*, p. 64
11 Some researchers have suggested that Frida was born with spina bifida, and the polio compounded a congenital defect. Budrys, Valmantas, 'Neurological Deficits in the Life and Works of Frida Kahlo,' *European Neurology*, Vol. 55, No. 1, 2006
12 Undated note to Adelina Zendejas quoted in Tibol, Raquel, *Frida by Frida*, Editorial RM, 2006 p. 15
13 Tibol, *Frida Kahlo: An Open Life*, p. 39
14 The research of Gaby Franger and Rainer Huhle, published in *Fridas Vater: Der Fotograf Guillermo Kahlo*, in 2005 dispelled many myths about Guillermo's family history.
15 His health started to fail in the mid-1930s and he died in 1941, so he wouldn't have been in good condition to fight against Hitler even if he had the desire. In Isolda Kahlo's book, *Frida Íntima*, Dipon, 2004, he is depicted as apolitical, he even advised Leon Trotsky to stay out of politics.
16 Letter in the Nelleke Nix and Marianne Huber Collection: The Frida Kahlo Papers. Special Collections, Library and Research Center, National Museum of Women in the Arts, quoted in *'Dearest Frieducha!': The Letters of Guillermo Kahlo to His Daughter Frida* by Annette B. Ramírez de Arellano and Servando Ortoll.
17 Coronel Rivera, Juan Rafael, *Frida Kahlo: The Metamorphosis of the Image*, Editorial RM, 2005, p. 67

School Days in Mexico City

1 Diego Rivera Frida Kahlo Archive, Banco de México
2 Tibol, *Frida By Frida*, p. 15
3 Diego Rivera Frida Kahlo Archive, Banco de México
4 Marnham, Patrick, *Dreaming with his Eyes Open: A Life of Diego Rivera*, University of California Press, 2000, p. 117
5 Grimberg, *Frida Kahlo: Song of Herself*, p. 75
6 Rivera, Diego and Gladys March, *My Art, My Life*, Dover Publications, 1992, p. 74
7 Tibol, *Frida By Frida*, p. 51
8 Rivera, Diego and Gladys March, *My Art, My Life*, p. 76
9 Carranza, Luis E., *Architecture As Revolution: Episodes in the History of Modern Mexico*, University of Texas Press, 2010, p. 47
10 The letter by Fernando Fernandez is on display in the Frida Kahlo Museum.
11 Herrera, *Frida: A Biography of Frida Kahlo*, p. 49
12 Tibol, *Frida By Frida*, p. 41
13 Ibid., p. 53
14 Ibid., p. 50
15 Ibid., p. 70
16 Ibid., p. 76
17 Ibid., p. 77
18 Oles, James, 'At the Café de los Cachuchas: Frida Kahlo in the 1920s.' *Hispanic Research Journal 2007*; 8(5), 467–89
19 Ibid., p. 468

An Unlikely Match

1 Her recurring physical ailments are alternatively attributed to congenital deformity (spina bifida, scoliosis), post-polio syndrome, and consequences of the accident.
2 Rivera, *My Art, My Life*, p. 102
3 Grimberg, *Frida Kahlo: Song of Herself*, p. 74
4 Some have suggested that the young woman is Frida herself, but she lacks the joined eyebrows that usually appear in her self-portraits. Frida's niece Isolda contended that it is in fact her mother, Cristina.
5 La Prensa, Mexico City, August 23, 1929
6 Wolfe, Bertram, *Diego Rivera: His Life and Times*, p. 275
7 Rivera Marín, Guadalupe and Marie-Pierre Colle, *Frida's Fiestas*, Clarkson Potter, 1994, p. 32
8 Wolfe, *Diego Rivera: His Life and Times*, p. 249
9 Herrera, *Frida: A Biography of Frida Kahlo*, p. 101
10 Bambi 'Frida Kahlo es Una Mitad' quoted in Herrera, *Frida: A Biography of Frida Kahlo*, p. 101
11 Diego Rivera Frida Kahlo Archives, Banco de Mexico
12 Diego Rivera letter to Frida Kahlo dated January 27, 1939, Diego Rivera Frida Kahlo Archives, Banco de Mexico
13 Folgarait, Leonard, 'Tina Modotti and the Image of Mexican Communism in 1928: *La técnica' Crónicas'*, Instituto de Investigaciones Estéticas, Universidad Nacional Autónoma de México, no. 10–11, March 2002–February 2003, pp. 41–52
14 Herrera, *Frida: A Biography of Frida Kahlo*, p. 106
15 Marnham, *Dreaming with his Eyes Open: A Life of Diego Rivera*, p. 228
16 Turok, Marta, 'Mirrors of the Soul: Textiles and Identity in Frida Kahlo' in *Frida's Blue House*, Chapa Editions, 2007

Mexicans in Gringolandia

1 Quoted in 'April 23, 1932' by Juan Rafael Coronel Rivera, in *Diego Rivera and Frida Kahlo in Detroit*, p. 124
2 Edward Weston, diary entry for December 14, 1930, quoted in *Frida Kahlo* by Gannit Ankori, Reaktion Books, 2013, p. 10
3 Memorial plaque at the Luther Burbank Home and Gardens

4 Diego Rivera Frida Kahlo Archive, Banco de Mexico
5 Rivera, *My Art, My Life*, p. 107
6 Quoted in Herrera, *Frida: A Biography of Frida Kahlo*, p. 118
7 Grimberg, *Frida Kahlo: Song of Herself*, p. 116
8 Grimberg, Salomon, *I Will Never Forget You*, Schirmer/Mosel, 2004, p. 14
9 Tibol, *Frida By Frida*, p. 111
10 Ibid., p. 105
11 Ibid., p. 107
12 In a March 11, 1934 letter to Ella Wolfe, Frida mentions that she saw O'Keeffe again but they did not make love on that occasion because of O'Keeffe's poor health. Tibol, *Frida by Frida*, p. 129
13 Friedler, Sharon E. and Susan B. Glazer, *Dancing Female*, Harwood Academic Publishers, 1997, pp. 25, 26
14 Tibol, *Frida by Frida*, pp. 113, 114
15 Rosenthal, Mark, 'Diego and Frida: High Drama in Detroit' in *Diego Rivera and Frida Kahlo in Detroit*, p. 51
16 Ibid., p. 53
17 Letter to Dr Eloesser, May 26, 1932 in *Querido Doctorcito: Frida Kahlo y Leo Eloesser Correspondencia*, p. 26
18 According to Lucienne Bloch, Bloch/Crommie interview, quoted in 'The Lost Desire' by Salomon Grimberg in *Diego Rivera and Frida Kahlo in Detroit*, p. 151
19 Letter from Diego Rivera quoted in 'April 21, 1932' by Juan Rafael Coronel Rivera, *Diego Rivera and Frida Kahlo in Detroit*, p. 141
20 Letter from Diego Rivera dated October 1, 1932 in Diego Rivera Frida Kahlo Archive, Banco de Mexico
21 Grimberg, 'The Lost Desire' in *Diego Rivera and Frida Kahlo in Detroit*, p. 154
22 Ankori, *Frida Kahlo*, p. 74
23 *Detroit News* article by Florence Davies
24 Bloch, Lucienne, diary entry quoted in Herrera, *Frida: A Biography of Frida Kahlo*, p. 170

Separate but Connected in San Ángel

1 Carranza, Luis E. and Fernando Luiz Lara, *Modern Architecture in Latin America: Art, Technology and Utopia*, University of Texas Press, 2015, pp. 71, 72
2 Osorio, Ernestina, 'Unequal Union: La Casa Estudio de San Ángel Inn c. 1929–1932' in *Negotiating Domesticity: Spatial Productions of Gender in Modern Architecture*, Hilde Heynen, Gülsüm Baydar eds., Routledge, 2005, p. 225
3 Medical History, Begún. cited in *Frida Kahlo: Song of Herself*, p. 116.
4 Letter to Dr Eloesser dated November 26, 1934
5 Herrera, Hayden, *Frida Kahlo: The Paintings*, Harper Perennial, 2002, p. 111
6 Lindauer, Margaret A., *Devouring Frida: The Art History and Popular Celebrity of Frida Kahlo*, Wesleyan University Press, 1999, p. 31

7 Letter dated July 23, 1935, quoted in Wolfe, *Diego Rivera: His Life and Times*, p. 357
8 Wolfe, *Diego Rivera: His Life and Times*, p. 358
9 Herrera, *Frida: A Biography of Frida Kahlo*, p. 200
10 Ibid., p. 306

Claimed by the Surrealists

1 Zavala, Adriana, *Frida Kahlo's Garden*, Prestel, 2015, p. 29
2 Patenaude, Bertrand M., *Trotsky: Downfall of a Revolutionary*, Harper Collins, 2009, p. 57
3 van Heijenoort, Jean, *With Trotsky in Exile: from Prinkipo to Coyoacán*, Harvard University Press, 1978 p. 114
4 Patenaude, *rotsky: Downfall of a Revolutionary*, p. 102
5 Lindauer, *Devouring Frida: The Art History and Popular Celebrity of Frida Kahlo*, p. 39
6 Zarobel, John, 'The Hybrid Sources of Frida Kahlo', *Berkeley Review of Latin American Studies*, UC Berkeley, Fall 2008, p. 29
7 Breton, André, *Manifestoes of Surrealism*, University of Michigan Press, 1969, p. 26
8 Tibol, *Frida By Frida*, p. 275
9 Letter to Antonio Rodriguez, 1952, quoted in Helland, Janice, 'Aztec Imagery in Frida Kahlo's Paintings: Indigenity and Political Commitment' in *Woman's Art Journal*, Vol. 11, No. 2 (Autumn 1990–Winter 1991), p. 12.
10 Wolfe, *Diego Rivera: His Life and Times*, p. 360
11 Ibid., p. 359
12 Letter to Diego dated January 28, 1939
13 Letter from Frida dated February 27, 1939, Archives of American Art, Nickolas Muray papers
14 Quoted in Herrera, *Frida: A Biography of Frida Kahlo*, p. 251
15 Letter from Frida dated February 16, 1939, Archives of American Art

Return to the Blue House

1 *El Universal*, October 19, 1939, quoted in Herrera, *Frida: A Biography of Frida Kahlo*, p. 274
2 Rivera, *My Art, My Life*, p. 139
3 Letter to Nick dated January 1940, in Grimberg, *I Will Never Forget You*, p. 35
4 Letter to Alfonso Manrique, editor of *Hoy*, dated October 25, 1939. Author's translation.
5 Baddeley, Oriana, 'Engendering New Worlds: Allegories of rape and reconciliation' in *The Visual Culture Reader*, Routledge, 1998, p. 586
6 Nick Muray letter to Frida Kahlo quoted in Grimberg, *I Will Never Forget You*, p. 26
7 Baddeley, Oriana, 'Defrocking the Kahlo Cult', *Oxford Art Journal*, Vol. 14, No. 1 (1991), p. 14
8 Letter from Frida to Sigmund Firestone dated February 15, 1940, in Tibol, *Frida by Frida*, p. 223
9 Letter from Frida to Diego dated June 11, 1940, quoted in Tibol, *Frida By Frida*, p. 237
10 Letter from Frida to Diego dated July 10, 1940, Diego Rivera Frida Kahlo Archives, Banco de México

11 Ibid.
12 Ibid.
13 Frida, letter to Emmy Lou Packard quoted in Herrera, *Frida: A Biography of Frida Kahlo*, p. 303
14 Zavala, Adriana, 'Frida Kahlo: Art, Garden, Life' in *Frida Kahlo's Garden*, p. 32
15 Emmy Lou Packard papers, Archives of American Art, quoted in Zavala, *Frida Kahlo's Garden*, p. 35
16 Letter to Dr Eloesser dated 18 July, 1941, quoted in Lindauer, *Devouring Frida: The Art History and Popular Celebrity of Frida Kahlo*, p. 49
17 Grimberg, *Frida Kahlo: Song of Herself*, p. 67
18 Rivera, *My Art, My Life*, p. 155
19 Guillermo Monroy in Frida Maestra, Luisa Riley/Canal 22 (Producer), 2005. Documentary
20 Deffebach, Nancy, *María Izquierdo and Frida Kahlo: Challenging Visions in Modern Mexican Art*, University of Texas Press, 2015, p. 136
21 Tibol, *Frida Kahlo: An Open Life*, p. 178

At Home in the Blue House

1 Kahlo, *Frida Íntima*, p. 115
2 Rivera Marín, *Frida's Fiestas*, p. 24
3 Grimberg, *Frida Kahlo: Song of Herself*, p. 37
4 Ibid.
5 Lindauer, *Devouring Frida: The Art History and Popular Celebrity of Frida Kahlo*, p. 58
6 Quoted in Martha Zamora, *The Letters of Frida Kahlo: Cartas Apasionadas*, Chronicle Books, 1995, p.121
7 The door connecting the terrace to the kitchen was blocked over when the house was made into a museum, according to Scharrer Tamm.
8 Scharrer Tamm, 'La Casa Azul' in La Casa Azul de Frida
9 Kahlo, *Frida Íntima*, p. 166
10 Freund, Gisèle, *Frida Kahlo: The Gisèle Freund Photographs*, Harry N. Abrams, 2015, p. 27
11 Fuentes, *The Diary of Frida Kahlo: An Intimate Self-Portrait*, p. 274
12 Ibid., plate 141
13 Rivera, *My Art, My Life*, p. 177
14 Fuentes, *The Diary of Frida Kahlo: An Intimate Self-Portrait*, p. 278
15 Wolfe, Bertram, *The Fabulous Life of Diego Rivera*, Cooper Square Press, 2000, p. 399

Legacy

1 Kandell, Jonathan, 'Dolores Olmedo, a Patron to Diego Rivera, Dies at 88', *New York Times*, August 2, 2002
2 Wolfe, *The Fabulous Life of Diego Rivera*, p. 413
3 In 2003, the name was changed to the Rotunda of Illustrious Persons.
4 Letter dated July 1958 from Carlos Pellicer addressed to Frida, quoted in Porfirio Hernández 'La Casa Azul', *Milenio*, June 22, 2015. Author's translation.
5 Tibol, *Frida Kahlo: An Open Life*, p. 174
6 Ibid., p. 175

SELECT BIBLIOGRAPHY

Ankori, Gannit, *Frida Kahlo*, Reaktion Books, 2013

Baddeley, Oriana, '"Her Dress Hangs Here": De-Frocking the Kahlo Cult.' *Oxford Art Journal* 14, no. 1 (1991): 10–17

Baddeley, Oriana, 'Engendering New Worlds: Allegories of rape and reconciliation' in *The Visual Culture Reader*, Nicholas Mirzoeff, ed., Routledge, 1998

Carranza, Luis E., *Architecture As Revolution: Episodes in the History of Modern Mexico*, University of Texas Press, 2010

Carranza, Luis E. and Fernando Luiz Lara, *Modern Architecture in Latin America: Art, Technology and Utopia*, University of Texas Press, 2015

Casanova, Rosa, *Guillermo Kahlo: Luz, Piedra y Rostro*, Cangrejo Editores, 2012

Castro-Sethness, María A., 'Frida Kahlo's Spiritual World: The Influence of Mexican Retablo and Ex-voto Paintings on Her Art', *Woman's Art Journal* 25, no. 2 (2004): 21–4

Chapa, Arturo, et al., *Frida Kahlo's Blue House*, Chapa Ediciones, Banco de Mexico, 2007

Coronel Rivera, Juan Rafael and Nadia Ugalde Gomez, *Frida Kahlo: The Metamorphosis of the Image*, Editorial RM, 2005

Craven, David, *Art and Revolution in Latin America, 1910–1990*, Yale University Press, 2006

Deffebach, Nancy, *María Izquierdo and Frida Kahlo: Challenging Visions in Modern Mexican Art*, University of Texas Press, 2015

Fraser, Valerie, *Building the New World: Studies in the Modern Architecture of Latin America 1930–1960*, Verso, 2001

Freund, Gisèle, *Frida Kahlo: The Gisèle Freund Photographs*, Harry N. Abrams, 2015

Fuentes, Carlos, *The Diary of Frida Kahlo: An Intimate Self-Portrait*, Abrams, 2005

Fuentes, Carlos et al., *Frida Kahlo: National Homage 1907–2007*, Editorial RM, 2008

Giese, Lucretia Hoover, 'A Rare Crossing: Frida Kahlo and Luther Burbank', *American Art* 15, no. 1 (2001): 53–73

Glass, Daniel, 'Once Upon a Time in Mexico: Frida Kahlo's Garden at La Casa Azul, Coyoacán', *Garden History* 39, No. 2 (2011): 239–48

Grimberg, Salomon, *Frida Kahlo: Song of Herself*, Merrell, 2008

Grimberg Salomon, *I Will Never Forget You: Frida Kahlo and Nickolas Muray*, Chronicle Books, 2006

Helland, Janice, 'Aztec Imagery in Frida Kahlo's Paintings: Indigenity and Political Commitment', *Woman's Art Journal* 11, No. 2 (1990–1991): 8–13

Herrera, Hayden, *Frida: A Biography of Frida Kahlo*, Harper Perennial, 2002

Herrera, Hayden, *Frida Kahlo: The Paintings*, Harper Perennial, 2002

Kahlo, Isolda P., *Frida Íntima: Frida Kahlo 1907–1954*, Dipon, 2004

Lindauer, Margaret A., *Devouring Frida: The Art History and Popular Celebrity of Frida Kahlo*, Wesleyan, 1999

Lozano, Luis Martín, *Frida Kahlo: El Círculo de los Afectos*, Cangrejo Editores, 2007

Marnham, Patrick, *Dreaming with His Eyes Open: A Life of Diego Rivera*, University of California Press, 1998

Oles, James, 'At the Café de los Cachuchas: Frida Kahlo in the 1920s', *Hispanic Research Journal* 8, No. 5 (2007): 467–89

Ortiz Monasterio, Pablo, ed., *Frida Kahlo: Her Photos*, Ediciones RM, 2010

Osorio, Ernestina, 'Unequal Union: La Casa Estudio de San Ángel Inn c. 1929–1932' in *Negotiating Domesticity: Spatial Productions of Gender in Modern Architecture*, Hilde Heynen and Gülsüm Baydar, eds., Routledge, 2005

Patenaude, Bertrand, *Trotsky: Downfall of a Revolutionary*, Harper Collins, 2009

Rivera, Diego and Gladys March, *My Art, My Life: An Autobiography*, Dover Publications, 1992

Rivera, Guadalupe and Marie-Pierre Colle, *Frida's Fiestas: Recipes and Reminiscences of Life with Frida Kahl*, Clarkson Potter, 1994

Rosenthal, Mark, et al., *Diego Rivera and Frida Kahlo in Detroit*, Detroit Institute of Arts, 2015

Tibol, Raquel, *Frida by Frida*, Editorial RM, 2007

Tibol, Raquel, *Frida Kahlo: An Open Life*, UNM Press, 1993

van Heijenoort, Jean, *With Trotsky in Exile: from Prinkipo to Coyoacán*, Harvard University Press, 1978

Wolfe, Bertram, *Diego Rivera: His Life and Times*, Robert Hale, 1939

Wolfe, Bertram, *The Fabulous Life of Diego Rivera*, Cooper Square Press, 2000

Zamora, Martha, *The Letters of Frida Kahlo: Cartas Apasionadas*, Chronicle Books, 1995

Zarobel, John, 'The Hybrid Sources of Frida Kahlo', *Berkeley Review of Latin American Studies*, UC Berkeley (Fall 2008): 22–9

Zavala, Adriana, et al., *Frida Kahlo's Garden*, Prestel, 2015

INDEX

PICTURE CREDITS

The publishers would like to thank all those listed below for permission to reproduce artworks and for supplying photographs. Every care has been taken to trace copyright holders. Any copyright holders we have been unable to reach are invited to contact the publishers so that a full acknowledgement may be given in subsequent editions.

All artwork by Frida Kahlo and Diego Rivera © Banco de México Diego Rivera Frida Kahlo Museums Trust, Mexico, D.F./DACS

In addition, the following acknowledgements are due:

akg-images: 72 right, 118, 137

Alamy Stock Photographs: 14–15 (Wendy Connett); 18 (World History Archive); 29 (The Print Collector); 59, 107 top right, 115 top (Heritage Image Partnership Ltd); 72 left (Granger, NYC/ Photograph by Lucienne Bloch); 107 bottom (© Prisma Bildagentur AG); 122–3 (© National Geographic Creative); 158 left (© Paul Gordon); 158 top right (© John Warburton-Lee Photography); 158 bottom right (© The Art Archive); 162–3 (© John Mitchell)

Archives of American Art, Smithsonian Institution, Emmy Lou Packard papers, 1900–90: 129 top (Emmy Lou Packard photographer); 129 bottom (Diego Rivera photographer)

© Archivo Diego Rivera y Frida Kahlo, Banco de México, Fiduciario en el Fideicomiso relativo a los Museos Diego Rivera y Frida Kahlo: 10 top left, top right, bottom, 13 left, right, 16, 17, 20, 21 top, bottom, 29 top left, top right, 47, 53, 66, 114, 128, 141 bottom, 148–9, 152 top

Suzanne Barbezat: Back cover, 6–7, 134–5

Bridgeman Art Library: 26, 38 right (Private Collection/Photograph Jorge Contreras Chacel); 50 (Galerie Bilderwelt); 62, 84 (Private Collection/ Photograph © Christie's Images); 87 (Detroit Institute of Arts, USA); 90, 97 (Photograph © Christie's Images); 104, 108 (Christie's Images/

Photograph © Christie's Images); 110 top (Photograph © PVDE); 127 left (Photograph © 1985 The Detroit Institute of Arts)

© Museo Casa Estudio Diego Rivera y Frida Kahlo: 92, 94

Courtesy of the Detroit Historical Society: 75

Courtesy of Detroit Public Library, USA: 86

Courtesy of Fototeca, Hemeroteca y Bilbioteca Mario Vázquez Raña/ORGANIZACIÓN EDITORIAL MEXICANA S. A. DE C. V.: 52

© Javier García Moreno Elizondo, www.javiergmphotography.com: 30

Getty Images: Cover (Bettman); 33 (ullstein bild); 64 (General Photographic Agency); 71 (MCNY/ Gottscho-Schleisner); 74 (Bettmann/CORBIS); 78–9 (Photograph by Time Life Pictures/Mansell/ The LIFE Picture Collection); 98 (Alejandra Matiz/Leo Matiz Foundation Mexico); 102 (© Underwood Archives); 127 right (Paul Popper/ Popperfoto); 130 (Graphic House); 132 (Jacqueline Paul); 136 left (Hulton Archive); 159 (Miguel Tovar/STF)

Courtesy of Laure van Heijenoort: 110 bottom

Photographs © IMEC, Fonds MCC, Dist. RMN-Grand Palais/Gisèle Freund: 140, 143, 152, 153, 165

© Nickolas Muray Photo Archives, photographs by Nickolas Muray: 115 bottom, 147

Courtesy Old Stage Studios: 81, 88 (photographs by Lucienne Bloch 1909-1990, www.luciennebloch. com); 89 (photograph by Stephen Pope Dimitroff)

Courtesy Pointed Leaf Press, first published in *Frida Kahlo: Photographs of Myself and Others*: 5, 103 (photograph by Carlos Dávila); 46 (photograph by Guillermo Kahlo © Guillermo Kahlo Estate); 95, 142 (© Vicente Wolf collection)

Photo © Centre Pompidou, MNAM-CCI, Dist. RMN-Grand Palais/Jean-Claude Planchet: 117

Scala Archives, Florence: 8, 23 (Digital image © The Museum of Modern Art, New York); 93 (Photograph by Guillermo Kahlo/Digital image © The Museum of Modern Art, New York)

© SECRETARIA DE CULTURA. INAH.SINAFO.FN.MX: 136 right (498388)

Shutterstock: Cover quarter binding, 4 (anafotomx); 56–7 (Noradoa)

Courtesy Throckmorton Fine Art, New York: 43, 85, 141 top

Courtesy of Villasana-Torres Collection, photographs by Guillermo Kahlo © Guillermo Kahlo Estate: 12 top, bottom, 25

ACKNOWLEDGEMENTS

I would like to express my heartfelt thanks to the many people who offered their assistance with the research and writing of this book, as well as those who granted permission to use photos.

Carlos Phillips Olmedo and Hilda Trujillo Soto of the Museo Frida Kahlo and Museo Anahuacalli generously granted me access to the Diego Rivera Frida Kahlo Archive, and gave permission to quote from Frida and Diego's correspondence and publish photos from the archive. Alfredo Ortega Quesada of the Museo Casa Estudio Diego Rivera y Frida Kahlo kindly helped obtain images and permissions from various sources. Rebecca Baker at the Luther Burbank Home & Gardens graciously answered my questions about Luther Burbank and Frida and Diego's visit to his home. Andrea Reichow Jimenez helped me immensely by interpreting German language texts about Guillermo Kahlo.

A few friends read different sections of the book and offered insightful comments, including Jan Jorgensen, Kim Lewis and Danielle Conte. Serena Makofsky's proofreading was invaluable and she assisted me over a few hurdles in the writing process.

I feel very fortunate to have signed on with Frances Lincoln; everyone there has been a joy to work with. In particular, my editor, Nicki Davis, had a wonderful vision for this book and it was a pleasure to collaborate with her every step of the way. Anna Watson exhibited great patience and good humour while tirelessly hunting down photo sources and permissions.

I am very grateful to the women in my writing group, 'Las Creativas' for their friendship and encouragement, and my parents and extended family who believed in me and cheered me on from afar. My mother, Ann Price, sent books and other goodies when I needed them most. Above all, I am deeply thankful to Benito, Jasmine and Jeronimo for their continual support and their patience while this project took up much of my time and attention.

Frances Lincoln Limited
A subsidiary of Quarto Publishing Group UK
74–77 White Lion Street, London N1 9PF

Frida Kahlo at Home
Copyright © Frances Lincoln Limited 2016
Text copyright © Suzanne Barbezat 2016
Images copyright © as listed on page 174

All artwork by Frida Kahlo and Diego Rivera © Banco de México
Diego Rivera Frida Kahlo Museums Trust, Mexico, D.F./DACS

First Frances Lincoln edition 2016

A catalogue record for this book is available from the British Library.

978-0-7112-3732-2

Printed and bound in China

1 2 3 4 5 6 7 8 9

Quarto is the authority on a wide range of topics.
Quarto educates, entertains and enriches the lives of
our readers – enthusiasts and lovers of hands-on living.
www.QuartoKnows.com